After The Second World War, in Soviet occupied Hungary, everyone waited for the dreaded "Knock" in the night. When it finally came to Balazs and his family, he knew he had to act.

Not since the discovery of Anne Frank's autobiography, has there been another first-hand account of a life spent under terror and an oppressive regime, so vivid and captivating as, KNOCK IN THE NIGHT.

The author's narrative in third person, shares painful and tender anecdotes that makes one laugh or moves one to tears. Balazs was barely thirteen by the time the violence of the Soviet Communist occupation led to the 1956 Hungarian Revolution. After it's bloody defeat, he set out alone to defect from behind the Iron Curtain to the USA.

KNOCK
IN THE
NIGHT

KNOCK
IN THE
NIGHT

BALAZS SZABO

Prodigal Publishing Co.

2006

KNOCK IN THE NIGHT
Copyright © 2006 Balazs Szabo
Prodigal Publishing Co.

Photos in the center of the book are from photo albums of the Szabo family.

For more information on this title, please go to:
www.balazsart.com

Cover and book design by Balazs Szabo
www.balazsart.com

Printed in the United States

ISBN: 0-9772117-0-3

LCCN: 2005907555

To my wonderful sons,

Dominik and Sandor.

Acknowledgements

I am indebted to many special people for helping me with this book. I thank the Honorable Mayor Mary V. Mochary for her confidence in me and for her kind support; Amy Galland and Mark Bitleris for suffering to interpret my cover design into digital reality; my friend Janos Gerzsenyi for his infinite patience in helping me on the computer.

I am grateful to Mrs. Delores Cecchetti for her encouragement and friendship, and for typing much of the manuscript before it got to my editor's desk; Laszlo Papp for allowing me to use his photos of the Hungarian Revolution.

Special mention to my closest friend of 40 years, Frau Dr. Livia Karwath of Vienna, Austria, a survivor of Auschwitz herself and an inspiration for me to tell my story.

Most of all, I thank my beautiful and patient wife, Donna, who put up with me for 25 years and the many months of neglect through this book's production.

To my adopted American family—Ann Scott and Robert P. Morningstar—in whose memory I am dedicating this book. Their unconditional love and their generosity made it possible for me and my brother, Barna, to have the finest education in our adopted country. They were the kindest and most caring people I know and I am forever grateful.

A special thanks to The American Hungarian Foundation of New Brunswick, NJ for their archival assistance and overall support.

Foreword

IF YOU ARE reading these lines, most likely you are living in a free society, a democracy. If you are not so fortunate, then you live under a communist-run country or some other terrorist system and this book was smuggled to you via the black market because you have no rights, no freedoms and you are reading this in secret and fear.

This book is not for you; you already know. It is for those who don't know what kind of hopeless life you are living and wondering if the oppression will ever end in your lifetime.

My name is Balazs (pronounced Balage) and, as fate would have it, my spirit came to a physical existence in 1943 in Second World War-torn Hungary. I had no idea that my first 13 years of life would be spent in the snake pit of Soviet Communist occupation, in terror and constant fear without any hope of ever having the freedoms others enjoy on this planet. The Iron Curtain was a reality, not a myth, for me and my people.

I want you to imagine yourself accompanying me through this real journey, not in the privileged life where you were fortunate to have your beginnings, but in mine to see how you would fare.

I took this journey myself and fortunately found refuge in the United States, where I hope to spend the remainder of my life. Through my personal experiences, I have learned to admire and love the American people for their infinite generosity. They are not only giving within their own borders, but most of all for their willingness to give the ultimate sacrifices of their cherished sons and daughters

for the freedom of others—during World War II, the Korean War, Bosnia, Kuwait and now in Iraq.

Communism is spreading and is still an imminent threat to the free world. Beware!

Despite my freedom of 50 years (since 1956), I still fear The Knock in the Night.

—Balazs Szabo

Introduction

HUNGARY BOASTS a fascinating history. Hungarians frequently emphasize with much pride their countless countrymen who have contributed much to the world. Renowned names such as Franz Liszt, Zoltan Kodaly, Bela Bartok, Sir George Solti, Eugene Ormandy, George Szell. But they are also proud of their forebears—the nomadic Magyars who are believed to have settled the land in 896 A.D. The Magyars were pagans but the country, through the efforts of St. Stephen (997-1038), crowned as the first king of Hungary, embraced Christianity and integrated his country in the European community.

Throughout its history, the nation had been beset with a series of internal revolutions and foreign invasions. The Mongol invasion of 1241-1242 was the most horrific of all. One third of the population perished. Followed by the Turks who invaded in 1526 and brought similar devastation. After the Turkish rule that lasted 150 years the Habsburgs of Austria inherited the Hungarian crown by default to rule and tax the Hungarians.

In the Twentieth Century the 113-day Red Terror in 1919 led by Bela Kun, a disciple of Lenin, tested its power. But Hungarians will long remember the second rising of the Red Star in the wake of the Russian occupation in 1945. Some of the horrors of the Russian invasion are partly reported in Stephen Sisa's book, *Spirit of Hungary*. Sisa quoted the Swiss Legation to Budapest to show some of the atrocious behavior of Russian soldiers.

"During the siege of Budapest and also during the following fateful weeks, Russian troops looted the city freely. They entered practically every habitation, the very poorest as well as the richest. They

took away anything they wanted, especially food, clothing and valuables. Furniture and larger objects of art that could not be taken away were frequently simply destroyed...After several weeks, looting stopped...but Russian soldiers often arrested passers-by and dug into their pockets and stole watches, cash and even papers of identity."

Most disturbing was the report on rape, a horrendous act Hungarian women were unable to escape. Many, in fact, preferred death to being subjected to this despicable act. "Rape caused the greatest suffering. Violations were so general—from the age of 10 up to 70 years. Misery was increased by the sad fact that many of the Russian soldiers were ill [with syphilis] and medicines in Hungary were completely lacking."

The fate of the peasant population was no different, especially when the Red soldiers discovered stores of wine. "Once drunk, nothing was sacred to them. They raped half-grown girls and screaming grandmothers; they robbed the peasants of their animals and stole everything they could carry.

"But the most tragic losses were the thousands of men and boys whom the Soviet army seized for deportation to Russia. 'Malinka robot' (a little work) was the slogan with which the male population was taken to Siberia, which became for most a land of no return. The numbers included thousands of Hungarian Jews who had managed to survive the Nazi occupation only to be seized by their 'liberators.'"

A group of Muscovite Hungarians headed by Matyas Rakosi (1892-1972) came to complete the takeover. Ironically, Rakosi was born into a wealthy Jewish family and was a hard-core member of the Bela Kun regime. With his deceptive ways, he reassured Hungarians of his support for a democratic and independent Hungary and without Soviet interference in Hungary's internal affairs. All lies, naturally. Rakosi and his cohorts lost the national elections set in November 1945. Their Communist-Socialist ticket lost to the Small Landholders, an agrarian party.

Not about to accept defeat, Rakosi began retaliating against the

winning party using coercion and false accusation. His rule was characterized by police terror, with that knock in the night no one can prepare for petrifying everyone. His oppressive rule finally ended in 1953; Imre Nagy was appointed premier. Unlike Rakosi, Nagy had Hungarian affinity and wanted the abolition of the one-party system and withdrawal of Soviet troops. Demonstrators looked to him during the 1956 revolution: "Imre to the government." He was later illegally executed for his part in the revolution.

For decades, Hungary was a one-party state and a Soviet satellite dominated by the Hungarian Socialist (Communist) Workers' Party.

The Hungarian Revolution, which started as a peaceful demonstration, began October 23, 1956, with young students who wanted to be heard on their 16-points demands. (My book describes in detail these fateful days. My family and I were eyewitnesses to the massacre at the Parliament Square. My father was scheduled to recite Petofi Sandor's 1848 poem of freedom written at the time of the defeated Hungarian Revolution against the oppressive Austrian Monarchy.) After the Hungary Revolution of 1956 was abandoned by the West, the overwhelming Soviet force annihilated the resistance.

Soviet presence in Hungary ended in 1991 when all the Soviet troops left—pillaging and raping as before.

After being subjugated and repressed for decades by Mongols, Turks, Romanians, Austrians, Germans and the Soviets, and having its land dismembered by the Treaty of Trianon of 1920 then again in the Second World War at Yalta by the Allies, reducing its size to two-thirds, Hungary has recovered and is standing tall and proud. Today, it is a free, independent nation, and in 2004 became a member of the European Union (EU).

Hungarians are a spirited, resilient people who have endured the tyranny of communism without it killing their spirit. Hungary's more than 10 million people are now enjoying a multi-party political system, with free elections and rights to free speech, free press, free worship. According to recent statistics, some 67.5 percent are

Catholics, 20 percent Calvinists, 5 percent Lutherans, 5 percent unaffiliated. Twenty percent live in the capital city of Budapest; 35 percent in other cities and towns; 45 percent in 2,892 villages.

More information on the history of Hungary can be found in *The Spirit of Hungary* by Stephen Sisa (Vista Books, Morristown, New Jersey, third edition, 1995). I credit the book for the historical facts mentioned in *Knock in the Night*.

To comment about the book, e-mail author Balazs Szabo at **balazsart@yahoo.com;** visit the web site for more related photos and additional information about the author: **www.balazsart.com**

ONE

THE LAST RUN

AS HE LAY in the powdery snow from his fall, he quickly examined his body for glass cuts. The coal miner catapulted him through the closed window of the train. He was amazed that the only injury he received was the bump on his forehead. Balazs was only a few hundred yards from his wounded friend the train. As the rattle of the deafening machine-gun fire filled the air, he lay low focusing on the scene. Only a few dark, shadowy figures ran from the wreckage toward him, as everyone else bailed out and scattered in all directions. Several of the cars were turned over, some were blown off the tracks, he couldn't tell. The powerful engine was somewhat dismembered and partially derailed—riddled with bullet holes releasing steam everywhere, like blood spouting from a wounded bull.

The wheels were still turning slowly—some suspended in air, others digging into the frozen ground leading nowhere as the horizontal steel bar kept the motion going in some mindless reflex. The squeaking and grinding of the damaged moving parts called out to him with pain. He felt a great desire to return not abandon it in its moment of need. He remembered with guilt the happy times they

spent together. The time the train brought him to his grandparents'
home in Fuzfo. There were countless fun rides. The circus trip and
the many free rides about the lake. Balazs felt he took its faithful
presence for granted. Now he watched it dying, alone and aban-
doned by its ungrateful and cowardly friend, but what could he do?

Russian soldiers were swarming everywhere searching the wreck-
age and executing those who survived with spurts of gunfire. They
also shot blindly into the dark with hopes of killing the fleeing. He
did not dare move; he lay like a hare in the brush—one with the
ground, not to be flushed out until it became absolutely necessary.

Suddenly, there was a bright flash of light and a big explosion
that rocked the earth and the sky, followed by a deadly silence and
darkness. The train and all its parts blended into nothingness.
Stunned, he blindly glared into the blackness and not until the
tanks' searchlights began to sweep the terrain did he regain his
vision. All evaporated in a split second before his eyes. It seemed that
the last deafening explosion and the flash of light took what
remained of his past—the train and his childhood.

The illuminated landscape brought him back to the present
instantly. Several shapes began to move near him on the white frost.
He heard the muffled voices of some kids as they crawled by. Getting
his courage up, he quietly called to them. "Hey, guys, are you from
the train, too?" "Yeah," replied one of the kids softly. "What are you
doing sitting there, are you wounded?" "No, I just don't know what
to do." "What do you mean, moron? Go toward the border, natural-
ly," said a rather snotty voice with that jargon of tough, Csepel
Island street kids. "Okay, smart guy, if you know so well, why don't
you point the way?"

"All right, kid, just fall in line, we have some idea. By the way,
this kid here is Laci I am Joska. I don't know the name of the other
three." Joska was about 16 or so, a rough-looking, well-built kid,
obvious to Balazs that he was working class. He had unkempt, long
hair and the smell of a wet fox. "This here is my brother." Joska
brandished a heavy, black revolver into Balazs's face. Balazs was very
impressed. He wanted a gun at the outset of the revolution, but his

father would hear none of it. Then Laci offered, "Joska was fighting in Budapest and Csepel, you know, and so was everybody in his family. His brother and sister were shot off the roof of the factory during the invasion. Later, he watched his father being captured with a bunch of other freedom fighters as they ran from a burning building, then executed. He was out of ammunition by that time and was helpless. By then, he killed lots of those sons of bitches!

"Look, Joska's pocket is full of red stars from their jackets." Laci dipped deep into Joska's pocket and proudly produced the familiar enamel red stars that the Russian soldiers wore on their lapels and fur hats. "All right, let's stop the social bullshit and move on before they catch up with us," implored Joska. "See in front of you, far in the horizon those flashes of lights, beyond that is where the border is. The flashes are the flares that the Russians and the border guards shoot into the air to see where you are. There is no arrest here—you just get shot to hell when they spot you. Every forty meters or so there will be a tower at least eight meters high, the tripod machine guns are mounted there and manned by guards. The Russians stay near them for self-defense since lots of Hungarians come with arms, too. Damn it, we'd have a lot better chance with some snow fall."

As they looked up, to their surprise, they saw the flakes descend a little thicker and larger. They decided to make a run for it and sprinted on the frozen soil. A round of machine-gun fire came from close behind them and as Balazs turned to his side, he saw a mass of people running through the low brambles not far off. He heard another round of gunfire and saw many of the dark figures fall. He could hear screaming, shouting, commotion, but it was too dark for him to see clearly. He ran in mad fear now and sensed the danger approaching close behind him. He heard excited shouts in Russian, followed by rounds of shots overlapping each other.

In front of him, Joska hit the ground falling face first, groaning and holding his leg. "I've been hit, oh, I've been hit!" Panic-stricken, Balazs and the others who were lagging behind the fast, strong runner dove on the ground next to him. "God, Joska, where did they get you, where?" Joska looked up from the ground with a large,

shit-grin on his face, laughing at the little frightened faces around him. "You guys, I was just kidding, wondering when you were gonna catch up with me." "Geez! Joska, that was stupid, this is no time to joke," said Balazs. "What the hell were we to do if you really got wounded?" "Well, if that happens I want you to finish me off with this here gun, "cuz I am not gonna fall to a Ruszki! You got that?"

"All right, now listen, I've got something to do. As we ran, I saw only one bastard behind us, but he hasn't spotted us yet. I think he is the one that shot at that group on our right." As he said that, the words froze in his mouth. Three Russian soldiers towered over them, appearing from the thin air with machine guns pointing into their faces. They were paralyzed with fear, expecting the spray of bullets through their bodies. Balazs could not believe he had gotten this far only to be shot, now!

One of the soldiers broke the silence, speaking in Russian. "All right you little rats, what you gonna give us if we let you go?" They could not believe their ears. Let you go? My God, thought Balazs, do they really mean that? These lying scum of the earth, they'll probably just rob us and shoot us afterwards. The kids next to him were already reaching into their pockets, producing cash, pocketknives and other personal treasures. Balazs automatically reached and patted his jacket. He knew he still had the two aluminum flask filled with Palinka in his inner wool pockets; the ones exchanged for his bike.

Knowing how much Russians valued watches and alcohol, he handed the flasks over to the soldiers. He noticed in the glow of the flares that the soldier's left arm was already covered with countless watches. He wondered what fate befell the previous owners. The Russian grabbed the flasks out of his hand and approvingly laughed as he guessed its contents. He grunted over to the other two, "Now this is something worthwhile!" As the others stuffed the loot into their pockets, this one took the twist cap off the flask and took a deep swig. The excellent Hungarian plum brandy was something he never tasted in all his cheap, vodka-drinking years. The first swallow hit him so hard that he nearly choked on it. The other two laughed at him while they took long hits of their own.

Somehow the drinking party on this killing field, was out of place and looked surreal to Balazs. The soldiers, very content with the loot from the kids, were impressed enough and shouted, "Davay, Davay," which means go or scram, but a ruder version. It was a gruff term used when they pushed people around at gunpoint or shoved them into prisons to line them up for the firing squad.

The kids didn't believe their ears! Impossible, they thought. They kept on turning back to see if they would shoot them in their backs. But no! The three silhouettes slowly blended into the darkness as they returned in the direction of the train. "Where is Joska?" Balazs asked, when he noticed the missing boy. No one knew. They turned every which way looking for him, but he was nowhere to be found. Laci exclaimed, "Jesus Christ, while we were digging into our pockets to give all we had to these bastards, all I was thinking of was Joska's gun in his pocket and what if they find it"

In the midst of all the machine-gun fire, they heard three solitary gun shots. Bam. Bam. Bam. Stunned, they waited and kept wondering if Joska was going to return. Soon, they saw a person running towards them from the direction of the train. It was Joska! The bewildered bunch, seeing him all wet, covered with slimy blood, grinning and breathless, asked, "Joska, where the hell have you been, what happened, why did you vanish?" "One question at a time, fellas," he pleaded, with obvious satisfaction on his face. "I could not let you little morons give everything to those assholes. Especially when I saw Balazs hand them the booze. Hey, you have been holding out on us, where did you get that stuff?" "Never mind that," said Balazs. "Tell us what happened!" "Well, nothing, I stole away while they were all busy with the booze tasting and partly because I was worried they'd discover my gun. I was waiting for them back there, where the train was—figuring they were the dirt from the tanks. No one was around and by the time they approached they were pretty happy from the good stuff. I hid in one of the ditches and, when they came in close enough, I just pumped them one fat bullet each. They went down like sacks. I got one for my sister, one for my brother and one for my dad. Boy, it felt good!"

He reached into his pockets and pulled out bundles of money, watches and finally one of the flasks with most of the Palinka still in it. "Hey, we might need this if we get through the border!" The kids stuffed everything back into their pockets, not bothering to divide it fairly. There was more than what they gave since it came from other victims, too.

They each took a swig of the Palinka, which was very potent and felt comfortingly warm on this freezing night as it went down, burning their insides. "Now let's get going before we are caught again and get shot right here on the spot," said Joska. They turned toward the flashing lights of the flares and rapid machine-gun fire, which was getting louder and more constant. It was like running into the mouth of hell, running toward danger, instead of away from it. It was against all logic and to Balazs it began to look like a futile effort.

As they ran closer and closer, toward the evermore visible towers on the horizon, the smoke from the guns began to veil everything. Yet, through the repeated flashes of the flares they could make out thousands of people everywhere, running toward what was certain death. As they advanced, they fell into ditches freshly created by exploded mines stepped on by unsuspecting feet. Dead bodies were scattered in all direction. Adults, children of all ages; fresh and old, blue frozen limbs without bodies and bodies without limbs or heads littered the open field. All this seemed to be the Revolution all over again, reenacted.

Almost somersaulting, Balazs fell deep into a hole, biting deep into his tongue. As he tasted the blood, he noticed he landed in a small child's washbasin and other belongings spilled from an abandoned trunk of an earlier refugee family. It was ridiculous what people would drag with them at such times, he thought, gathering himself for the next dash.

The closer they came to the towers, the more frequently they had to dive on the ground to avoid the thick spray of machine-gun fire. The bullets incessantly pierced the air everywhere around them. The air filled with smoke and the choking stench of spent gunpowder. The shafts of light from the towers swept the thick curtain of

smoke as the red and blue flares lit the entire landscape from above. There was no wind and the smoke was trapped low making it harder to see despite the constant searchlights and flares. Nevertheless, the guards who also shot blindly into this haze in hopes of killing everyone had ample ammunition to waste, so the rattle of the guns went on uninterrupted.

There were groups of people everywhere facing the horror of the whistling bullets. "Oh, God, if we only just make it through those towers," was everyone's pressing thought. They were all on their own and no one looked to others for assistance. This was the last run! This is what Balazs was waiting for too. Death was everywhere. There was no turning back, only the road ahead toward death or freedom. Yet that slight chance of survival, the one in a thousand, was in the heart of each and every one. Maybe I will be the one to make it to freedom! If not, I'll just die here and give up the fight. I will never return to the terror of the Russians and communism.

Joska, up front of the boys who were now scattered and not a group any longer, fell again! Some of them noticed, but kept running on, no longer involved and feeling responsible for the fate of others. Balazs, too, ran past Joska's body, thinking to himself, shit, not this stupid joker again! What an irresponsible jerk to play those dumb games. But then he thought, my God, he may really be hit because he went down so quietly. I can't just leave him there. He returned quickly and saw Joska, lying in the same spot in the same twisted position when he passed by him. "Joska, you're hit!" Balazs yelled as he dove to the ground next to him. It was soaked with blood all around Joska.

He was laying with one arm under his body, the other was thrown across over his face. When he didn't respond, Balazs lifted Joska's arm from his face, but withdrew horrified at the sight and rolled back away from the body. Joska's throat had been shot clear through severing it from his head. It looked like the necks of chickens his grandfather Eugene cut through, still attached by a loose flap of skin. In the clear light of a new barrage of flares, he could see the pipes protruding from his neck with blood spurting, bubbling out of Joska with every beat of his still pumping heart. His legs began to

kick and his body jerked; shaking in that horrible death rattle Balazs became familiar with.

He bolted from the scene with terrific speed toward the towers. The hate and anger that filled him made him feel invincible. He felt he could run to the towers, scale the supports and tear the hearts out of every one of those murdering bastards. He would run and kill and kill, until they were all dead, until every Russian and evil person that hurt an innocent being is dead on the face of this sick, evil world. The lights blinded him as he ran in a numb, automatic motion between the gates of Hell with Cerberus, the three-headed hound, biting at his heels. Thousands became visible everywhere, running in front, in back and besides him—falling in death or falling with screams of pain from wounds.

Nothing would stop him now—he was determined to continue running. A flash of memory swept his subconscious as he remembered the man he saw shot at the Parliament. The man's leg was separated from his body by machine-gun fire—the severed leg continued in running motion, as if it wanted to catch up with its owner. He had no idea of time and distance nor was he aware of the numb sensation in his feet and hands from the frost. The sound of his breathing became amplified, then there was silence. He fell exhausted to the ground. The towers were far behind him. The screams were almost inaudible, yet the flares appeared playfully dancing behind the veil of smoke. One, ignorant of the cruelty being played out there would have thought children were at the fair playing and screaming with delight. With extreme exhaustion and spent energy, he vomited. Balazs laid there in utter abandon and it was a while before he stirred. Finally, he sat up and washed his face in a patch of snow. He was uncertain where he was. In the confusion of the last run, he thought he may have become disoriented and ran back the wrong way. None of the other boys were any-where to be seen.

On the other hand, he could be in "No Man's Land," too. The parcel of neutral land sandwiched between the two countries' borders. If someone escaped into that area, the international rules were

that no guard was allowed to shoot. Naturally everyone knew that the communist guards and the Russians broke that rule every time. Before he realized, he was up and running again, but this time toward that strange and inviting soft ribbon of blue light in the horizon. It looked like an Aurora, suspended above the white frozen land as far as the eye could see.

He slowed down and waited, then stopped altogether. All about him the landscape began to come alive with shadowy figures. The dark forms appeared from everywhere, calling out to one another in Hungarian searching for loved ones who were lost in the run. Some received joyful responses others were quiet with grief after discovering the inevitable reality of their loss. Nonetheless, it seemed that everyone was instinctively attracted to the blue lights like so many moths drawn to the porch light.

Hesitantly in silence, groups drew in tight formations to march together for a kilometer or so. Balazs joined a group of adults. They arrived at the edge of a quaint village aglow with fluorescent streetlights the likes of which they had never seen in Hungary under communism. The frightened, exhausted group stood for a while simply staring. Slowly with caution they approached a small street sign; someone read aloud for everyone to hear the name of the street in German! A confirmation to all that they had reached freedom! They were free! They crossed the Iron Curtain! Stranger embraced stranger— happy for each other, yet sad for those left behind or fallen.

TWO

THE TRAIN

SQUINTING HIS EYES tightly against the smoke-filled wind, Balazs strained forward to see the winding tracks come slithering toward the train. At the bends it seemed that the steam engine ran away from the wagons at which time he caught the usual sparks and soot-filled steam right in his face. He wiped it off and turned his head down wind to avoid another onslaught. His destination was the northernmost point of Hungary's largest lake, the Balaton. It ran a narrow stretch of 120 kilometers from east to west with the northern tip pointing toward Budapest.

Hungary, after the Trianon agreement following World War I and its division by the Allies after World War II, was shaped like a kidney bean on its back, a quarter of its original size sliced by two great rivers. It is located in the northeastern part of Europe flanked by Slavic nations almost on all sides—Czechoslovakia on the north, Russia on the east, Yugoslavia, Romania on the south. On the western border is Austria, with its Germanic population.

Since the Russian occupation of 1945 and the result of the Yalta Conference, where the spoils of war were divided by the victorious Allied nations, Hungary was formally given to the Soviet Union to

be ruled for a term of eight years, after which it was to govern itself freely. The Russians secured borders—surrounding them by minefields, electric fences and miles of barbed wire. At every quarter kilometer or less were towers with machine guns and armed soldiers scanning the horizon to keep out the "Western Imperialists."

The country is split in the center, east and west by the Danube (or "Duna" in Hungarian) The right half is cut in a diagonal from north to south by the river Tisza. The western half, where Lake Balaton is located, are fertile hills and woods. The eastern side is flat and in its center lay the famous Hungarian prairie, the Hortobagy, famous for its exotic cattle, horses and sheep, all raised under the open skies. This resulted in a natural selection of the fittest, given the extreme climate of the hot summers and the bitter cold winters when the weak perish.

The lake, situated in the moderate climate of the western side, is favored for recreation by the city dwellers. The region surrounding it is also a fertile land of volcanic origin, with red dirt glowing from beneath the rich, green growth. Balaton is laced with beautiful vineyards around its hilly shores and hot geyser spas. The lake itself is rich with freshwater fish and it is not uncommon for fishermen to catch carps and catfish, both favorite delicacies of Hungarians, in weights more than 100 kilos. In the ancient woods of Badacsony, a volcanically created mountain plateau, roam thousands of elk, deer and wild boar.

Balazs stood as tall as he could on the worn, cracked-leather seat holding the rusty metal rim on the grimy, filthy train window. The wagon smelled of smoke and urine inside, which penetrated body and soul. As everything of public domain, the train was also neglected since the communist takeover. The piercing, chilled wind of the early spring burned his cheeks and temples which gave him cramps like those caused from fast-consumed ice creams. The greenish-brown landscape of the season only added to the post-war scars of the Hungarian countryside.

The train rushed by peasants' burned-out and bombed dwellings. Scorched woods littered with debris of war equipment, rusting tanks,

vehicles of every kind disrupted the natural landscape. Helmets of dead Russian, Hungarian and German soldiers were scattered everywhere. Not comprehending all this with a child's mind, the passing landscape offered him pure excitement and delight.

The constant clanking and rocking had a mesmerizing effect on him and on his attractive young mother, who sat beside him in distant awareness. She was well dressed despite the poverty of the times in the Soviet-occupied Hungary. Her graceful, narrowly shaped hands sported fresh, bright-red American nail polish acquired on the black market for hefty sums. Her refined figure revealed her higher birth and genteel upbringing. She was the daughter of the ministerium's advisor and attorney to the prewar Catholic Diocese and the wife of the most celebrated young classical actor of the times. The affluence was swept away by the war; now her years at Sacre-Coure were just a memory. The tumult of life's painful memories was also a muddle of confusion in her head, with the final blow of her divorce proceedings.

With the wind and the sound of clanking metal, the cabin door flung open. The draft of the momentary compression blew in the passenger serviceman. He had greasy hair and wore a shiny black uniform baggy at the seat bottoms from years of wear. The dirty, half sawed-off wooden crate, strapped with leather to his bony shoulders next to his deeply grooved dirty neck, was filled with cheap postwar candies.

Almost incoherently, he, like a sheep, bleated out the names of the items for sale. The young woman signaled to him, with that typical flippant gesture rich people tend to use when summoning someone of lower birth and purchased a chocolate-covered wafer for the boy. This was offered by dirty hands and without a wrapper. Many items such as paper were in great shortage and a luxury after the war. Toilet paper was unheard of. Balazs received it with a polite thanks and within moments consumed it.

He was a thin boy, not yet 4, with the bone structure reminiscent of his mother's having no resemblance to his stout, monumental father. However, the delicate, small features of his face were a mix

of both parents, but without his father's protruding jaw. His father's eyes were sky blue under an evenly wavy chestnut brown hair. Balazs's hair was sandy blond with streaks of reddish brown. His eyes were almost yellow-green. His mother's were a darker, angry green framed by blonde hair. Her firstborn son, Barna, a year older, was of heavier bone structure, blond, blue eyed with a stronger jawbone more like his father's. However, his lips were full like his mother's, unlike the second born, Balazs, whose were thinner and less pronounced.

She and her husband fought for the custody of the firstborn. The placing of the younger child was strictly a strategic move on her part without a concerned who gets him.

Her parents, in their 60s, escaped deportation from Budapest by leaving before the authorities of the new Soviet regime shipped them out with the rest of the intelligentsia. The state confiscated their elegant Budapest home and all its belongings, but allowed them to take refuge in part of their former summer villa, overlooking Lake Balaton. (All homes with six or more rooms fell under a government confiscation quota.) They were allotted one room with a glass-enclosed veranda and kitchenette. No bathroom, only an outhouse, no running water, just a well.

Balazs turned from the window. His mother met his curiously restless eyes, she thought this was perhaps the look of war children, defiant of fear, not childish at all. The look disturbed her so she averted it pretending to take interest in the swift passing of the landscape. For some unknown reason, he made her feel uncomfortable, giving her visible nausea. She lit a cigarette inhaling deeply, relieved at the thought of leaving him with her parents. She felt him staring still as was his habit, almost insolently, as dogs do when they sense one's fear. He would not let go and the time seemed to stop for her. She wondered how much longer it would take to their final destination.

The old couple was waiting at the small train station, sitting close by each other on the hard, bright-red, wooden bench facing the tracks. The parallel silver lines of the rail divided the sea of green reeds and the glistening surface of Lake Balaton from the land. The

train would come from the east, where the old pair arrived some 30 years ago for the first time. At the time there wasn't much of a town there. Much of it was swampy land with thousands of wildly growing, giant weeping willow trees. In ancient times this land was tended by the early Avars, then the Sumerians, followed by the Romans, Huns and finally the Magyars—all left it rich with thousands of years of buried artifacts.

Eugene was assigned by the old regime to deal with the parceling of three counties and developing the land to create a resort town. Mountains of dirt had to be moved and the swamp had to be drained, all paid for by private investors. Within a few years, much was accomplished. Valuable ancient artifacts in gold, silver and gem-laden weaponry were discovered on Eugene's lot. He built his villa on top of a hill. At the corner of it he had all the bones from the digs re-buried reverently, then covered it with red volcanic rocks with an appropriate stone cross atop. He kept one pair of golden stirrups in his uncontrollable fascination, the rest were donated to the nearby museum in the city of Veszprem.

The villa, which Eugene designed, had two towers. One large with living quarters and a smaller one at the other end of the roof with a small lookout. This tower had a sand floor with three permanently open slits for windows, facing the lake. It was of tastefully mixed styles—Germanic and Mediterranean influences, with cream-colored stucco exterior and red slate roofing. Arched windows graced the glass-enclosed veranda. The remaining windows for the house were square with Hungarian folk-style shutters.

The house was furnished completely in the Hungarian high-peasant style. The heavy wooden chairs were fitted without nails and were hand painted with customary Hungarian floral motifs used in the traditional embroideries. In the back panels of the chairs a tulip or a heart had been cut through—as did the heavy, dark wood dining table. The painted wood-paneled walls and ceilings were completed at great expense by the finest artisans of the region. Slowly, the town attracted not only the vacationers, but farmers as well.

Because the willows were preserved and more were planted

along the train tracks of the lakeside, the town came to be known as Balatonfuzfo, meaning Willowhead at Balaton. These were the pre-war prosperous times in Hungary, when Eugene was successful in his work. He was the youngest of five children from northern Hungary in Nagyszombat, now Tvarna, Czechoslovakia, His father abandoned his young mother with five children. His mother, through her seamstress earnings, raised two boys and three girls. The oldest boy became a priest; the oldest girl worked at the post office and later married the postmaster. The two younger girls never married and lived to ripe old ages. Eugene, was a very talented artist, but knew he could not have an easy life pursuing art, left home for Budapest's better work opportunities and higher education. He attended the Budapest University of Law and Philosophy, where he met his wife, Paula Knapp. Somehow, he ended up spending more time sitting in lectures on Hungarian studies than law.

Paula was from an upper-crust family. After her wealthy father died from a riding accident, her mother married the manager of a major hospital in Budapest. She had a fine upbringing. She spoke German, French, Latin, a little Greek and played the piano beautifully. A striking beauty, she was petite, outgoing and full of pep. Her bright, pale-blue eyes shone of intelligence and integrity. She was an independent thinker and was spiritual without being dogmatic. She raised her family of two boys and a girl with the finest intellectual and spiritual guidance possible.

As the town grew, Eugene encouraged his friends to invest their wealth into building a church for the residents as only the stone walls remained of the original ancient chapel in town. It was destroyed by the invading Turks hundreds of years ago.

The new church, in front of this ancient monument, was built out of white granite in a very clean modest design. The arched windows featured the stained-glass portraits of saints. The names of families who donated the money for the project were displayed below the images. Eugene, who had donated the money and led the project, was given a special place of honor on the first window at the right of the altar, where his daughter was portrayed at age 16 with

an exact likeness of her beauty as St. Hedviga, her namesake. The extraordinary artistry of the stained-glass master pleased everyone.

Those times seemed long ago now, almost a dream. Paula and Eugene sat by each other quietly, beaten and bewildered from the events of their lives. Although the old man was against his daughter marrying the actor ("a clown," as he referred to him), he would not have guessed that things would turn out this way. He was angry and upset. He could not understand the big fuss over everyone's concern with winning the first born child in the custody fight. It seemed to him that everything was destroyed by the war and people have lost their last remaining common sense. The country fell to the communists, people were persecuted everywhere, deportations were en masse, his oldest son jailed and tortured, his daughter divorcing. To make things more intolerable, the communists denied the old couple their pension.

The train turned into the sharp bend while blowing the whistle twice sharply. Paula and Eugene felt the rumble of the ground beneath them. The stationmaster, in his black uniform, walked across the red cinder gravel and each time his weight came down, the gravel made a pleasant crackling sound beneath his shoes. As the locomotive slowed to his command, he disappeared into the clouds of snow-white steam, comically his red flag continued flailing through it in the air. The young woman called out to her parents from the window as the train came to a deafening and long screeching halt. Suddenly she could not see them as the tears overwhelmed her. She felt sad, yet overjoyed. It was always a comfort to be with them and especially now!

Eugene helped them off the stairs with their luggage and kissed the boy's cheeks warmly while petting the top of his head. Paula held her daughter tightly with a silent understanding that only a mother can communicate. Eugene held Balazs's hand and went up the stairs behind the station that led through a small park facing the elementary school. His grandfather's hand was gentle and smooth; his nails well kept and clean. His voice, mellow and warm, revealed a very pleasant and soothing nature. Although Balazs did not remember

ever meeting his grandfather, he felt quite comfortable with him and responded with enthusiasm to his questions regarding the train ride. There was something very special about the train and he was certain that Eugene could answer all his questions about the workings of the steam engine.

They arrived at the top of the hill. When they turned to wait for the rest of the family they saw the train speed along the bend and disappear around the corner toward the next resort town. Suddenly, Balazs felt a special yearning to see the train again. Eugene, noticing this, reassured him that from the villa he would be able to see every train that passes by.

They arrived at the rusty iron gate of the villa, which was light, rust red, with straight diagonal designs and baroque curves. A narrow and steep gravel road led up to a crossing. A smaller path, left from that point, led to a mud-brick, peasant hut (used as maids' quarters before the war) with a well in its small courtyard. The main gravel path led to a Swiss-style, square-shaped lattice gazebo. There was an immaculately planted flower-bedecked yard at the back. A large area, cleared and covered with white gravel, had assorted pines sporting sculptured cones, which offered wonderful refuge to a variety of bird life.

At the far end of this plateau, occupied by the house and the front yard, stood a peculiar stone fountain (unfortunately out of service). It had a cherub-like figure, half-fish, half-boy, crawling up around a large half-shell. This was held by a similar creature, from the bottom, which spouted water upwards, so the water fell back into the shell. This courtyard was so well elevated that when the trees were bare in the winter one could easily see the vast lake below.

They took the four steps to enter the house through the veranda, which had wide-arched windows made of white, iron frames. The center wings were open, allowing the fresh spring air in. There was a lot of furniture and clutter, belongings saved from the other rooms of the house, now occupied by the government-assigned tenants. A large, baroque armoire blocked the entrance to the original main dining room to give the old couple some privacy. It held their

clothing and the large drawers were crammed with wrinkled apples (preserved from last fall), walnuts, hazelnuts and almonds.

Along the wall under the open windows were three large peasant grapevine baskets filled with straw. Three fat Rhode Island Reds each spread their heat-filled wings gently over more than a dozen eggs in anticipation of hatching. However, one of these hens was in for a big surprise. Eugene put fertilized duck eggs under her. In months past, the ducks, being clumsy and heavy, broke many of their own eggs and hatched fewer than half beneath them. The hen seemed to be a more careful mother. (The chicks took 21 days to hatch and the ducks four weeks.)

Now Eugene opened the two tall wings of the doors entering the bedroom and the only living space left them, in addition to one tiny room, about 1 ½-by-3 meters. Originally built as a pantry, it was now being used for their wood and butane gas stove. This was a luxury since many households still used wood stoves for the preparation of foods. The authorities missed this during confiscation of goods. Next to this was a three-legged stool with a white enamel laveoir or washbasin on top and a water pail with homemade dark soap (prepared of pig's lard mixed with lye). This was therefore the bathroom and the kitchen as well.

To bathe one fetched the water from the well, then heated it to the right temperature before proceeding to wash body parts from top to bottom—reserving the cleanest water for the face first and the feet last. This helped conserve water and made for fewer trips to the well which, in bad weather, was unpleasant and something to avoid.

The French flush toilet was awarded the tenants' part of the house, so this left the old couple to build an outhouse, which was dangerously close to the well. When the weather was bad or it was too dark to go out, they used the so-called "bili." This was quite a disgusting invention of the Romans 3,000 years ago. Into this porcelain or tin enamel pot with a handle, one would relieve oneself then post it under the bed, where it sat all night and filled the room with a stifling stench.

The bedroom, also known as the "everything room," held a two

meter-high porcelain, wood-burning stove with an iron door. Two other large armoires—one elegant Biedermeier and the other a functional dark wood—faced each other. There was a double bed in the center against the facing wall, with attractive carved bedposts. On either side of the bed was a night table with drawers and two lovely antique, German bronze figurines of nude Hermes holding the post. A card table with three chairs pushed against the foot of the bedpost, served as the dining area. In the remaining space a small bed was pushed against the wall with hardly a pathway between the two beds. When Jadda (pronounced Yadda) came to visit, she slept with Balazs on the small bed.

For the few remaining days of their daughter's stay, the couple made their rounds of elderly friends who had similar circumstances—sharing in the events and the family sagas. The only source of news about deportations and disappearances of relatives was the people's grapevine. The authorities would not release any information regarding deported, jailed and, naturally, tortured citizens. They discreetly discussed the many political events.

News from the West came only by way of Radio Free Europe, aired by American and European Allied stations and heavily jammed by the communists. The sound would come and go in waves inaudible most of the time, but it came from the free world shut away by the so-called Iron Curtain. Each forbidden word caught on the airwaves was cherished and put together like a puzzle. Anyone caught listening to this station was immediately punished by severe beatings, long jail sentences and deportations to unknown places without trial.

Therefore, the short-wave radios were highly priced and in great demand on the black market but at a great risk to the owner. Eugene owned one of these fine radios from the famous Hungarian manufacturer, Orion. It was a formidable instrument, with a beautiful wood-finished casing. When turned on, one had to wait for the bulbs to heat up. In its upper center was an eye like a Cyclops, a small glass bubble. When the radio heated to the proper temperature, a green pupil-like eye glowed beautifully. This green color consisted

of several fan-like rays that separated or closed according to tracking of the tune on the sending station, which then resembled a frog's eye.

Eugene enjoyed Balazs and took pleasure in his interest of flowers, animals, birds and all that fascinated a child reared in the city. Growing up in the midst of the Second World War and moving from one dark bunker into another to escape the falling bombs, surrounded by machine-gun fire, smoke and screams of the panicked population, Balazs found *magic* in nature's splendor.

THREE

THE HATCHLING

THE FEW DAYS spent with her parents were filled with the warmth and comforts of parental love. She felt stronger and ready to face the chaos awaiting her in Budapest—the fight in court for her son, Barna. To Balazs's shock, Jadda postponed telling him at the last moment, that she was to leave him behind. She offered some vague and shallow comforting words, in the hope that her mother will step in and help her out of the situation, which both parents did without being asked. His grandfather tried to distract him with things of interest, but the panic hit. Balazs realized that he was to be abandoned.

Although he enjoyed the days spent with his grandparents, he was sure this was not where he wanted to stay. Frightened, he held on to his mother's dress tightly, insisting on going back with her. She tried to reason with him, to explain that it was temporary and that it was better for him to be here. He would have none of it. His grandfather had to tear him away from his mother, who took a toothbrush out of her pocketbook, left it on the table and said, "Now be a good little boy, don't forget to brush your teeth."

As she stepped out, she felt a definite relief putting distance between herself and the house on her way to the train station. Her steps began to quicken as her mind raced toward the coming events in the city.

Balazs was outraged at being overpowered—he cried and screamed in protest. He withdrew to the corner of the room and decided to have nothing to do with the old couple. At every loving approach, he would yell at them or cry again. Hours passed and dinner time came. His stomach ached from hunger and crying, but he was going to win. However, the couple was well practiced at dealing with children, so they let him be and waited patiently. It was now getting dark and Paula lit the kerosene lamps, which emitted a gentle, not disagreeable scent that was familiar to him from all the blackouts of the war and the smell of bunkers. Eugene and Paula sat down to dinner with an extra setting waiting for him. He was dying to eat, but didn't give in. After dinner, Eugene went to the veranda, and moments later, returned with an egg in hand. He placed a small towel in front of Balazs on the floor and placed the egg on it, gently. He then joined Paula at the little table to play cards. Balazs had no idea what that was all about, if his grandfather thought that he was going to eat that egg, he was mistaken!

As he decided to look away, pretending he was not even interested, the egg moved! It actually moved by itself and rolled a bit to turn. Balazs's heart jumped. A second later it moved again, but this time he thought he heard a tiny sound. Minutes passed and there was not another stir. He forgot his anger, not to mention his hunger. He was fully concentrating on that egg, waiting in anticipation. He reached out and pushed the egg tenderly with his fingertips. It moved once more and a small crack appeared at the pointed end of it. Suddenly, the tip of a little twig-like thing protruded. His first reaction was to run to his grandparents. He had no idea what was happening. He was frightened, but before he had a chance to act the egg came totally alive.

A small, wet little head pushed through the opening which it created, with the little feet folded right by its yellow beak. It lay with its head on the towel panting from the strain and the effort of birth. With an ever so audible peep, it pushed again to kick off a large area of the shell revealing a wet and messy-looking creature. Balazs was so fascinated at the miracle which unfolded before him that he was unable to contain himself.

He laughed out loud with delight and reached out for the little chick placing it in his hand, still with some of its shell attached. He held it under his chin and blew his warm breath on it instinctively. Maybe he felt a kinship with it, a bond of some kind. A surge of unfamiliar love engulfed him. Eugene and Paula were quietly watching. The couple knew that this moment was special in bonding them with Balazs. The thought of one day losing him would bring great pain.

FOUR

NEW LIFE

FRAGRANT, WHITE cherry blossom flurries hovered in gusts like snow in nature's confetti. Plum, almond, hazelnut and pear blossoms were all bursting from their pinkish white buds making his head swirl. Nature, however, immersed in its rebirth, took no notice of the human suffering in its womb. It went on as it had done for millions of years, undisturbed, uncaring without the slightest compassion. So what, if mankind was causing suffering to itself? For Eugene's three hectares filled with many fruit trees and flowers, pollination was no problem. At the end of the lot, past the wine grove, was the servants' hut with its reed roof housing thousands of wild bees. When Balazs got older, he carefully spied out the flight of the bees returning from work, then gently pulled out the reed stock that he thought was filled with the sweet honey and sucked out its aromatic contents.

Eugene was busy doing chores in the radiant blinding spring light. Meanwhile, in the glass-enclosed veranda, Paula was busy teaching Balazs how to read—partly to prepare him for kindergarten coming soon in the fall. But, she also had something else in mind for her grandson's early education. She was a patient and an excellent

teacher—she knew that children are impressionable at a very early stage provided that the methods were playful and short. In the communist school system, children were taught in the beginning concentrated Socialist dogma in many clever ways. She noticed how they parroted the government slogans without any critical or individual thought process and soon became mental midgets and robots of the state. She was determined to prevent this from happening to Balazs at all cost. Both grandparents became very protective of him and all their years of parenting gave them the expertise to mold his fresh little mind.

In the few months spent in Fuzfo, Balazs had almost no time to think of the city and family he left behind. With time they all became a blur in his memory. He was reminded daily of his mother as her colored photos were hanging everywhere and her portrait image adorned the church window. He missed her and wanted to see her, but she never came. Paula always spoke of her with affection and when Eugene was not present, she talked about Sandor (pronounced Shandor) his father, with admiration and love.

She recalled the first time she met him. "The first thing I saw was his beautifully expressive hands, pushing a bouquet of flowers through the crack of the door, followed by a thin, radiantly handsome face. He had wavy, chestnut brown hair, mischievous, ice blue eyes and a prominent chin. When I saw him play the roles of Romeo and Hamlet, I knew he was a genius. I was so pleased that your mother and he were in love, for they made such a handsome couple. But then this horrible woman took him away!" Balazs heard many things about this horrible woman through the years. The spell she had on his father—that woman who had no particular refined background like his mother. That woman was famous, but an untalented, loose actress. After all, she started in circuses at an early age, carrying signs of the coming attractions, baring her breasts in public. Poor Barna, Balazs's brother, having to live under one roof with this witch and also his step-grandmother, who was equally a controversial actress.

After the reading lesson ended, Balazs ran outside to see what Eugene was doing. Almost four years old, Balazs's curiosity had no

bounds. When Paula knitted, he learned to knit; when she braided her hair, he wanted to do it. When she prepared the wool for knitting, he happily offered to prop his small arms up vertically from which she unraveled the wool into a ball of yarn. Eugene had no money and no access to toys, but with the richness of life in nature and animals, Balazs had little need for toys.

The weather was warm. With the weeping willow bark now tender and soft, Eugene, cut off with his pocket knife a 15 centimeter straight branch. He beat the bark with the handle to loosen it and slid the slippery, yellow-green skin off the white slimy branch. He then fashioned a wedge-like shape at the end of the stick. Afterwards, he clipped an angled V shape a centimeter from the edge one top and slipped the skin back onto the stick. He produced the nicest flute. Balazs thought it to be magical! Terrific! Stupendous!

On one occasion, they were searching through the wreckage of a Russian tank, which Balazs was strictly forbidden to do alone, since many children were left without limbs or lost their lives from meddling with abandoned explosives. Among the debris next to a burned-down little farmhouse were some old, broken wine barrels. One thin metal ring, in perfect condition, was a great treasure for them. Eugene taught him how to beat it from behind with a short stick and by running along it, he could keep perfect control by guiding it from the sides with an occasional whack from behind to keep the momentum going.

Shortly afterwards they built him a scooter. It was cut from rough planks and two used steel bearings taken out of another wreckage. Helping with the housework and around the yard was lot of fun, too. He was included into every detail of life. One thing he wished he could do was to draw the water from the well, but he was too short. The water level was very low and as he stared down into the deep darkness of the well, he saw a dark circle that reflected the light like a black mirror. The water was ice cold. When Eugene was not looking, he would drop tiny pebbles down and wait for the sound of the plop...plump... Its deep, dark mystery hypnotized him.

At the east end of the lot was a spring, which bubbled from a

small tunnel Eugene built decades ago. It was 2 meters deep in the hillside. It was constructed of round fieldstones and a carved stone cross on top, represented its healing powers. The water was so clear one could see every speck of the reddish orange mud on the bottom. A few, small black frogs with red-spotted bellies inhabited the icy water. The water always had a thick, green alga or "frog saliva" as the Hungarians called it, floating at the edges. It was there the frogs hid their eggs.

In the summertime, Eugene cooled white wine in the icy water given to him by some farmer friends. One day, he noticed that someone had carefully removed much of the wine and replaced it with water to avoid suspicion. He and an old doctor friend of his were determined to catch the culprit by loading the wine with an extremely strong laxative. When the guilty neighbor came to the doctor complaining of severe diarrhea, they knew they had the culprit. He eventually confessed and the wine was safe once again.

The iodine and iron content of this underground spring was so high that women with goiters from all over the countryside came to drink and take barrels full on horse-drawn carts, as a cure. Iodized salt in those days was unheard of, so Balazs saw many women afflicted with these hideous, huge, tumor-like growths under their chin, hanging like cow tits without their utters. The spring did not freeze in the winter and was ice cold in the summer. Therefore the small goldfish Eugene let loose in there some years back were happily flourishing among the occasional floating chilled wine bottles.

From this hill, the spring trickled down through a guided canal to the bottom of the property. As it traveled to the bottom, Eugene cleverly irrigated all the vegetables with the fresh flow. When it reached level ground again, there was a small puddle of a pond and a little watermill generated by the speed of the flowing water from above. A gigantic weeping willow grew from the moisture of this mini paradise, with a thick trunk and strong branches to support its grand stature. The bushes that bordered the property were overgrown with layers of thick vine, also nurtured by the well and supported by a forged iron fence beneath it.

Years of this growth evolved into a natural, thick trampoline, where Balazs and his friends repeatedly hurled themselves from the branches of the weeping willow above. The effect was thrilling and yielded at least one good bounce. The leaves off this vine, though sour, were delicious. They ate handfuls of them while resting between dives. In the hot summer days, the sourness seemed to have a cooling effect.

These days were filled richly with activities and play, yet he always stayed an earshot away from the house. The only time he ventured farther from the boundaries of the yard was to be near his friend the train. By now, he knew every sound and every part of this fascinating contraption, suspecting, Balazs was almost convinced that it had a life of its own. He knew the times the locomotives would pull by with the passenger cars or when they would pass through the town sometimes with a hundred wagons in tow. Often it carried Russian tanks and large guns covered with canvas or shiny mountains of black coal and hundreds of cattle or pigs.

To his delight one day it carried an entire circus! When Eugene told him stories about the circus he could not sleep from excitement. All he thought of were those amazingly painted, colorful cars and the many animal cages housing the exotic beasts. The train, this lifeline, carried all that by him as it traveled everywhere—they said even to other countries! It was free... And oh, so beckoning.

Many children he knew jumped trains all the time. They rode to a town or two and before their parents caught them, returned on the one traveling the opposite direction. He stole across the highway several times, unnoticed by his grandparents and hid in the tall grass of the ditch in order to be closer. From this vantage point he could look at the people in the coupe or watch them hanging out the windows waving with friendly smiles at him.

He often thought as happy as he was here, the train that brought him could easily take him back to Budapest. It was faithful and punctual; he could see and hear it from anywhere in or out of the

house—huffing and puffing or screaming sometimes when it whis-
tled. Before bedtimes he often waited for the night Express to rush
by to see the little windows alight, slithering by the lake on invisible
tracks, then he'd go to his bed and sleep totally content.

FIVE

SETTLING IN

THE DAYS BEGAN to flow into each other smoothly and naturally as life does in the countryside. The resident roosters started their morning routine rudely waking every resting soul in an earshot. Eugene threw the shutters open to the gray early light of predawn and attached the squeaking iron latches to the outside walls; Paula slid off the side of the bed to heat the water for the morning's vigorous wash.

By the time Balazs peeked over his warm goose-feathered covers to see if he was missing anything, the aroma of coffee and burning wood filled the room. The couple sat quietly by the table, which was against the foot of the bed. Eugene slurped his hot, cheap coffee while he dunked his "kalacs" (a light sweet bread), and Paula delicately sipped hers like a cat. Her thick, snow-white hair flowed beautifully below her shoulders to the middle of her back before she braided it for the day. Eugene was not so fortunate, for his thick, white hair was only sported above his upper lip. There was hardly any on his head—most of it was gone. Yet he brushed with loving care the remaining strands about his ears.

Before the daily chores began, there was already a morning family

ritual developed and enjoyed by this newly formed trio. Balazs, who crawled out of bed rubbing the sleep from his eyes, bumped into grandmother's chair and cuddled closely to her warm, little body. She always smelled of lavender, which she grew in the yard and dried every year to keep fresh scent in the drawers. She pulled him close with a warm hug and kiss, then like an unfaithful kitten he would crawl to his grandfather's lap, which was bigger and more comfortable. Sometimes, he would fall back asleep just for a moment or two.

The old man enjoyed this special moment. Balazs would watch his mustache move as he spoke or ate. It had to be trimmed every day or so with scissors. It felt ticklish a bit, but good when the kiss came on his cheeks or eyes. His hands were also warm and comforting—always cleanly manicured and the half moons of his cuticles clearly defined. Balazs was given a bite from the coffee-soaked kalacs, which tasted good this week because they were able to buy sugar. (Sometimes they stood in line for hours for sugar and lard at the country store.)

After the morning coffee, Balazs would offer to brush his grandmother's hair with a beautiful silver brush. He learned to braid her long hair and was very proud of his ability and happy with the result. Shortly after, he put on a pair of shorts and stepped out for some chilled morning air. He saw that the chickens were flying out of the coop with great fanfare and were ready for Eugene, who began throwing seeds on the ground and putting out fresh water.

Sunday was a special day for them. They would air the house, clean it, and be dressed in time for the first Mass at the church. The young priest, Lajos (pronounced Layos), was recently allowed by the government to preach and "ordained" by the Marxists. It was required of him to take courses on communist dogma before extending him a license. The communists wanted to show that the religious leaders, so-called "Peace Priests," were on their side. This also assured them that these priests would somehow prevent people from rebelling against their godless ideology.

Churchgoers, including the three, loved congregating and listening

to Lajos. However, they were all careful in their conversations, for even in church there were snitches. Snitches, who were the guardians of the state, were well paid and recruited from among the townsfolk in exchange for special favors by the government. They kept lists of the devout and listened at the gatherings for anti-government remarks. No one was certain who they were. Only in the most trusted circles would people relax. The people on the regular churchgoers list never got promotions or help from their bosses at their place of work. The government preached strict atheism.

On Sundays, Paula played the organ at the upper level of the church where the chorus sang. The children stood in front of all the pews, except for the little ones like Balazs, who sat by Eugene. They generally got the seats near a window that had his mother's image portrayed on stained glass—looking like a goddess shining through the color and light. Whenever he missed her, he would run to the little church, crash through the doors and kneel by the window. He knelt and prayed. He knew three prayers his grandmother taught him by repetition every night.

The heavy scent of incense was comforting as Lajos walked down the aisle in his black frock after Mass and cast the smoke over the congregation as his last blessing of the day. The altar boys, in their long-flowing, black-and-white robes, followed behind him all the way to the door through the aisles where he stood exchanging words with the townspeople before they departed. They were a poor-looking flock—the men dressed in tattered, worn-out pants and jackets and the ladies generally wrapped in variations of black colors with scarf covered heads. The small crowd dispersed and as was customary, Eugene welcomed the priest to his home for the Sunday lunch.

This was always exciting for Balazs. To him Lajos was unique since he learned in church that priests were connected to God and had a special mission in helping mankind. They were all married to Virgin Mary. Well, Balazs thought that was fine, since Lajos was a very handsome young man despite his wire-rimmed spectacles. He was tall and lean with delightful humor and a pleasant smile to

match. Virgin Mary could not have done better! It never ceased to puzzle him how Mary could remain a virgin and be married to thousands of men around the world like some female sultan.

The adults always talked politics at lunch and news of neighbors' recent fate under the government. The meal's first course was caraway seed soup, which Balazs hated as it tasted medicinal. It was followed by cucumber salad and the rare occasion of fried chicken, the only meat they had on the table in weeks. Unexpectedly, books slid out from under Balazs's armpits and hit the floor with a thud. Lajos picked them up and returned them to Balazs, who was struggling under Paula's rigorous training on table manners. She was appalled by the deterioration of people's manners. She would have none of that for her grandchild whom she hoped to raise in the manner befitting his class, no matter what.

Paula reminded him that elbows were kept tightly against the torso (thus the books under the arms) and never touched the table while holding the forks and knives properly at the end of their handles. "Balazs, if it was meant that you hold a fork 3 centimeters from its base then the handle would be 3 centimeters, not 10 centimeters, long. Besides it looks more genteel and graceful," offered his grandmother. "Now please sit up straight and move close to your plate. Don't hunch and don't slurp."

With lunch over and Lajos gone to prepare for the Sunday evening Mass, the couple took out their deck of cards on the cleared table to play. Balazs curled up in Eugene's lap and sank into a deep afternoon nap while classical music filled the room from Eugene's favorite station.

SIX

THE KNOCK IN THE NIGHT

THE GENTLE RAYS of early summer sun turned the cherries bright shiny red, as it spread comforting heat through the countryside. The warmth on the back of the old man felt good as he bent over tending his garden.

Balazs and Eugene began to pick the cherries, both sweet and sour, from the lower tree limbs. Paula was busy in the kitchen making jams and canning hundreds of jars of fruit preserves for the winter. The vegetables such as white parsley snips, kohlrabi, carrots, potatoes and beets were stuffed into burlap bags, then lowered into an underground hole and covered with hay. In this communal "Frigidaire," a man on horse and buggy delivered large blocks of ice which he lowered into the hole in the Spring and Summer. In the winter, the ground temperature kept things from freezing as the small community retrieved their stash from time to time.

There was no refrigeration in small towns because there often was no electricity. Most homes were lit by kerosene lamps at night and were heated by wood stoves. In the fall they gathered the walnuts, almonds, hazelnuts and laid them out on the attic floors surrounded by mousetraps. (It was a mini iron curtain and as effective

as the one the communists put around the Hungarians at the borders.) There was a distinct aroma of drying nuts and preserved fruit in the attic and the veranda.

Balazs enjoyed gathering the walnuts Eugene knocked off from the branches, which had thick, green, meaty flesh surrounding them. When peeled, they left nicotine-colored dye from their juice on the hands as well as an unusual scent. The dye was so permanent that it only disappeared with the erosion of the layer of skin. Eugene successfully grew figs with the helpful advice from the neighboring farmers. As they gathered through the seasons and prepared for the long winter they also ate plenty of fresh fruit and vegetables, which supplemented their meat-deficient diet.

Despite the political horrors around them, they seemed to slip into a protective bubble. They had food and a small amount of cash, which Eugene's youngest son Gyorgy (George) sent regularly. But like other families, they had their own woes.

The couple's older son was taken in the night from his family and arrested by the AVO secret police, the Hungarian extension of the KGB. An engineer, like his younger brother, Eugene Jr. was accused of political crimes in collaboration with the "enemy." No one knew who the enemy was and much less how to collaborate with them as the borders were totally secured and all mail was read by the government mail systems. Eugene Jr. had not been seen for a long time and no one knew whether he was thrown into prison or to concentration camps in Russia or possibly China. His young wife, a physician, barely supported their two small children since doctors under communism scarcely made more than those of the working class.

Balazs's uncle, Bobby, his father's older brother, after returning from the Russian front at the end of the war, brought with him a Russian wife. He was an officer in the Hungarian army and fought on the Soviet side against the Germans. His wife, deprived of material goods in Russia, went wild and overindulged herself with minks, silk stockings and expensive jewelry.

While Bobby visited Sandor at Eugene's lake home, a lone drunk Russian soldier tried to steal Bobby's Jeep parked below the

villa. Just that moment Sandor, was leaning out of the second floor balcony flicking his cigarette butt from the porch. He noticed the Russian. In his drunken haste, Sandor ran down the hill, dragged the soldier from the Jeep and beat him severely. On his return he told his brother what he has done. Bobby, being an honorable young man, packed the half-dead soldier into his Jeep and gallantly delivered him to the nearest Russian headquarters for medical attention.

It wasn't long before a truckload of armed Russian soldiers showed up at Eugene's house. Sandor was terrified. Bobby told him to hide and he will take care of everything. He was confident, since he was on the Russian front and spoke fluent Russian, married a Russian woman, that he would have some clout with them. Instead, Bobby was arrested on the spot and taken into their custody never to be heard from again. His Russian wife too was eventually apprehended and taken back to Russia.

Sandor's oldest sister became a victim, too. This was war. The Germans were losing and the advancing Russian army was occupying Eastern and Western Europe, while the American and German Air force bombed everything strategically in order not to destroy thousands of years of culture. The fast-retreating Nazi armies were followed by waves of murderous, robbing and raping Russians against unarmed defenseless civilians. All the population could do was to live with silent suffering; they were slaves and prisoners in their own country.

Balazs and Eugene walked to the lake to fish using homemade fishing rods. The lake water, still and clear, was abundant with fish of all kinds and the afternoon overcast skies brought the promise of hungry fish. The easiest catch was the red fin Bream (keszeg to Hungarians), but Eugene often pulled in a good-size carp, too. They went down to the docks that Eugene "used" to own which were now off limits to them, since they were also confiscated. Eugene's small rowboat was still there tied to the dock with a communist party member's name on it.

Suddenly there was a rush among the reeds and violent splashes

and jerks broke the silence making the surface boil. Calm followed. Eugene whispered and pointed out to Balazs a longer wave created by the strong tail fin of a ferocious barracuda. Quite elusive to catch, the prehistoric barracuda, with its rows of sharp teeth, was coveted by the Hungarians for its delicate, white, boneless flesh.

At the end of the day, the two had nearly 20 fat Breams strung through their pink gills, which they happily brought home to have Paula clean and cook. Paula fried the catch in pig's lard with onion and red Hungarian sweet paprika. After dinner, Balazs prepared for bedtime reading. He read "Babar the Elephant" for the 100th time. Paula was happy that in a very short time he learned to read and was reading at every opportunity. Eugene was quietly closing the shutters and the windows to secretly tune in to the forbidden station of Radio Free Europe. In the darkness, only the eye of the Orion radio glowed like a gem. The broadcasting was horribly difficult to decipher as the Hungarian Communist government spent millions on jamming interference. This was true news coming from the Western free nations, which was kept from the people behind the Iron Curtain who were allowed only artificial news and fabricated documentaries of anti-American propaganda.

Balazs dozed off listening to the announcer's voice competing with the wave of whining noise. This particular night Eugene was not successful in making out much of the report, yet he hung onto every word that penetrated through the jamming and his heart leaped from joyous and spiteful defiance. Before retiring for the night, he shoved the radio under his bed.

As in a bad dream, the hard banging penetrated the peaceful, dark room. The old couple and Balazs woke to loud shouts and the vibrations of the front glass doors. Startled, they stared and groped in the darkness. Eugene fumbled to find some matches to light the kerosene lamp, but before he succeeded bright lights penetrated their pupils through the window—rendering them temporarily blind like deer on the road. He rushed to the glass doors to see who was making the commotion and shining the bright lights on them.

By the time he arrived at the doors, they blew open, nearly knocking him down.

Two short, stocky men shoved him back. Paula finally got to light the lamp and the glow evened the power of the bright flashlights making the two figures more defined. One of them emulated the typical Lenin look with hat and beard, the other was bald and wore the black leather jacket of hoodlums. They reeked of cheap tobacco and strong Hungarian plum brandy. "Come, you lazy capitalistic bastards," said the one with the Lenin beard. "You've rested enough for a lifetime at the expense of the people, now it's time to work and contribute to society! Now get your rags on and hurry about it!"

The ambushed and confused couple went white with fright as their first suspicion was that the tenants next door must have heard the Radio Free Europe from their room and snitched on them. Where were they being taken, were they being deported, what will be the punishment? This was the "knock in the night" that all people across the communist-occupied countries dreaded—wondering when their time would come. Now it is our time, Paula thought to herself as she nervously fretted about and wondered what would happen to Balazs.

"Do with the runt whatever you want, bring him or leave him, your choice," was the man's remark as he looked at the frightened face of a skinny child curled up in the corner of the room holding his blanket about him. Paula and Eugene were relieved to hear this. In their terror they dressed so hurriedly that Paula nearly forgot her dentures in the glass of water by her nightstand. They went outside into the cool night and walked down their gravel path to a dirty, old, open truck waiting for them at the bottom of the hill. The truck smelled strongly of pig droppings most likely from the previous occupants taken to the slaughterhouse. Now it was the turn of the capitalistic pigs, Eugene thought to himself. They were shoved up into a crowd of people. Huddled in the back among the dark figures, Eugene recognized their elderly friends from town, accompanied by their grandchildren as well.

As the truck rolled down the hill they were told that this was not

a deportation, thank God, but a free labor force to the nearby collective farm. Thousands of hectares of ripe tomatoes began to rot and the harvest was in danger of being lost since the farmers whose lands had been confiscated by the Stalinists refused to work with haste. They grumbled that they fared no better now than in the times of the feudal lords when they worked for nothing on other people's land. It made no difference now how they performed, hard work or lazy work; they all made the same wages because the communists did not believe in the healthy incentives of the capitalists, which they sneered at. In the "Workers' Paradise," everyone received the same pay except for the "comrades," the party members.

By the time the caravan of trucks turned into the fields the sun was up and it turned out to be a hot June morning. Hundreds of people from all over the countryside were hauled in and unloaded. They were mainly from the questionable intelligentsia or bad "Kader." This is a term used by communists that disqualified you from the favored population, meaning you were not of the working class or you had no relatives in the proletariat. Farmers were distrusted by the communists who preferred the Bolsheviks or the helpless, impoverished, dependent working class whom they could manipulate. This class, which was the product of the industrial revolution, was forever dependent on and slave to any system for welfare. They were all thankful and relieved to be here and not shipped off to Siberia or to some unknown Chinese concentration camp.

The countless children were shoved into large circular cells corralled by rusty barbed wire. In the center of each of these open holding pens was a wooden barrel of water and a communal tin cup hung from twine nailed to the wood. Balazs went to the barrel, dipped deeply into the still cool water and took a long drink. There were more than 50 children in his pen of similar ages up to about 6-years-old. The older ones were pushed with the adults along the rows of tomatoes.

A little girl stood nearby crying uncontrollably as her tears ran down in rivets of dirt on her cheeks. Another child tried to comfort her, but that just made her carry on even more. She was abandoned

to her crying. Balazs tried to find Eugene and Paula, but he could not spot them as thousands were bent over toiling in the fields. Everyone was given baskets and wooden crates, which they delivered full to the rim to the waiting trucks. Once the trucks were filled, they drove off in clouds of dust.

The day wore on and the people worked hard through the miserable heat. These people, who were not used to physical labor, were formerly from middle and upper classes. Eugene tried looking, but he had not seen Paula ever since they separated them. He was lucky enough to be assigned to one of his bridge partners, a retired orthopedic surgeon who was ten years his senior and could hardly carry his full basket. Eugene was a bit stronger and was now used to everyday labor as he tended his own garden. This was different. He was not humiliated by the work—simply from the treatment by these scum "comrades." He had contributed a great deal to his country and everything he owned was the result of his diligent work. His education was also accomplished by his intellect, ambition and hard work—he was no "silver spoon" or leach, as the communists labeled him.

They were rarely offered water, but when it came, the men in gray always distributed it with ample insults. Responding would have meant suicide, so everyone tolerated the treatment in dignified silence from these despicable beings who reveled in their invincibility. The children quickly made friends and began to play. Some threw pebbles at the posts that held the wires, while others played tag. Their stomachs began to burn from hunger and by the time someone came with a large pot of hot corn and tomato soup, the sun was past its zenith.

The woman who brought the food looked like a zombie. She was as foul smelling as her comrades. This creature threw some more tin cups into the dust by the pot. Then, devoid of any feelings, she yelled to the children who gathered about her, "Eat!" And abruptly left the corral, tightly hooking the wire gate behind her. Balazs began

to chew the corn in his soup and realized it was the hard corn kernels grown for farm beasts.

It was now twilight and the whistles sounded to end work. The trucks lined up and were soon filled with exhausted people. Eugene, with bleeding hands and cursing under his breath, fetched Balazs first. He was a spirited man, not a sheep to be herded. He was mad, but knew better than to show it to further endanger his family. Frail little Paula's disheveled white hair was plastered with sweat to her face and forehead and was entangled with stems of tomato branches. She looked like a mad woman who escaped the loony house, Eugene remarked with a laugh.

At home they all washed up in fresh well water and dropped into bed, feeling lucky to be delivered to this fate. They were herded off to the fields of the collectives six days a week, so Eugene was only able to tend to his own garden on Sundays. They were thankful that at the end of every two weeks, they were given food tickets, which helped to augment their meager budget.

SEVEN

POLLUTING THE BEACH

SUMMER WAS IN full swing. City and country folks loved gathering on the shores of the lake like migrating flocks. Despite miserable conditions, Hungarians refused to relinquish the simple joys of life. Thousands of people soaked in the velvety warm lake water with its soft, muddy bottom. They enjoyed bathing under the bright and humid-free sun. Although the lake posed dangers such as unpredictable storms resulting in the drowning of swimmers and electrocutions in the lightning storms, people kept returning every summer.

It was Sunday, a day off from the collective farms. The three decided to walk down to the lake in the still cool of the morning. Paula packed sandwiches, some spring onions, yellow Hungarian peppers and smoked sausage. After a quick dip in the water with Balazs, Paula and Eugene retired on the soft grass beneath the shades of the weeping willows. The peaceful scene of children splashing in the waters and others lounging on the shore could have easily been mistaken for a French Impressionist painting of eternal summer. The air was clear under the pale-blue skies and the distant purple hills framed the green-blue water as it caressed the lush vegetation by the shore with the colors of the bathers.

Suddenly, there was a big commotion. Like parent seals frantically gathering their young from the danger of the approaching polar bears, the adults were running about in search for their young, too. They were calling out names in chaotic confusion.

From the entrance to the beach, hundreds of uniformed and armed Russian soldiers appeared with camouflaged vehicles. As the armored cars roared off the main road, the dark diesel smoke eclipsed and dirtied the gentle blue sky. They shouted orders at one another in what sounded like a mini invasion. The many consonants in each word of this hideous language sounded like hungry wolves barking while gorging, gnawing and ripping flesh from their victims. When Balazs heard this hateful language, he felt a deep resentment that sent cold chills into his heart.

Since the early years of pillaging and raping of the Hungarian people, the Russian army was now strictly confined to their bases and prohibited from fraternizing with the population for "their own safety." On extreme hot summer days, they were allowed out for brief visits to the lakes and like Mongol hoards they swooped down on the lake literally attacking the water. They were permitted to use only one end of the beach by the reeds which, unbeknownst to them, was infested with fat, black leaches. As if the waters became contaminated, all the Hungarians withdrew, cursing while going to shore. They kept their families close and safe.

The soldiers wore ugly, large, baggy shorts as they charged into the water. Everyone watching them wished them to be eaten alive by the leaches. As they splashed, laughed and yelled like children, the others remained behind with their machine guns pointed at the frightened people. To everyone's relief, this only lasted a short while before they were herded back to their trucks. The departing trucks reversed into the road from where they came in a large cloud of dark smoke. Slowly, everyone returned to resume the interrupted day of joy.

Horrible tales began to circulate among the people who suffered under the hands of these villains—ruining a perfect summer day.

Eugene told some about Sandor's sister's fate—her attack and rape by Russian soldiers. She was returning home from shopping as a passing Russian tank's commander forced her into the tank then raped her. She was repeatedly raped and beaten by 11 soldiers in all before the ordeal ended. Then they dumped her mangled body by the sidewalk and kept her groceries. When some neighbors discovered her and dragged her home, she remained in a coma for weeks.

There was no authority to complain to or ask for protection since the very army that was there to protect the Hungarians from the Nazis and "liberate" them was now the law—the law of barbarians.

The soft, large, orange sun descended slowly beyond the last hill of the horizon, but not before it withdrew her golden reflection from the lake's surface, like some cosmic bride gathering her train of splendor. It was time to head home. But as the air cooled and the still was laced with the sounds of crickets, Eugene and Balazs decided to trek up the hill for some fresh milk from the nearby farmer. By the time they arrived, the farmer had relieved the bursting utters of his cows and his wife served it up with her freshly baked bread out on the summer kitchen's table. The two dunked their bread into the foamy, warm milk and savored its rich, wonderful flavor. They took their two-liter fresh milk container with them, but before they descended the hill to the villa they stopped at the summit lookout directly over the vast open lake.

The water was now silvery cool, awash in the rising moon's light.

Everything bathed in dark French, ultramarine blue in the village below them. Above the sky was thick with a blanket of shining stars.

The air had the pleasant scent of drying hay while millions of fireflies reflected the stars above with perfect mimicry blending everything into a cosmic stew of nature's inspired, everlasting beauty.

EIGHT

A POEM FOR BALAZS

FALL CAME AT last for Balazs who was anxiously waiting to enter kindergarten, located only a kilometer from the villa. After learning his way around, he was allowed by his grandparents to walk by himself. That proved to be adventurous, for he had the opportunity to meet more of the townspeople.

The women who worked at the school treated the children well despite the early communist indoctrination they subjected them to. In addition to the traditional Hungarian songs and nursery rhymes, the children had to learn the Communist Russian songs and hear Russian folklore all rewritten with the system's own agenda for early brainwashing. Naturally he was unaware of these things yet. He drank acrid, cheap hot chocolate, more like muddy water. Since he never had the genuine article to compare it with, he was happy.

As for Eugene and Paula, their misery continued. Work at the collective farms was no longer needed, so both were shipped out to a brick distribution depot where there were mountain loads of bricks to lift into trucks on the cold days. However, all hardships of life contain some hidden good—this hard physical labor made them stronger. Eugene lost nearly 20 kilos, which he collected in the good

times before. Sometimes they were able to get news on Eugene's short-wave radio. However, there was a town crier, who had a small drum and read the news of the day, the town officials composed. There were several appointed stations for this event and one happened to be under their villa across from an old tavern.

The old, emaciated man beat his drum until enough people gathered around to hear his loud orations. Sometimes he would visit all three taverns along the way. By the time he reached the villa, the information got so jumbled up that people were annoyed and left quite disgusted. It mattered little to him, for he continued shouting the news to himself.

The tavern, like all taverns, had regulars even in the daytime. The runoff from the beer kegs was a primitive solution of a 5-centimeter wide and 5-centimeter deep trench carved into the concrete floor leading to the outside of the building. There, beer collected in a small puddle before slowly seeping into the ground. The mischievous patrons, drunk or sober, threw pieces of bread into the puddle, where the neighborhood goose begged for food. This fat, white goose was one of the tavern's regulars, and its most popular patron.

After he gobbled up a few of the beer-soaked bread pieces the alcohol took its toll. The bird began to sway, then burped in a bird's fashion and plopped down. When very drunk, sometimes he did not make it back home; instead he sprawled out like a genuine drunk, wings and his orange legs spread in every direction. If the patrons were more sober than the goose, sometimes they carried him to his home under their arms as the bird's head swayed lifeless like a pendulum at the end of his long, white neck. (By the way, he outlived the drummer by two years, proving to the world why the goose's liver is so highly prized!.)

The cold winds that whipped through the town brought with them a severe winter and snow so high that Eugene and his neighbors were forced to dig tunnels to visit each other. This was a blessing in disguise because no one was able to go to the collectives and instead spent wonderful times in their warm houses with their families.

They listened to good classical and Hungarian folk music and read many books.

Eugene and Balazs began to draw pictures together. Eugene's oil paintings were terrific and tastefully done. He had little formal training, yet his keen eye helped him decipher the secrets of the masters adding to his knowledge. He was what artists call a Sunday painter. Balazs admired two of Eugene's large oils—one large elk in each work. They stood proudly baying in a swamp while their hot breath could be seen; they looked real and powerful since Eugene hunted and knew the anatomy of animals. He also painted the little town at its inception showing the few peasant homes beneath the hill, above the villa.

One day, Eugene decided to stretch some parchment paper on wires to replace an old lampshade. Before he did this, he drew many beautiful Hungarian folk motifs with colorful flowers filled in primary and secondary colors. Since he didn't have varnish, he improvised with grease to secure the pigment. When he lit the kerosene lamp, the magic of the colors glowed like stained glass in the church windows.

One of the neighbors, who later noticed the shade, asked him to make her one in exchange for some beef as payment. He happily obliged; they had not tasted beef since before the war. It was a special occasion and lucky for Lajos the priest because it was his Sunday with the family again. Lajos encouraged Eugene to make more of the shades to improve the Sunday lunches.

By now the lake was frozen solid and the men shoveled much of the snow. They also cleared a huge area of the lake in their vicinity for "wood dogging" Hungarians called the peculiar sport of fitting wooden chairs with metal tacks on the bottom of the legs for smoothness. A pole was attached to it with sheets for the sail. The persons seated, more like trapped, in this contraption flew frantically in all directions without much hope of control. They depended on the wind's velocity for the injury they sustained by falling.

Probably, this reminded Hungarians of their chaotic history, for

they identified with and loved this sport. Lajos held tightly onto Balazs's chair as his black priestly frock and skirt flew every which way. Several times he let go and fell sliding on his butt with his legs irreverently pointing toward his boss in heaven. Like children, they screamed and laughed as Eugene sailed by them just to crash into a snow bank and vanish. After several well-spent hours—blue with cold and soaked—they returned to the warm house to thaw out in front of the stove that glowed red with the burning wood. Paula heated some red wine with cloves and cinnamon as a special treat, which Balazs was allowed to indulge in, too.

Eugene took Lajos's advice and went to the local butcher the very next day to get butcher's paper since vellum was hard to come by. He prepared many drawings for a series of shades and asked Balazs to color one like the first successful sample. Eugene was very pleased at the neat rendering his grandson had done so they established their little cottage industry. They easily sold them for cash, food and tobacco. They felt proud and prosperous when they returned home sometimes with items such as sugar or butter they could otherwise not afford to buy.

There were occasional letters from Jadda, but never from his father. Her letters were quite impersonal when she inquired about him and his brushing habits. His bonding, long eroded, was replaced by deep love toward his grandparents. One cozy winter evening while they busied themselves making lampshades and listening to the radio, the music ceased. The voice announced Maestro Szabo, Sandor, who was to recite poetry by Jozsef, Attila, a great Hungarian country poet. The poem's title was "Go To Sleep Little Balazs." Balazs saw Eugene stiffen in his chair, but Paula sat up with interest. Balazs was overwhelmed having heard his father's name as the next performer to read a poem addressed to him. Was he sending a message, he wondered?

He shouted, "It's papa on the radio, did you hear, it's papa!" And before he settled down, the deep, beautiful baritone voice of his father, for which he was famous, filled the little room. He was a master

not only on stage and film, but one of the best in reciting poetry. Balazs was swept away not only by the beauty of the Hungarian poetry, but by the closeness he felt hearing his father's voice for the first time. His voice was energetic, sometimes dramatic, then gentle, filling the room, speaking just to him.

Suddenly, he felt deep sadness, wanting to run and run until he reached his father and jump into his arms, kiss him and tell him how much he missed him! Then a thought crossed his mind—why has he not come for me? He felt empty, betrayed and hurt by the time the voice disappeared.

He looked over at Eugene, who sat like a carnivore watching his prey, but no, was it that he was the wounded animal, sitting small, reduced by a power he could not compete with. He was frightened and tried to hide his emotions sensing Balazs's thoughts. He was so attached to this child that he could not face sharing or losing him even for a moment. Competing with the father, even a phantom voice on the radio, was a reminder of a day approaching, yet he tried to deny it. Eugene had a fleeting image of the little ducklings that hatched under the hen's care—bolting for the lake as soon as they were able. While they were splashing and frolicking in their natural habitat, the surrogate mother hen ran frantically on the shore bewildered and miserable at the loss of her chicks.

Balazs instinctively felt what went through Eugene's heart and within a split second landed in his lap, crying pitifully. Paula approached to embrace them both and joined in a good cry.

NINE

LITTLE CSILLA

SHE CAME DOWN the hill from the government apartment compound that was converted from a private resort. Csilla (pronounced Tchilla) wore her usual shabby clothes. She was only a year or so older than Balazs, whom she found fun to play with despite his wild and over-energetic personality. She was also drawn to the villa and its two towers, especially the small one, where they spent hours spying on the world about them while raiding the adjoining attic, crammed with dried fruits and walnuts.

The tower afforded a clear view not only of the lake, but also of the road below the villa. Since it was the only major road around the lake and its neighboring villages it was busy with trucks and the ever present armed military vehicles.

They played in the healing spring of the garden and caught the frogs with red-spotted bellies. Balazs liked to build her small water mills as the water cascaded down the hill. He climbed the highest branches to fetch for her the last sweet fruits of the season that the birds missed. Clearly, he enjoyed clowning around to entertain her.

He loved being in her company, too. She was very pretty, always clean despite the poverty she was raised with. Her parents worked at

the chemical factory four kilometers from the town. The factory, which manufactured components for bombs and other military weapons for the Soviets, drained waste water into the lake—eventually killing much of the fish life and vegetation, slowly turning the water into a putrid opaque-green. There were no provisions, under the communists, for the prevention of pollutants.

The hillside above the little town and the villa had no houses on it. It was covered with grass that grew tall by the end of spring. Among the grass grew beautiful, purple, wild tulips with fuzzy petals, which smelled bittersweet. A small, yellow, waxy flower called the "herald of the storks" popped its pretty head up from the tall grass too. It was given that name because that was when the storks returned from Africa every spring to build their nests. The grass reached a meter high and had fuzzy stems toward its tip.

When the wind or a breeze blew over the hill, the tall grass moved in waves, much like long, blond hair on girls' heads. The country folks called this Orphan Girl's Hair. Csilla's blond hair reminded Balazs of this vision. He often stroked her long, blond hair, which she allowed him to brush and braid hours at a time while they chatted.

With his friends he played soccer and did many rough things, which he enjoyed. But she was special—with her he could talk of things personal, things he was afraid to talk to his grandparents about for fear that it would hurt their feelings. Mostly he wondered about his father and what it would be like to have young parents like she had. Every summer his mother came for a brief visit, but spent little time with him. She played bridge with her parents' friends and others who came to vacation. She was surrounded by strange men who were irritated by Balazs' presence and she obliged them by getting rid of him most of the time. She often reminded him that she was looking for a new dad for him. He resented hearing that, for he already had a dad and didn't want a new one. He did not bond with her on these infrequent visits. Her shallow, meaningless kisses and strokes annoyed him. Somehow, he sensed her insincerity.

Little Csilla seemed much like a grown-up; she would always

know what was on his mind or what to say to soothe him. Csilla told Balazs that her parents saw his dad in the movies and he was tall and very handsome. Balazs had not been to the movies yet, but neither had most of the townspeople. The only movie theatre was outside at the end of the town, where millions of ferocious bloodsucking mosquitoes from the swaps waited to feed on the people. Because money was scarce and the communists made books cheaper and more available in libraries, not many worried about missing the luxury of movies.

Families who owned radios gathered around it for music, plays and poetry readings. Hungarians love poetry and the arts. Every time Sandor's name was announced on the radio, Eugene made certain it was not on. He hated to see his grandson hurt in the anticipation of the visits that never came. Almost every time a train sped by toward Budapest, Balazs thought of stowing away in it to visit his father. Maybe, Csilla thought, Balazs should write to his father and secretly mail the letter.

With that in mind, Csilla brought letter paper and an envelope to instigate the project. She was determined to do this because she knew how much Balazs hurt. He was also curious to meet his new mom, who was known for her beauty. The more negative he heard from his grandmother and his mother regarding her, the more he seemed to like her. They sat in the little tower and composed the letter:

Dear Dad: I am your son Balazs and I miss you very much. Please come to Fuzfo. Million kisses, Balazs

She stuffed the folded paper into the envelope, licked the glue and sealed it. She addressed it to the Maestro, the famous actor, Szabo, Sandor in Budapest.

Csilla promised to mail the letter the next day at the post office and assured him that even without the correct address it would get to him because he was famous and everyone knew him. They both got excited about their project, but Balazs felt guilty doing this without his grandfather's knowledge. Csilla calmed him down by telling him that everyone had a right to meet his or her dad at least once in

a lifetime. Also, Eugene was a nice man and she did not think he would even mind. Balazs loved her for saying that as he walked her up the street to her building. On the way, they caught low-flying brown beetles for their collection jars. There was a rumor among the kids that someone would pay lots of money for them, because they made medicine out of them. Balazs didn't know anyone who ever sold even a single beetle. The next day he always released them anyway.

The night seemed long and restless for Balazs as he thought about the letter. He went through the whole scene in his mind over and over. What would his father do upon opening the letter? He decided that by mid morning Csilla should have returned from the post office, so he ran down the gravel path to meet her.

As he approached the gate, he noticed an unusual commotion in the neighbor's yard. In the shade of the big cherry tree, by a large summer table, gathered a group of peasant women screaming at the top of their lungs. He could see them as they rang their hands in prayer toward the heavens, "Oh, dear God, Oh, dear God!" The odd gathering looked like a mad group of crows flapping their black wings as village women often wore black after they reached the age of 40.

There were other neighbors, men, too, who crowded around and tried to get a glimpse over the women's heads of something on the table. Balazs had enough of the mysterious theatrics. He energetically pushed his way through the circle of adults to see for himself what it was all about.

Before anyone was able to tear him away, he stood like stone as he beheld the bloated and naked, blue body of a little, skinny girl prostrate on the roughly hewn wooden boards. Her hands were stiff as they clenched in a frozen, pleading gesture to the skies. Her eyes protruded from their sockets as did her tongue from her distorted swollen lips. The once blond, beautiful hair was soiled and green, covered with human feces. The hideous expression of a silent scream stifled by her swollen black lips terrified Balazs who went into denial upon hearing Csilla's name called out by the bewildered, grieving crowd.

His mind went blank as he vomited uncontrollably until he felt his eyes would burst. The men dragged him away cussing at each other for allowing the child to penetrate the crowd. Later that night, he woke totally disoriented and feverish—without any recall of the ordeal. He drifted back to sleep. He slept for days, almost entering a coma. Eugene had his physician friend pay a visit to examine him. The doctor diagnosed severe trauma, which he said would pass after Balazs's subconscious dealt with it in his sleep. He encouraged close attention and nothing more, knowing that they themselves felt traumatized by the incident. They knew how close Balazs was to Csilla.

The evening when Csilla and Balazs separated, she took the letter and the jar of beetles. On the way home, she stopped at the only toilet for the compound of more than 50 people—an outhouse. As she sat on the bench with the hole in it, the evening breeze slammed the heavy door shut. She tried to open it, but it was stuck beyond her strength. She attempted over and over all the while shouting for help for someone to come. Nobody responded. Nobody heard her. She got frustrated and panicked. She decided to get up and stand on the bench.

She leaned forward to yell through the small heart-shaped hole to be better heard. The door gave a little and she lost her balance. As she leaned so far out, her foot slipped backward and she plunged down and was enveloped in fecal matter. She suffered as she struggled for survival in this vile form of death. No one found her until the next morning. One of the tenants noticed the top of her head.

Balazs was told of the events a few days after he readjusted to life. He seemed to shut the world out and did not respond to the news. He did not cry, but called his pig and the two went for a walk into the woods. He realized that he lost his father and his best friend forever. The world became empty and he felt alone.

TEN

CATS' FATE

IT WAS A crisp, clear, invigorating morning. The countless fruit trees were well past their prime and the young, pastel-green leaves matured into darker viridian hues, softly veiling the thick netting of branches. The scent of flowers was carried intermittently by the stirring breeze through the open doors of the veranda.

In the little bedroom, there was much excitement and bustle. Eugene had finally convinced Balazs that the newborn kittens must be done away with. There was no extra food to feed any more animals and the hungry cats would resort to eating the birds or even the small chickens. The cat shared what leftovers there were with the dog. In Hungary, there was no such phenomenon as pet food. The Hungarian Puli, an ancient Shepherd breed brought by his ancestors from Tibet in the ninth century, was a gift to Balazs from Paula in memory of the one they had for him when he was just a toddler at their Buda house at the end of the war.

Shortly as the advancing, occupying Soviet forces drove their tanks through the streets in front of their house, their former Puli went into a mad barking frenzy. The tank's commander spotted him behind the iron gate and slowly turned his vehicle with sadistic

pleasure into the gate to crush the barking animal. The beautiful wrought-iron gate of baroque design fell flat on the unsuspecting, innocent animal like a horrifying cookie cutter. The terrified grandparents whisked the bewildered child from the scene of cruelty to prevent further trauma.

Eugene was always gentle and patient with his approaches. He was respectful of the child's feelings and concerns. He made all the preparations like a ritual for this ancient act. As Balazs approached the wooden box containing the tiny bodies in tight formation suckling on the mother cat, he accidentally bumped the box. The kittens stirred into a chorus of thread-thin meows. The mother responded by purring with half-mast eyes at the familiar intruder.

Balazs already knew that the kittens would be put into a burlap bag with a rock tied to it as the sinker. They would be eased into the deep water below the fishing dock. Eugene assured him that the kittens wouldn't suffer, just get dizzy for a moment and fall asleep.

However, Balazs found this a bit hard to believe. Every time he swallowed water or it ran up his sinus while swimming, his sensation was traumatic and frightening. He decided not to give his grandfather any grief about this, remembering the first time he threw a tantrum about the chicken's throat being cut for the Sunday dinner.

He understood that every sweet little animal he raised from birth eventually would come to the same fate—into their hungry bellies. As the preparations were made, the quiet morning was suddenly broken by the neighbor's loud intrusion as she burst through the veranda door. "Master [as it was customary in the old days for country folks to call people of higher class], I am terribly sorry to intrude like this," she said with an exasperated expression on her face, "but last night they came and took Janos (pronounced, Yanosh). It was terrible! This shiny Russian Pobjeda [a Russian knock-off of the American Chevrolet] pulled up to the vegetable garden with its headlights off, three men jumped out leaving the doors open. I was still up, since Janos snored so loud, you know when he drinks he snores something awful. Anyway I ran to the front door to see what

this was all about, but before I got to open it they just broke the glass on the front door and ripped my crocheted curtains off! They said they are taking Janos! I said, he done nothing, what did they want with him?

They said they just want to ask him some questions. So, I asked them why don't they do it in the morning after he sobers up, besides he don't have the morning shift at the factory. They just shoved me to the wall, lit the kerosene lamp and went to the bedroom where he lay asleep. One dragged him out of bed while the other kept me in the hallway. I could hear Janos protesting, but I think he thought it was a dream until that bastard started twisting his arm and slugging him. He threw his clothes at him and shouted." "You got a big mouth Janos and we gonna find out if you are an enemy to the movement. We heard you were shooting your mouth off at the tavern about the movement and how the Five-Year Plan didn't work." They said they were going to take him to see how much he knew about running the government better."

Janos sobered up and was terrified. He realized that one of his friends must be an informer and told on him. The last time one of his friends was taken for questioning he was never seen again. No one knew what happened to him and the local Communist Party office would only respond that he went where all the enemies of the people go, to re-education. Frightened, he begged them, losing his pride as he cried like a child and pleaded not to be taken away. He would not get off the ground, but held onto the man's legs.

"I have never seen Janos like that, so scared like a child, totally out of control and without shame. I said, he has done nothing; he is a hardworking man. So what if he gets drunk once in a while and shoots off his stupid drunken mouth? It's only words, it ain't gonna change the system or nothing, it's just a bunch of harmless drunks feeling important. It's innocent and harmless."

She was exhausted and looked terrified. She ran all over the neighborhood looking for some comfort. After they stuffed Janos's limp, unwilling body into the car and took him off, she, at the first

break of light, mounted her bike and rode to the local communist office located at the center of town. It used to be home to an unfortunate family that was deported to make space for the headquarters. The door of the orange-yellow, neglected farmhouse was closed. A large, red communist star was welded to the apex of the roof. No one was there, so she waited sitting on the steps crying. When someone finally opened the door, she entered the already smoke-filled room. It had filthy wood floors with a chipped, old bench pushed against the wall.

There were two old chairs facing a scratched-up desk. Behind it sat the silhouette of a short, fat man, engulfed in smoke resembling a large steaming lump of smoked ham, she thought. She squinted her eyes, but could not make out his face, only the large, black-and-white photo of Stalin on the side wall, with his thick, Georgian mustache. Next to it was the fat, bald head of Rakosi, the Hungarian Soviet puppet Premier. Every school and public building had these two photos as a reminder that Big Brother was watching you. There was the red star above them and the red Soviet flag leaned against the corner. The revised red, white and green Hungarian flag with the Russian sickle, hammer and wheat pods in the center was in the other corner.

In response to her inquiry, she was told that Janos was taken for further questioning at the AVO office in Veszprem, a larger city nearby. She understood the meaning of that.

Balazs listened in frightened silence as he recalled his teachers encouraging the children to report the conversations of their families at home, to see if there were any reactionary remarks against our brothers and protectors, the Russian people. They would be well rewarded! He knew better than to fall for this as his grandparents had prepared him early on for the traps of the communists and their methods. After all he was the offspring of the intelligentsia, the enemy of the people from birth. He knew where he belonged. He was made quite aware of this as his grandparents were regularly herded out to forced labor on fields and to brick factories.

As Eugene eased the kittens into the burlap bag, they began to stir with repeated meows of panic. Then he thought of Janos. Like these kittens, he scratched and whined but to no avail. His fate was sealed like these cats, which couldn't be altered now! What price for the loose tongue of a drunk under communism? Balazs too felt nauseous at the thought of these irreversible fates—so absolute and final.

He lay on the docks and watched below as the full burlap-bag sank slowly into the deep dark abyss. He imagined a tiny Janos among the kittens screaming, clawing, gasping for air and trying to escape from the sinking bag.

The peasant woman sank to her knees, hopelessly lost and cried uncontrollably in the arms of his grandparents, who realized that this could have been their fate as well.

Eugene and Balazs stood silently at the edge of the docks in the bright sunlight. The lake swallowed the event without a trace, not even a ripple was visible. The birds chirped, as the silver guppies flashed undisturbed in the shallows. He thought he heard the kitten's meow from the depth rise to the surface by the ascending bubbles. Or was it just an echo of his guilty, for having a hand in their fate?

ELEVEN

PIG TALK

THE SEASONS passed with much learning and personal growth for Balazs. The forced labor for his grandparents lasted a few years until it was finally determined that Eugene and Paula were too old. The country had fallen into greater economic decay with the lack of incentives caused by collectivization and further mismanagement of the infrastructure by the inexperienced communist government.

The shelves were empty of food and to acquire anything such as clothing and shoes was a dilemma. Eugene had shoes that dated back more than 20 years. They had been resoled countless times. The Gypsy tinkers were getting prosperous from the demands of mending holes in everyone's old pots. They pushed their knife-sharpening millstones about the countryside and on the city streets propelled by homemade, sawed-off bicycle contraptions. Balazs outgrew the last pair of ankle boots the family was able to scrounge up for him. Cheaply made, the shoes were so hard and coarse that all his toes bled and he developed permanent corns. This time they had to slice the tip of the toes off to make room for his growing feet. Buying new ones had to be postponed for lack of money.

By now the whole country was in greater shortage than even under the war. The population seemed to be one endless, hopeless line in front of stores that ran out of provisions long before they could satisfy everyone's needs. People resorted to bartering to acquire some necessities. Balazs was old enough to walk to town daily and stand in line for sugar and other items when available. Often, he found to his disappointment that the doors were closed right in front of him for lack of merchandise. Curiously, when the local party members arrived, the merchandise suddenly appeared. They came to the back door of the stores to get all the sugar they needed. They later sold it on the black market, to the very same unfortunate people who stood in line all day before, without success.

The black markets flourished filling the needs of people, despite the severe punishments dealt out to those who were caught. Eugene and Balazs were part of that system and became experts in the lampshade business as they traded for goods with the local farmers.

The farmers began to farm small plots, though it was against the rules. They were only allowed to work on the collectives for their meager wages. Ironically the collectives were on the very same land they used to own before the confiscation started to collectivize "for the greater good of the people."

Third grade was approaching. Another beautiful summer was coming to an end. The small, red, late-summer pears were juicy and sweet. The swallows were busy teaching their young the "aerobatics" of fly chasing and soon their artfully built mud nests would be beaten and cast to the ground by the swift autumn winds and rains.

The little pink pig that his grandfather gave him the year before grew into a giant, round, walking lard of 200 kilos. Despite his heavy weight, it trotted faithfully with Balazs over the hills and into the woods on lonely walks in search of solitude or some acorns. They spent much time together and he felt that he was able to decipher most of the pig's language of different grunts and groans. Sometimes, they would spend all day in each other's company even skipping the midday meal and only returning at dusk.

They were content just mulling about the bushes and the hills observing the pig's little habits or watching his long blond eyelashes cast lazily half-mast as he expelled deep sighs napping.

One warm August afternoon high on the hill, the pig and Balazs were lounging together on the summit of the plateau where a deep crater was dug during the war for the anti-aircraft guns. It had grown in with thick brush and soft grass. The edges were lined with a variety of wild rosebushes. Plenty of small, spent, old blossom petals carpeted its basin like an artist palette.

He found it pleasant to hide out in the shades of these holes and take afternoon naps. He propped himself against the pig's soft stomach and listened for his even, but strained, breathing. The pig's flat circular nose was wet and his scent, which would have repulsed any city person, was warm and comforting to Balazs.

The pair fell into a gentle sleep. Subconsciously, they listened to each other's breathing, but began to sense a third or maybe a fourth breathing too. It was out of sync and not in harmony with theirs. It was more heaving, quicker and sometimes broken into short segments. Balazs and the pig were rudely derailed from their sleep, into reality with the persistence of the annoying sounds.

Balazs opened his eyes first into the blinding sun, but as it pierced his vision, he closed them immediately. After some comforting tears cooled his eyes, he rubbed the moisture out wiping it on the pig's coarse, white curls. He rolled gently off his pig, not to wake him, and slithered to the edge of the crater to examine the disturbance. The pig grunted in acknowledgment and drifted back to sleep.

Apparently, the adjacent crater also had some occupants in it. He crawled closer to spy. He heard some soft giggling and rather deep grunts. Some sounds seemed familiar to him even though he could not make out what was going on or who was making them. He decided to brave it and crawl closer on his stomach to the edge under the thick undergrowth, where he could not be detected. He could hardly believe his eyes! There was a young peasant woman, the oldest daughter of the farmer from whom his family got their milk.

She had a pretty, round face, nice light-brown hair, and was a bit on the plump side. Her layered peasant skirt was wrapped and pushed up under her armpits, making her look like one of the over-bloomed rose blossoms on the bushes.

From the mess of colorful petals two snow-white legs with red worn peasant boots were flying and kicking. They were also digging deep into the grass and the soft dirt bottom of the crater for leverage. She was heaving and clawing at the back of a mass between her legs, rising and falling toward her. Two pale, pink cheek bottoms flashed from tangled and hastily removed trousers. For a moment Balazs could not tell whether she was pushing this thing away or pulling it in towards her.

Her expression was pain and ecstasy mixed with giggles, laughter and short screams. He tried to move closer to get a better view of the scene, which by now was pretty clear to him. He was not a city boy, so he had seen animals do that in town and on the farms, but he never saw people before!

He began to look for details, but to no avail. If he moved in any closer by the bush he might be discovered. As the heaving and the grunting reached their crescendo, another grunting sound, a competitive grunting, became evident. The lovers also became aware of the third being out of rhythm with theirs. Irritatingly distracted, they both tried to turn and find its source. Too late! The grunting pig stood above them looking for Balazs. Following his scent, he scurried too close to the edge and lost his balance.

Down came tumbling an enormous mass of raw fat and meat wrapped in bristles of steel on top of the lovers—snorting, squealing and crushing everything in its path. The pig squealed in harmony with the farm girl, who screamed and squealed like a pig from fright. Balazs beheld a sight he was not prepared for; the man who rolled off her was none other than Eugene—fighting to push the pig off him and the girl.

It all hit Balazs with such hilarity that he laughed so hard the tears ran down his cheeks. Eugene was surprised, confused and embarrassed. As always, humor got the best of him too and he

roared with laughter. He struggled hastily to pull his trousers up fighting his suspenders that kept snapping back. The young woman still had not found her composure by the time Balazs and his pig reached the bottom of the hill. As they descended, the pig continued to grunt in a peculiar fashion. Balazs was convinced that the pig was laughing, if there ever was such a thing.

He recalled how Paula humorously told him of her aversion to sex and how the very act for her was only out of duty to please the husband she loved. She was relieved when he nagged someone else with it. She was sheltered as a young woman. On her honeymoon, Paula became so frightened by what Eugene presented her that she ran home to her parents in panic.

TWELVE

THE FORTUNE TELLER

THE COLD WINDS blew in from the angry, gray, murky autumn lake. The waves crashed against the shore, where the rocks were piled up to prevent erosion. The thick sea of golden reeds lining the lake swayed and rode wildly with the roller coaster of waves as the gusts of cold rain whipped it relentlessly.

The skies became dark with thick, black clouds turning the early morning into twilight. He leaned out of the window contemplating the empty landscape. The vacationers were all gone and the little town settled back quickly into its routine.

Drops of cold rain began to hit the window pane. He smelled the warm aroma from his grandma's kitchen, which made the room inviting, so he closed the window and tuned the radio to the classical station. Vivaldi's "Four Seasons" was on; it fit his mood perfectly. He entered the kitchen and hugged his grandma from behind. She reached back with her free arm while stirring the pot and pinched his side teasingly. Eugene was still outside cleaning the pig sty and the chicken coop. When he returned from the well with a large bucket of cold water, his clothes had the aroma of fresh rain.

Paula had gone to the library and took out several of James

Fennimore Cooper's novels, including *The Last of the Mohicans*. Balazs read very well and often for a child his age. This was due primarily to Paula, who taught him early to read. When chores were done and other children were not available or the weather was not practical for play, he read sitting in the corner of his bed leaning against the wall. His imagination carried him into the wilderness of the early Americas filled with Indians. He had read many of Cooper's and Mark Twain's books.

Most impressive to him were novels that dealt with the Turkish invasion of Hungary. The ruins behind the church in town were tangible evidence left by them. The city of Veszprem, a few kilometers away with its castle, was the victim of years of occupation. Silent minarets still stood there empty of the Turks eerie calls to Allah. No matter where he turned, he bumped into fascinating bits of history.

Last Spring, Eugene and Balazs were digging around the foundation of the house to make a new bed of flowers, when they hit upon many skeletal parts, including some well-preserved skulls embedded in the red clay. Eugene told him of the villa's excavation and their discovery of an ancient graveyard from early battles of Buda. Many brave warriors were found buried facing east toward the rising sun, as was customary, and surrounded by their bejeweled weaponry and earthly riches.

Reluctantly, Eugene, in the end, decided to donate all that was found to the Veszprem museum's archaeological department. His find was not only historically valuable, but monetarily as well. He kept one set of gold stirrups and spurs that he could not resist. Eugene was well read on Hungarian history and remembered that the Huns were the "barbarians" who introduced stirrups, from their Chinese origins to the West. They also brought with them writings from the Sumerian culture as Europe still lingered in the dark ages. They were credited for introducing such spices as paprika, ginger and live silkworms as well, from China.

After the communists took over, all the gold treasures had disappeared from the museum and to his chagrin he could only show Balazs his pair of finely fashioned golden stirrups and spurs. Upon

seeing this treasure, Balazs was left with a fever to discover additional items to his already growing collection of rocks, butterflies and bugs. For months the yard appeared under siege by millions of moles, because of the numerous holes he dug. He never discovered any treasure.

Winter hit with a severity unlike any he had experienced in his short life. The snowstorms were frequent and without pause. It was bitter cold, there was little opportunity to go and play. Instead, Balazs continued to spend a lot of time with Eugene making lampshades. They drew pictures of Hungarian forts and castles under siege by the Turks. When the weather improved, he dragged through the high snow, sometimes disappearing all together burrowing into tunnels that led from earlier ones dug by others.

This morning there was no hope at all. The snow must have been over two and a half meters in most places and higher in the drifts. The windows of the house were totally covered including the ones of the veranda and the bright snow bathed it with a cold white light. Eugene and Balazs had to make burrows to the coop and the pig sty. At one point, they noticed the shadow of a large crow above them—almost frozen onto the surface. Eugene and Balazs devised a plan to catch it.

Eugene would slowly and carefully dig under the crow while Balazs would distract it with a twig pierced through the surface to keep the bird busy watching it. When sufficiently close to the bird, Eugene observed the crow's shadow directly above him on the thin, frozen surface. With lightning speed, he thrust both hands upwards and scooped the surprised bird from below before it could say "kar." It screeched and fought, but Eugene held him tightly and stuffed it into the snow to grab his neck. With just a twist and a crack, the big black bird became limp, ready to be plucked.

Paula was so disgusted; she would have nothing to do with it. The two excited hunters had to clean the bird and make their own crow soup. It was a skinny, starved bird, but the two rascals enjoyed the whole thing and ate it to the last bone.

As the winter wore on, so did the events. The magical Christmas

season arrived and townspeople celebrated the birth of Jesus with beautiful Christmas songs and prayers for deliverance from the Soviet occupation. The manger was set up in the corner of the church entry and candle lights danced in the dark of the evening mass. Paula played the organ while the chorus of peasant ladies sang like many angels. Mass being over, the three walked home under the clear evening sky with billions of stars twinkling above. They looked up toward its mystical beauty recalling the story of the birth of Christ, wondering whether it was on such a peaceful night that the three kings saw the star which led them to Bethlehem.

As they looked up, a large V formation of wild geese flew overhead honking their peculiar horn calls. Eugene stopped dead in his tracks and as in his old hunting days, took his stance, holding his cherry-wood walking stick and pointed toward the sky at the flying birds. He sounded off two rounds of imaginary shots. Bang! Bang! With a sigh of satisfaction, he lowered his cane. As he did, a dark object fell not far in the distance from above, thud—it landed into the frozen snow, which bewildered the family.

They ran to the spot and saw a freshly shot fat gander lying with prostrated wings in the snow. The following day they solved the mystery as a local hunter complained of a missing goose. Eugene's loud imitation of the two shots rang out simultaneously with that of the hunters so they never heard them. Balazs became the owner of the newfound treasure of multi-colored feathers—shiny blue, green and purple.

That winter, on one of their bright moonlight walks as fresh snow sparkled and cracked below their boots, a solitary Gypsy woman appeared in front of them, like magic. All three were startled, especially Balazs who became frightened by the old, witch-looking woman bundled in rags.

Staring at Balazs, her eyes seemed to burn like amber beneath the shade of her scarf. She spoke first, "Kiss yer' hands and feet and have pity on a starvin' old Gypsy. I beg yer excellencies' pardon. I can tell you are of higher breedin' let me tell the fortune of this young

gentleman?" The Gypsy woman carried on with her honey-sweet compliments to earn her few coins.

Paula and Eugene felt spellbound, almost in a trance. Paula reached into her winter coat and put a few aluminum Forints into the skeletal-looking, bony hands of the Gypsy woman. "May yer' bless your generosity, always," said the shaky old voice as she reached for Balazs's reluctant hand. The moon was so bright that his little upturned white hand glowed against the dark hand of the Gypsy. He could make out the lines of dirt in the old wrinkles. Her touch was hot despite the cold. As she spoke in strange words he saw no trace of her breath in the frozen air. She frightened him and he tried to pull his hand back, but she held it fast and tight.

With meaningless mutterings, she ran her sharp fingernails along the lines in his palm and pronounced him a very fortunate child who will live in America, rich and happy. With that, he pulled his hand back as soon as she loosened her tight hold with the relief of an animal that escaped from the hunter's trap. Before Paula had cynically remarked at the pitiful and obvious fortune just told, the Gypsy woman had vanished without a trace. Eugene remarked jokingly, "Well, of course, if someone gives you money you are going to say something pleasant, even if it is impossible! I am certain none of us will ever see the free West as long as we live."

America! Balazs thought to himself, the West, the Indians and the cowboys, where everyone is free, happy and rich. The Gypsy woman said he would be there one day! He did not want to argue with his grandparents, but somehow he believed the old woman. She seemed special and mysteriously knowing. For many days he could not get her out of his mind and secretly thought about her prediction. He told some of his friends at school, but they only laughed at his gullibility, so he stopped talking about it.

THIRTEEN

THE MEETING

ON AN OVERCAST day, he took his grandmother's rusty bicycle out on the garden path that led steeply down to the iron gate. It was a good place to jump on the pedal and ride the rest of the way down. When he gathered enough speed he could stand with his left foot firmly on the pedal, then crossed his right foot easily over to the right pedal to balance himself. After he shifted his entire weight on his right foot he could break before hitting the gate. Some of his friends already knew how to ride and he could hardly wait to have the freedom and go with them around town.

Balazs was growing fast. His thin, little body was quick and beautiful as children are at 7 or so. The baby fat was absorbed more or less from his face to match his skinny body. He was happy and adjusted, immersed fully into the life where fate brought him, despite the abuse he frequently received in school from his communist teachers. As the teachers lectured the children on the evils of the old regime and the values of "The Communist Democracy" (a contradictory term and double talk by the communists, as they ironically called their system), Balazs was repeatedly asked to stand in front of the class as an example of the corrupt fascist, imperialistic and

capitalistic system. He supposedly embodied all the evil caused to the people by his grandfather's generation, the traitors of the people and the enemy of the government. All lies, of course.

Before he reached his seat, he was often spit upon by some riled up children of the working class but never by the children of the peasants. Balazs was so often called out for this that it no longer mattered to him. His grandparents explained to him everything about the politics of the day and of the world that existed before to avoid confusion. He had no doubts about the lies the teachers taught. Early on he learned to understand to live between two worlds.

The neighborhood was quiet and uneventful on a third overcast day when he practiced rolling down the hill. Only the crushing sound of gravel and his own puffing was audible as he pushed the bike back up the hill. He turned at the top with renewed confidence of his last success and sailed down the path again. Perfectly balancing and being in control of the bike made him euphoric.

Upon reaching the bottom, he noticed he was not alone. A tall, strange figure of a man was leaning against the gate, intently staring at him. The unexpected presence threw him totally off balance and out of control. The bike and child came crashing into the iron gate with the full force of the inertia.

Confused and embarrassed, he gathered himself from his wreckage and withdrew quickly from the helping hand offered by the stranger. He knew everyone in that small town and as country children often were, he was shy and distrustful of strangers. Yet, he felt a very strange sensation—fear and attraction mixed with his curiosity. There was also the urgency to run for his life—it was indescribable and confusing. He glanced at the superficial wound of his bleeding knee, when the tall, strange man spoke in a deep voice. "Are you hurt?" "No, I'm all right, it's just a scrape," replied Balazs, readying himself to bolt.

"Stay," said the man, calmly, looking down at him and still leaning against the gate with his hands holding the vertical bars. Balazs turned and noticed just how very handsome and different this man was from any man he had ever seen. He was broad-shouldered and

wore a stylish dress shirt casually opened at the collar; his sleeves were fitted with large, gold cufflinks. His grandfather had one of those, he remembered, but Balazs only saw him wear it when Grandpa went to the city once with the written permission from the local government.

He had on a pair of light-gray pants and shiny, expensive shoes. Balazs noticed the man's extraordinarily beautiful hands and his aquamarine blue eyes. Eugene had an engraving called "The Kiss," by the famous French sculptor Auguste Rodin; these hands looked like the exact replica of the ones owned by the male statue, sinking into the nude woman's tender flesh. However, being shy, he tried to avert eye contact with the man.

After the first glance at them, he withdrew his looks and returned them to his hands. His skin was soft; the man smelled clean and sweet. He spoke again to the boy in what seemed like a hypnotic, baritone voice, "Do you see that big bus down the road?" Balazs looked where the man pointed and saw what he did not notice until now—a large, new, shiny bus. "Yes, I see it," he replied. "Well, how would you like to take a ride with me on that for a while?" "God, could I?"

Balazs surprised himself, with his unguarded willingness. After he realized what he just said to a stranger in his excitement, he immediately withdrew the reply, knowing full well he was not safe even talking to him. Nonetheless, something drew him with curiosity. He was not afraid of him and seemed to know him. His eyes were warm despite their cold blue color. His voice mesmerized him. Yet, Balazs remained anxious.

"Wait here a minute," said the man, as he turned and walked across the street to the neighbor's house. Zsuzsa (pronounced Zs as-in Zsazsa) opened the door of the kitchen as he was about to knock on the glass. Standing still and rooted to his spot, Balazs could not make out the conversation. Balazs noticed an excited Zsuzsa, who seemed visibly shaken. He overheard her saying something like, "Yes, Maestro, I will be honored, oh what a blessing from God!" She totally changed with new composure as she backed off bowing in her

retreat. She ran into her house, hurriedly tied a scarf about her hair and hastily rushed to Balazs, who was now quite curious.

What was the big fuss and the excitement about? He wanted to get on that bus. He had seen one like it go through town once with lots of city people in it. It sped through town, but did not stop. As the children stood to wave from the ditch, he recalled that only one person returned the wave, but all the kids were happy for that little acknowledgement. If he were to get on such a bus in view of his friends, he would be the envy of them all; it would be fantastic! Oh, yes, he could not wait! Zsuzsa grabbed his hand and they ran up the hill to the house, while the man turned and walked down toward the bus.

She whispered something to Paula and they went to the bedroom leaving Balazs waiting outside. There was a big commotion inside the house and he heard his grandfather protesting and disagreeing about something. As the minutes passed, Balazs could no longer wait. He ran around to the other side of the villa and crawled into the little tower room. He peered down the road and watched the movements around the bus. The man was outside with a group of men and women, chatting and smoking cigarettes. The women, who wore red lipstick and lots of makeup, were dressed in bright, beautiful colors. The men, attired in handsome casuals, stood around blowing puffs of smoke into the air.

Balazs was called and he ran down. His grandfather seemed agitated, but Balazs knew that he must have lost the debate, because when women folk decided on something, there was no way a man could win. Zsuzsa was smiling radiantly and as Paula addressed Balazs, she seemed very nervous. "Grandpa and I have decided that you can go with the man on the bus, but it won't be just a ride. They want you to go with them to Fured for a couple of days."

"You mean I can miss school?" asked the excited Balazs, without even suspecting or asking what this was all about. "Yes, and I packed you some changes of clothes, you will be back in a few days. Now remember to be a good boy, polite, and make your grandparents proud, we are going to miss you." He hugged both of them, dismissing Eugene's discomfort and ran down to the bus. Balazs looked

around and was disappointed that not even one kid was out to see him board the bus.

The man lifted him up the steps with ease. Balazs felt horrified that he was suddenly in the company of these strangers. The smell of perfume and smoke was overwhelming from all the made-up women, who were chatting and laughing. They all seemed unable to keep their hands off him. They said nice things and asked him all sorts of questions, which he was very timid in answering. The beautiful man sat next to him and let him sit by the window. It all happened so fast that Balazs was frightened now and wondered if he did the right thing.

The bus roared by the familiar sights of the lake that Balazs knew well. On days when the long freight trains came slowly through the town, he and his friends ran along the tracks grabbing the handles, pulling themselves up the steps to get rides. He took many trips to other towns on the train, his cherished friend. If caught, they would have been in big trouble with the town officials and of course his grandparents. Especially, since not long ago a boy fell under and had his leg cut off by the wheels. By the time help arrived, he bled to death.

The bus ride was fun. The interior of this Icarus (named after the manufacturing company) was new and clean. These buses were well designed and built, despite their communist label. They were one of the few items exported and won awards in Western Europe. The soft sway of the well-built system made him sleepy. One of the attractive women moved up across from her seat and asked Balazs to sit on her lap. She had a son his age and she said she missed him. Balazs gladly obliged.

He became more relaxed and comfortable as the conversations were about theater, acting and reminiscing about past anecdotes on stage. He just listened and answered only when spoken to. He didn't say anything about his father being a famous actor too and if they knew him. For the most part, he pretty much gave up thinking about his father, since the drowning of little Csilla, which he managed to block completely out of his memory.

The late afternoon sun was large and golden as it broke through the softly painted, overcast gray skies. It settled into a brilliant orange, crimson glow before sinking into the lake.

Grandpa always said some things only nature can get away with because if an artist attempted to copy them they end up just creating kitsch—distasteful and mediocre. He drifted gently into sleep as the bus swayed and the twilight melted in with the muted chatter of the tired occupants.

The man didn't say much to him on the ride, but was satisfied just observing him for long periods of time when he felt Balazs was not looking. As Balazs was about to drift off, the woman stroked his head and leaned near the man, "Sandor, there is no doubt in my mind that this child is yours, just look at him. He is the spitting image of you!" "Yes, I think you are right," he responded with somewhat of a broken tone.

Balazs overheard the woman's comment. He opened his eyes and stared directly at the man, whom this woman addressed as Sandor! He was overwhelmed with the sudden and shocking realization. Tricked, cheated and betrayed! He turned to the woman who appeared caught and frightened. It all came to him that everyone had lied to him and played a terrible, cruel trick! He was unprepared and was shocked at the discovery.

Sandor, overcome at his son's visible distress and shock, reached toward him. Balazs instinctively withdrew in panic, then in the next split second, by an unknown force, found himself in his father's arms crying uncontrollably. "Dad, oh, you are my dad!" He was shaking as he buried his face into his dad's comforting embrace. Father and son held each other tightly as they cried from pain and happiness combined.

Balazs realized the man's mysterious magnetism and effect on him; his many secret and loving glances. "I knew you would come, I knew you would, one day!" Balazs exclaimed, laughing and simultaneously sobbing. Sandor stroked his son gently and lovingly. His mixed emotion of guilt and love toward his son was indescribable. For an instant the moment was filled with confusion for father and

son. The strain of this long-awaited moment was so overwhelming for Balazs, that he fell fast asleep in his arms.

Sandor looked down at his son with renewed love knowing that he wanted his child with him. He feared and anticipated the answers he must give Balazs the following day. He knew how cheated his son will feel the day the bus will return him to his grandparents' home. He wished he could take his son with him, but that was not possible. He realized how unprepared he was in his heart for this visit.

The two days were filled with deep bonding, joy and play. Father devoted every moment to his newly found son. Balazs asked Sandor about his brother, Barna.

Sandor told him about the wonderful woman he married, who loved and cared for them. She was also a famous actress and her name was Kati. Of course Balazs knew of her, but from different descriptions.

Sandor rented an air gun at the hotel where they stayed with the cast for the few days of the Summer Stock. The two of them target shot an old, white, chipped iron bedpost on a grassy hill. The air was aglow with the wet green day and in the still of an overcast sky everything seemed fresh. They strode by the lakeside on the boat docks and beneath it discovered a huge lobster skeleton bleached white by time. They attempted to pull it out from the water, but it fell apart, so they abandoned the project.

Night came and the play began at the local theatre. The lights were turned off over the audience. When the curtains were drawn, an unbelievable rich and stunning stage set appeared. The whole atmosphere was tantalizing with hundreds of hands applauding the entrance of Sandor, his father on the stage. Balazs was intoxicated with admiration and pride for his father, the father who returned, who came back for him, who loved him, who was the most wonderful man on earth.

He never saw a photo of his father and had no visual recall of him. He found pleasure in looking at him. He thought he was the most handsome and heroic man he had laid eyes on. Now he felt he would never be afraid of anything. His father will always protect

him. Unlike his grandfather, Eugene who was small and weak, more of a victim than a hero. Sandor on the other-hand was on top of the world and admired by all. Balazs felt guilty for feeling this way and realized why Eugene was protesting this visit on the bus. They knew who this man was! Eugene was devastated and feared losing the love of his grandson—now truly a son to him whom he loved.

Balazs's thoughts of Eugene vanished quickly in the speed of the events. Before he knew it the bus was on its way to Fuzfo to redeposit him back into the past. "But I thought you came back for me, so we can all be together," exclaimed the disappointed child with tears running down his cheeks. Frustrated and uncomfortably guilty, Sandor did not know how to handle the situation.

He tried to explain to Balazs logically that things are not as simple as they seem. There are laws, he can't just walk away with him. None of that made any difference to Balazs; he felt cheated and lied to again. His father did not really love him, he can't just leave him behind again! Sandor tried everything to console the broken-hearted child, but to no avail. He retreated to the far end of the bus and would not respond, now that he realized fully that nothing changed.

He was happy in the world he accepted and lived in, until his father showed up and ruined it all. Now, he will never fit in it again; it will never be the same! The bus pulled up the road of the twin towered villa. The town children were out in groves at play, but it did not matter anymore. Balazs pushed past his father who stood by sad and depressed. He watched him walk from the bus toward the villa, never looking back. In pain and in utter confusion, he sank quietly into the seat as the vehicle rolled down the path toward an obscure future.

FOURTEEN

SOVIET MAY PARADE

"ACTUALLY THAT WAS really funny, don't you agree?" Eugene asked Balazs as they laughed about the calamity that interrupted the May parade. The first day of May was the biggest communist annual rally, when the communists commemorate the grand socialist system. As the Soviets marched their armies and military muscle in Moscow's Red Square, so did the Hungarians and all the other occupied countries. All had to attend! Roll call was taken, resulting in serious consequences for not showing up. The school children were marched out too and they were made to carry large, heavy posters.

This particular May march was organized up on the factory settlement, where they built an enormous paved area to accommodate thousands of people. The settlement, where they had the paper factory and the chemical factory, also included the apartments that housed several thousand workers and their families. Combined with that of lower Balatonfuzfo, the population was more than 3,000.

The old folks were no longer required to march or listen to the boring speeches, but Eugene decided to come anyway with the bike. The gentle spring breeze kept the crowds somewhat cool in the morning, but these events took long hours. Everyone was made to

hold red flags or signs and Balazs, along with his classmates, was given a gigantic portrait of Stalin. The Party leaders were boasting of their wonderful accomplishments and conducted big sing-alongs of many Russian and Hungarian marching and party songs played from scratchy old recordings, amplified by tin-can sounding speakers.

It was a joke, since everyone knew that this was a forced celebration. All that was cheered were phony events followed by phony promises by phony people. Balazs wore his required red scarlet scarf of the communist youth called "pioneers," an idea the Nazi Youth organization was modeled after, but with green scarves. He stood for hours on the burning concrete in the sweltering heat, while his grandfather waited in the cool shade of the blossoming chestnut trees, rolling his homemade cigarettes. Like all his friends, Balazs was also bored by it all, but he stood patiently. Sometimes he was awakened by the sound of some new marching music that livened a meaningless speech. At times flies would land on the kid's shirt in front of him, distracting his attention for a while, helping the time pass.

He was not allowed to wear a cap out of respect, so the sun began to burn his scalp severely while the concrete boiled his toes, through the soles of his shoes. The sweat began to pour down his face and trickled down his sides from his armpits. He planted the pole of the large sign firmly on the ground for support, only raising it in the air when the signal was given for them all to cheer and brandish his hated Stalin head. He was thinking of a nice, cool swim down by the lake after this ordeal. Almost, as if in a dream, he felt light and relaxed with his feet gliding above ground when suddenly, he woke to a hard knock on his face and forehead.

His face was pressing against the hot concrete, totally disorienting him. He sat upright and found himself in the midst of a commotion. When he was finally able to focus the scene around him was a battlefield. Everywhere children were on the ground in contorted positions lying over each other and among broken signs and sticks in every direction. Balazs was sun struck and fell as hundreds of others came down with him in a domino effect, disrupting the entire affair.

Balazs and Eugene mused over the humor of the event as they

worked side by side, hoeing the weeds from the young carrot patch.

He was now able to plant any vegetable and tend to it by himself and even loved doing it. Lately, he found being with Eugene more interesting than playing with his friends, not that he did not play wildly and vigorously whenever possible. He knew that the young carrots would be about his hand's length, which he would pick and eat freshly washed in the spring's cool water. The vegetable garden became an open-air set table for him and he would return to it throughout the summer.

The betrayal he felt by his father's departure and the remaining guilt of his abandoning Eugene slowly subsided. When Eugene was not around, Paula asked about every detail of their visit and to Balazs's surprise he realized just how much she adored his father. Unfortunately, as in the past, he never got any communications from his father. No letters or cards on any occasion, Christmas, birthdays or ever. Deep inside he forgave his father. Balazs seemed to have developed the same love relationship with his father that his grandmother had.

The little kitchen became a sauna from the iron stove as the flames of burning wood leaped from beneath the iron disk supporting the pan.

Paula was frying breaded apple slices while Balazs helped peel the potatoes for dinner. Eugene went to release the pig and fetch some water from the well. Suddenly, Paula wavered, lost her balance and accidentally leaned onto the pan's handle. The pan flipped and the boiling hot grease spilled on her delicate, white skin, severely burning her. She fell faint.

In a flash, Balazs jumped to her aid and struggled to pull her through the little door. Eugene arriving on the scene immediately doused her burned arm with the cool bucket of well water as Paula made feeble attempts to regain her composure. She had severe third-degree burns. They put her on the bed. Eugene ran around the room frantically searching for the phone. "Grandfather, we don't have a phone, it was taken from you after the war." "Oh, God!" the old man broke down in desperation. "I keep forgetting, every damn

thing was taken away. Balazs, honey, go see if Erzsi is home next door, while I put some wet cloth on your grandmother's burns and forehead."

After Erzsi arrived to help, Paula was still in pain on the bed, Eugene decided he must get some help. He got on the bike with Balazs behind him on the metal rack and pedaled off to the local Communist Party headquarters. This was where Erzsi's husband was dragged off, severely beaten and later put in jail. Eugene wanted to ask permission to use the phone and call for help at the Veszprem hospital.

Frightened and out of his wits, Eugene kept repeating how much he loved Paula and begged God not to take her from him.

What would he do without her? He would make any promise to God just save her. Balazs began to panic, too, realizing how serious this must be, as Eugene talked about death, about losing her. Sitting on the back rack, he held on tightly and urged Eugene to pedal faster.

They arrived at the shabby farm house with the red metal star on the roof. It was the office of the fat little communist Balazs learned to hate so much. His son attended the same classes and encouraged Balazs's harassment. The man stood with his back to them at the side of the yard—pissing across the neighbor's fence onto the fruit laden raspberry bushes. Irritated, he turned to see who opened the squeaky gate as Eugene, in his haste, dropped the bike against it. The man's short penis slid back slowly through his unzipped fly, leaving yellow beads of urine running inside and outside his pant legs.

Layers of pigeon droppings piled on the threshold of the entry door which come from the suspended coop under the roof. Chickens were scratching mindlessly in the dirt of the neglected, grassless yard making small clouds of dust. The dog, with his empty water dish, parched and mad from thirst, barked viciously at the strangers, hopelessly trying to tear from his chain. "What you want?" he grunted, at the obviously panicked old man. "We need, with your permission, sir, ah, excuse me, comrade, we need to use the phone

for a family emergency," said Eugene stuttering, carefully and humbly, knowing the mannerism of these little men who were elevated to power.

Once they stepped into the office, the man deliberately and slowly walked around his desk noticing the urgency and the visitor's frustration. The torture he cultivated ever so well to exercise over helpless people was one of his sickest specialties. His pleasure in life was actually the pain he could cause these formerly well-to-do people. He thought, what right did they have to live so well? Now it serves them right to have nothing and to answer to the likes of him. Fortunately, Eugene never had any dealings with him before, It was obvious this man had been waiting a long time for the opportunity to cross Eugene's path. Here was the moment he was waiting for! "So the capitalistic pig wants to use the people's phone?"

"Yes, sir, err comrade, I implore you, we are desperate, my wife is ill and had an accident. We urgently need a doctor," begged Eugene, not heeding the sarcastic remark. "I am COMRADE to you always! PIG! There are no sirs in this era if you have not noticed," he screamed, his face all red. "Perhaps you need a little rehabilitation like your son got to bring you up to date!" "No, sir, I mean comrade." That term sounded so foreign to Balazs coming from his grandfather's lips.

"You know it's a communist phone, it might just contaminate your bourgeoisie ears," he teased the old man further. "Please comrade, please," Eugene pleaded in fear that time was wasting and might prove fatal to his wife. He would do anything to prevent that from happening. The man read Eugene's mind and said, "I suppose you would even get down on your knees and beg to use this here phone?" Balazs could not believe his ears or this whole cruel scene. Not just against his grandfather, but toward anyone; it was appallingly sick.

"Yes, comrade, I would," replied the humbled old man, broken and powerless. "Don't, grandfather, don't," implored Balazs, who was outraged. "Why don't we just get back on the bike and hurry to

Veszprem?" "Hush, child, we don't have that time," said his grandfather, who leaned on the edge of the desk, then knelt like a disciplined school boy to the visible satisfaction of this pompous, worthless excuse of human trash.

A moment of suspenseful silence held the room. Then the man said, "I could also make you sing like a canary if I wanted, but to show how lenient I am with scum like you, I'll let it pass." He lit a cigarette and took a deep breath and exhaled, filling the room with a cloud of smoke. With that he cleared his throat, then from the depth of his sinus he scraped up a mouthful of yellow phlegm, which he spat right into Eugene's shocked face. Eugene was transfixed with disgust and humiliation. Balazs watched the old man's kind blue eyes fill with tears that riveted down his face as the disgusting spit stuck on his left cheek.

Balazs was so filled with hate and anger that he did not see the man depart and say with a triumphant smile, "The phone is yours, pig." "My father would never ever let this happen to him," he shouted in Eugene's face in utter frustration. But as soon as he said those words he felt Eugene's pain and the humiliation he endured under this dreadful, despicable creature parading as a human being. He felt ashamed.

Eugene, not responding to the pain caused by Balazs's remark, reached for his handkerchief and slowly wiped the spit off his face like a quiet martyr. Painstakingly, he stood up, reached over the desk, removed the heavy black receiver and with shaking fingers, dialed the operator.

FIFTEEN

FIRST MOVIE

HE WAS AT the crossroads of his life. Everything became more complicated, when it should have been easier. Ever since his father paid him that unexpected visit, Balazs felt he was hurting his grandfather unintentionally at every turn. It wasn't long ago when he openly rebuked him at the Communist Party headquarters.

Today, he felt excitement in the air. The town was looking forward to some kind of film attraction. There were posters announcing the film showing Sandor, his father, in the main role. Everybody was talking about the movie. Children, even the ones related to the Communist Party members, became more lenient with Balazs and gave him more respect after they found out that the featured actor was his famous father. Now everyone wanted to know whether he was going to the movies or not.

Certainly, he wanted to go. He had an immense yearning and curiosity. How was he to ask Eugene for money knowing the pain he might cause with that request? He could ask Paula, but still it would get back to Eugene and he did not want to play one against the other.

He decided that the only way to get the money was to swipe it from the drawer, where Eugene always dropped change or leftover coins after shopping. This was stealing! He never stole or thought of stealing anything ever before. He followed his Ten Commandments very strictly now that he was an altar boy helping Lajos at Sunday Mass, baptismal and other functions. (He did confess in the dark confessional booth of the church to cussing a lot. After he confessed his sins, Lajos made him say hundreds of prayers over the stages of the Cross.) Nevertheless he was able to rationalize things for himself somehow, but stealing was something difficult to contemplate.

They were still dirt poor. The trading of the lampshades was absolutely necessary. Even through the little garden brought in the badly needed produce. It was still insufficient with the rising prices. To make ends meet, they made most of their basic necessities themselves.

Paula joined the peasant women of the village in boiling pigs' fat and mixing it with lye to make soap. Balazs hated the disgusting tasting soap, which he was told to use to brush his teeth, because there was no toothpaste in the house.

The chickens they raised were infected by disease that swept the region. They lost more than 60 out of 70, which they raised from the corn harvest from their yard. The painful day arrived when his grandparents gently informed him that his pig had to be slaughtered for food. He knew that the time would come one day, but somehow he duped himself into thinking that it only happened to his friends' pigs, not his. His first reaction was to hide the pig in the nearby woods, but the pig chewed its rope and returned home. In fact he hid him in several sties of trusting buddies, but to *no* avail.

In the end, he gave up the fight and released his loyal friend to the ultimate fate of all pigs. The village butcher came in early November morning to do the butchering. He was known to do the best job, causing the beasts the least amount of suffering. The neighbor's roughly hewn table (same table where little Csilla's body was stretched out) was used for the prepping. The hand-held coal torch

was ready to burn the bristles from the surface of the skin as the peasant women readied large cauldrons of hot water to clean the intestines. They were to be filled with the finest of spices and ground meat to create the famous Hungarian sausage. The pig hoofs and head parts made up the base for aspic in the aromatic garlic broth. The brain was prepared in various ways for the major contributors of the labor as a gift of delicacy. The sausages and the thighs were later smoked as an ancient preservative for prolonging the shelf life of the foods.

All of this was going to be done to his friend. Like Judas, he sold him out! He was miserable and guilty, yet helpless. His self-consoling promise was his determination that, even if starved to death, he was not going to eat any part of his friend. He stayed inside the house to avoid being seen by his pig, yet he could not tear himself away from spying through the wooden shutters, which Eugene closed in order to protect him from the painful sight. The pig was brought out and the men tied his front and hind legs together.

As he, unsuspecting and trustingly lay on his side a sharp pointed knife penetrated through the more than 12-centimeter layer of fat on his chest, just slightly above his front legs. As the knife slashed through the first real flesh and nerves on its way to the deeply hidden heart, a piercing scream came from the beast. It ripped the air and ricocheted off the walls of the house, the trunks of trees and echoed back from across the hill. The butcher struck deeper—cutting the vitals and passing into the lungs as well. It was awful.

Thankfully, the bloody ordeal did not last long even through it did felt like an eternity. It left him feeling empty. He opened the veranda door and entered the scene to everyone's surprise. He saw his friend lying on the table with a clean, open cut on his chest, he was dead—just like the table below him, he became an object. He saw nothing through his glassy eyes of death, but Balazs felt somehow that his little pig's spirit was lingering about him watching. He leaned over—kissed the peaceful head and walked away toward the lake in dazed numbness.

Now with the weather becoming pleasant and easy the previous year's unpleasant memories behind him, Balazs thought of the outdoor theater which reopened. He stood, looking into the drawer with fear and indecision—aching to take the money from his grandfather. This was his first film and he wanted to be near his father, if only through the fleeting screen's projection. Again the same nagging feeling of guilt came over him with the knowledge that he was causing Eugene pain.

Nevertheless, he snuck into the last row of folding chairs, under a great big tree by the old creaking projector. The film started over several times and broke down often with the strips of film flapping furiously about like a chicken with its head cut off. None of this seemed to distract him from the trance which possessed him. The enlarged image of his handsome father on the screen carried by his strong and graceful stature captivated him completely. He yearned and ached and loved all at the same time. As much as he loved his grandparents he knew with all his heart where he belonged- by his father's side.

The thrill of having seen his first movie starring his father filled him with much pride as he walked through the veranda door. Flushed like a young lover, caught sneaking home from a night's passion, so Balazs was caught totally off guard when he found Eugene sitting up with a reproachful look on his face. "You could have asked me for the money, Balazs. You know my love better than to resort to stealing." That was all he said, as he turned and went out into the darkness to hide his pain.

Balazs was stunned by the blow of that simple pronouncement. A good spanking would have been easier punishment to lessen his guilt. He was left with the permanent burden of guilt! He could not bring himself to run after his grandfather and comfort him. He had cheated and deceived him. His guilt turned to anger and resentment toward him—this was not fair!

He threw himself onto his bed, looked over to his grandmother who was pretending to be asleep. Balazs felt for the first time in his

life that he wanted to run away, to run and it didn't matter where!
The room seemed very small and stifling. He slid off the side of his
bed with his pillow in hand—turned the corner of the house, mounted
the stairs for the tower and opened the hinged door to settle in on
the sun-warmed sand. Lying there, he peered out through the slits
and cast longing gazes across the silvery surface of the tranquil lake.

SIXTEEN

THE CIRCUS TRAIN

NOTHING STIRRED yet and the 5 a.m. express was not even half way around the lake. On a peaceful summer morning like this, he liked to wait in complete stillness to catch the very first faint vibrations of the train. Balazs regularly jumped on the freights or the passenger trains undetected to get a free ride and visit some towns bordering the lake.

He was home before anyone missed him. The early train had to wait 20 minutes sometimes for the oncoming trains to avoid collision. This gave ample time for his inquisitive hands to touch every part of the engine in his reach that wasn't too hot. As he felt the great iron wheels with their bright, red spokes he imagined that the great patient beast had some sort of awareness of him.

Sometimes, the soft huffing and puffing sounded to Balazs like an expressions of approval by the trusting Avatar, tolerating and yielding to his inquiring presence. Balazs had no doubt that there was a secret, special bond between them, perhaps the thing was not merely so much metal and steam. It had a free spirit and a thundering personality—not to mention its speed and strength. Even the smell of soot created by the glowing and smoking coal being digested

in the hot belly had a special nostalgia for him. It sent sparks flying into the dark night sky as it rushed past the villa slithering like a smoldering dragon, screeching as it made its way around the sharp turns.

Now and then, he was able to deceive the conductors and let them think he belonged to the families he shared window seats with. He enjoyed the magic of the continuously flowing landscapes. The rhythmic clanking of the metal wheels, repeatedly hitting against the steel track joints sometimes rocking him into a hypnotic slumber.

Some of these deep sleeps were interrupted by the sharp whistle calls from his friend jolting him back to reality. With haste, he would jump off the moving train to catch the returning ride back.

Balazs tried gazing through the slow rising fog. He sensed the first gentle vibrations beneath the villa from the distant rumbling of the train. He did not return to the house, but as soon as he reached ground level, he mounted the old, rusty bike and rolled down the hill to intercept his friend. Some sparrows began early to chirp in the trees, but did not leave the safety of their perches. The greenish-white fog which greeted him in the early morning, still lingered about him. He did not go as far as the station, but turned sharply and crossed the tracks, dumped the bike into the ditch and sat on the soft, uncut, tall wet grass. Through the fog he faced the hardly visible villa, which looked like an enchanted castle suspended in the sky.

He heard his friend as the wheels screeched in the tight bend, followed by the triple-whistle warning. He was pleased that it was punctual. The nozzle of the whistle atop the engine looked like the spout of some giant whale depicted in old engravings Eugene had in Jules Verne novels. In his mind, he could clearly see every detail— the wheels, the wagons and the black locomotive with the chimney appearing first, erect and proud through the fog. The wagons followed like a serpent's tail, whipped in any direction at the will of the behemoth.

As the anticipated image of the engine with the red star penetrated the fog and flew towards him, the most surprising scene unfolded to test his imagination. Colorful, large, painted wagons

hitched behind the locomotive unraveled from the mist. As in some happy celebration the whistle blew again countless times. These wagons were the types that carried closed freight, but now had painted murals of bright images on them, depicting exotic animals—tigers, elephants flying through wheels of fire. Clowns and half-naked women balancing on large balls, hardly resembled the drab, rust colored wagons he was expecting. These colorful cars glowed and decorated the otherwise monotonous landscape around him, which seemed as bland as he felt his life to be—compared to this jubilant barrage of fantasy rushing upon his tranquil, sleepy town.

He saw equally colorful people shouting and yelling through the windows—laughing, throwing kisses toward him and releasing bright flyers into the air. Some blew trumpets, some beat on brass plates and some even danced atop the moving vehicle's rooftops. There were clowns, jumping from wagon to wagon with ease and great precision without falling beneath the wheels of the blazing train. Balazs was spellbound—his heart raced with imagination far ahead of this train, which now accelerated rather than slowed at the station.

As the noisy, chaotic scene ran past his bedazzled eyes, he realized he was holding the circus prospectus announcing the following week as the date of the performance in Fuzfo. He ran in mad, frenzied delight to gather the flyers, which decorated the green ditch like hundreds of red poppies in bloom. Forgetting the bike, he ran up the hill, burst into the sleepy villa, breathlessly trying to explain everything he just experienced, totally incoherent from the muddle in his mind. He attempted it over several times while waving the leaflets like a windmill in the face of his grandparents.

The days dragged on and he could not concentrate on anything especially at school, as his mind was totally preoccupied with the circus. There were only a few days left which made it all the harder for the children. Spring fever, accompanied by the rare, forthcoming circus in such a small village, sent the children and adults alike into unusual anticipation. This week was Soviet week, which meant that all the children were forced to speak only Russian! Balazs so hated

Soviet week or anything Russian that he found it psychologically debilitating and burdensome to memorize his homework. He developed an angry aversion—a mental block to it. This was not a unique affliction—the symptom had affected millions of children across the Iron Curtain countries, especially the ones whose families suffered personally from the occupation.

His excitement was so extreme that he slipped and broke the rules just as he was standing by the Russian language teacher. The freshly brainwashed communist woman, who recently returned from Moscow's Marxist school, hated Balazs for one reason or another. Her persecution was so vividly concentrated that even his classmates, who often made his life miserable, turned with sympathy and consoling glances toward him. This short, skinny, unhealthy looking witch with charcoal-black hair, would hit Balazs with a wooden ruler anytime she had an opportunity. She would whip him across his bare neck as she passed in the aisles. Worse yet, when he gave an unsatisfactory answer to her question, she would have him hold his small hands vertically with fingers tightly closed together, With full force and lightning speed, she would bring the ruler down hard on its mark on the tip of his nails.

The shock and pain were so severe that he thought he'd get a heart attack. The blood squirted from under the bed of his nails as he suffered this agony reverberating through his entire body. He flinched as he held the other hand, allowing her to deliver the second assault. He could see an evil glow in her passionate, coal-black eyes in the pleasure she derived from the torment. He wished her dead and imagined her demise in many ways. For days following these debilitating beatings he was unable to do his homework or help Eugene in the yard.

Strict rules of conduct and obedience were enforced throughout the communist school system. All students had to sit straight up in their chairs with hands folded behind them. The only time it was allowed to bring one forth was when raised for questions or writing. The classrooms were always silent and undisturbed places for education. No time was wasted on discipline, but when it happened it was

carried out with severe corporal methods at the teacher's discretion. Balazs witnessed the abuse of others as well. When his grandparents went to plead with the principal, their complaint fell on deaf ears.

There was renewed anti-Semitism instigated by the ruling leaders called "The Red Gang of Four". Ironically with Matyas Rakosi at the helm, a Jew. The Gang of Four, Jews who were survivors of the Nazi era and later trained in the Soviet Union as communists, did not retaliate on the few who were guilty Nazi sympathizers, but on the entire nation. They used fascists' methods, combined with Stalin's to purge the intelligentsia. They executed hundreds of thousands and banished as many to Soviet Gulags in Siberia or China to forced labor camps.

They reigned with terror—labeling anyone as "subversive" who questioned their rule even if they were of the same communist stock as them. Their methods were similar to Stalin's who exiled Trotsky, a loyal Lenin communist, to South America and later hunted him down to be murdered by his loyalists. They viewed every idea with suspicion and ideological betrayal. Therefore, no one felt safe. Rakosi's terror on this small nation made Eugene feel betrayed and furious.

He could not comprehend how a Jew, who suffered under Nazi terror and survived, did not learn anything from it, but continued his evil works against humanity under another excuse.

Before the war, Hungary was not affected by the wave of antisemitic hysteria of Europe and other neighboring countries. It had a history of tolerance—allowing Jews to own land unlike the other European countries. Through hundreds of years, a large Jewish population evolved—drawing more and more Jews to the land for better and higher opportunities in government and business. It was only here that the Jewish aristocracy evolved (land owners with titles) These Jews lived freely in wealth and unchallenged pomp.

As a result of the Austrian (the country that produced Hitler) occupation of Hungary (against whom the Hungarians revolted in 1848) there were thousands of resident German sympathizers to the Nazi cause and still loyal to their fatherland. While living in Hungary

their voices of sick fascism were often mistaken for the Hungarian's. Jews were not interned into camps in Hungary, because the government didn't allow the camps or the persecutions to exist. Many attempts to destroy the Jewish population of Hungary by Hitler's regime were derailed. (The 1941 census counted some 825,000 Hungarian Jews, 6 percent of the total population. This number included 100,000 converts to Christianity who, under Hungarian race laws passed between 1938 and 1941, were considered Jews. In 1942, the German government kept pressuring Hungary to hand over Hungarian Jews into their custody. But prime minister Miklos Kallay refused.)

Eugene was in an advisory high-ranking position to the ministry and the Catholic Diocese of the previous regime. He was open-minded and respected different views in life; he reared his children in the same manner. His younger son Gyorgy happened to fall in love with and marry a Sephardic Jewess at a time when the long German arm was beginning to reach out for the destruction of the Jewish people. Eugene, seeing the situation for what it was, quickly used his influence and had papers forged for his daughter-in- law and her family proving them to be Catholics. Eugene thus managed to save the lives of hundreds of Jews from being deported and taken by the Germans. Had he been discovered by some Nazi sympathizer, Eugene knew he could have ended up in some concentration camp and gassed like the other three million non-Jewish victims of Hitler.

Despite the dangers, Eugene continued to practice what he felt was morally correct. Ironically, the local Soviet-trained communists in Fuzfo, despite the country's Jewish Communist leadership, hated the Jews as much as the Nazis and began to bully Eugene for being a Jew lover. So, Balazs also had the pleasure of not only being labeled as the descendant of capitalist pigs, but a Jew lover as well. The madness of human prejudice and ignorance was as confusing to Balazs as it was to his grandparents.

When Balazs accidentally spoke in Hungarian about the circus to the child next to him, the Russian teacher overheard. She didn't

waste a second to let him know he broke an important rule. Before he was able to duck, she hit him with full force, almost puncturing his eyeball.

As a small injured vein spurted with blood, Balazs dropped instinctively to the floor covering his face in fear that he lost the eye. After the initial shock and the realization of what happened, he was consumed with hate. Spying the open door, he jumped up and bolted through it to freedom, not stopping until he reached the villa. Paula carefully examined the damage and determined that his sight was not in permanent danger outside of the temporary scratch on the cornea and the deep wound to the flesh. There could be no consolation, for the inner damage was more lasting and deeper than the flesh wound. Only Eugene's reminder of the forthcoming circus restored his sanity.

SEVENTEEN

THE RUNAWAY

THE THREE WALKED through town under a gigantic, dull-orange sun. They were joined by groups of excited villagers for the main event—the circus. The train pulled in at dawn to give their workers time to set up the huge tents in the green meadows at the far end of town.

The entire town showed up willingly, unlike the compulsory parades in May. All the villagers were excited to have this momentary escape from their otherwise miserable existence. The soft, gentle breeze carried the pleasant scent of the muscular stallions that snorted and dug their hoofs into the dirt. Lions roared somewhere in the distance while large Indian elephants calmly reached out their trunks for the carrots offered by precocious children. Jugglers teased the delighted crowds and numerous competitive clowns ran mischievously among the children handing out cotton candy or multi-colored popcorn.

A man on incredibly high stilts took giant steps around the campground, announcing the coming events, as colorfully garbed Gypsies read the palms of the gullible. The crowd pushed the three of them through the entrance. Balazs was dazzled. The band played

festive music, while the circus attendants tidied up the equipment for the show. Sawdust was thrown unto the rink inside the red-velvet border that circled the stage. Trapeze artists' ropes and ladders hung overhead, like the web of a giant spider. They cut the bright lights into angles crisscrossing the flying dust resembling a cubist painting. Children shouted and screamed as horses neighed, tigers roared and dogs barked. The deafening loud music made for a happy mix of sounds.

By now all the seats were occupied and the repeated blinking of lights heralded the beginning of the show! A heavy, mustachioed circus master appeared in the arena and as all the floodlights focused on his stumpy figure, he graciously swung his cylinder hat into the air to acknowledge the audience and to introduce the performers.

Balazs sat spellbound with his mouth agape at the masterful performances and felt envious of such an exotic, exciting life. These people seemed so free, not like the people of his village and the rest of Hungary, he thought. The men and women were masters of their skills—riding while standing on the backs of fast horses, juggling and twirling plates with flawless precision, throwing knives aimed to miss a woman spinning on a wheel. There were dangerous stunts by fearless tamers of tigers and bears. All the color, pageantry and music brought nonstop applause from the happy, delighted crowd.

He heard that the Hungarian circus performers, like the Hungarian athletes, were allowed to travel not only throughout the Eastern Block countries, but even to the West! Even if they were strictly guarded by the AVO men (disguised as colleagues) to prevent defections, they were still freer than anyone else. As he was dreaming about circus life and comparing it to the drab life in his village, an attractive family of trapeze artists in glittering outfits entered the arena. With swift agility, they climbed the ropes to the utmost heights of the great tent, accomplishing stunts that defied gravity and fear.

The couple's little daughter, a beautiful girl around Balazs's age with sparkling blond hair, held a long, slightly bent rod in her hands across the tightrope. She was crossing at least 14 meters or so above the spectators, without a safety net. The audience was quiet and

refrained from making a sound for fear that she would lose her concentration and balance, falling to her death. She stood on one foot in the center of the rope as the drums began to beat faster and faster to accent the zenith of her performance. Her young parents stood on the sides with unwavering confidence, admiring their child's stunning feat.

The little girl, kind of fragile but with well-formed muscular legs, wore makeup and lipstick that made her look quite mature. After she completed numerous heart-stopping stunts, she took to the vertical ropes and slid onto the firm ground below to execute her graceful bow and receive the well-deserved applause from the relieved audience.

As the show continued, Balazs kept thinking of this superhuman little girl and how wonderful it would be to travel with the show. Learn to perform something or tend to the animals, just anything to be gone from this life. He felt the scab on his temple throbbing at his touch and the difficulty of seeing the show through one swollen eye reminded him of his condition. This made him all the more determined for a change of venue.

Perhaps he could work with the circus train and be by his friend the train, forever. He loved his grandparents and did not want to hurt them, but he would not have to attend school. He could earn money to send them. He would no longer be a burden to them, since it is easier to feed two mouths than three. His grandparents could not protect him anyway from the people that hurt him. Perhaps one day he'd become a famous performer like his father and show up in Budapest with the circus, inviting him to a show! What great fun that would be! He was now determined to do this, but how? His grandparents would naturally never consent to his leaving for the circus, so he had no other choice but to run away!

He had to act fast and think of a way to accomplish this knowing that the circus was there for only one night and would be packing up after the show. He knew no one at the circus, so what if they did not want him and rejected him? Looking very innocent, he turned to his grandparents and excused himself to go outside. He exited into the

fresh cool air of the night. He ran to some wagons that held the cages of performing animals. He glanced back at the great tent. In the night it looked like a giant Japanese lantern rocked by music and laughter. He almost returned, not to miss anything, but then again what would it matter anyway if he were to go away with the circus?

Just as he was about to seek someone out for advice, a door opened from the adjacent wagon casting the light on him. He was about to bolt in that split second, but there in the doorway was none other than the little tightrope dancer. "You came to see the animals?" she asked as she found him standing dumbfounded and lost for words. "Yeah," he replied. Before he knew it they were skipping from cage to cage while she entertained him with informative dialogue about the animals. She was very open and personable, not as cautious and shy as he was with strangers. She made him feel so much at ease that it seemed as if they knew each other for a long time. He could not help casting secret looks at her beauty. She still wore her costume, which made her look like a miniature copy of her beautiful mother.

Abruptly, Balazs asked, "How can I get a job with the circus?" "I don't know, I guess one has to be born into it. Everyone here is like me—either they are the kids of someone or they came from another circus," she replied innocently, not realizing his full drift. "No, I mean how could I, if I wanted to come to work for this circus?" asked Balazs, now a little irritated for not getting a direct answer. "No, I told you already, I never heard of anyone joining the circus unless they were born into it," snapped back the little girl, now a bit annoyed with him. Then with a light laughter as she finally realized the real meaning of his inquiry, she added, "Well, if you really want to run away with us, I would help you. You see, there are not many kids at the circus for me to play with. The other children are much older or much younger than I, so I can't even talk to them. You know what, I have an idea!"

"What?" asked Balazs so loudly that he frightened himself, lest someone overheard and would unveil their conspiracy. "What's your idea?" "Well, perhaps you could come back after everyone has gone

to sleep at your house. I will let you in the wagon while everyone here is busy dismantling the camp; my parents will be gone helping, too. You can hide in the back where I sleep and by the time they find you, we will be far away and no one can do anything about it! It will also be easier then to talking them into keeping you."

Balazs thought that sounded great, but asked, "Are you sure your parents won't mind?" The girl thought for a moment and a shadow of doubt passed across the so-far enthusiastic expression. "My parents could be persuaded by me, but I forgot about the two AVO among us! We don't exactly know who they are, but we think one of them is a clown. If they catch you, you will be in big trouble." "What do you mean?" asked a totally depressed Balazs, just when everything seemed to fall into place with the plans.

"Well, the AVO men or women were planted among us and they are everywhere, so none of us are sure who our friends are. Mom and Dad told me never to talk about what we say at home because they will be taken away to camps or tortured us as the others were in the circus last year. We just don't know who they are and it's really scary. Now my parents don't talk to anyone, because the AVO could even be their best friends. Everybody is afraid now." Balazs thought for a moment and suggested, "But maybe because I am a kid they won't notice," he said with conviction, not wanting to give up his plans. They agreed to meet later in the night.

He returned to the bright lights. The noisy performance was still in full swing. Hurriedly, he snuggled up to Paula, who reproached him for worrying Eugene, who went looking for him. Eugene returned from his search with a smile, informing Paula that he ran into the circus manager who turned out to be an old attorney colleague of his. Naturally he was denied law practice, too, for being an enemy of the people, but was allowed this new position. It lifted his spirits to have found someone from his past and class with relative good fortune.

They were all tired from the late circus night. Balazs faked again the brushing of his teeth with the dreadful-smelling pig's lard soap. He kissed and wished them goodnight. He thought for a moment of his flight and returned again to their bed-side kissing them with more

passion, not knowing when he would see them again! He felt guilty, but his excitement for a new life overcame it as he stared at the ceiling wide-eyed, awaiting the first signs of their deep sleep. Before he quietly dressed himself, he deliberately made some coughing sounds to test the depths of their sleep. There was no response, so slowly like a shadow he stole across the floor and exited the villa.

He crossed the village—passing the church on the street parallel to the main road to avoid being detected. A few solitary dogs barked in the night at undetermined noises, but he safely reached the tributary tracks where most of the circus wagons were parked. The camp was already bustling with circus people—feeding animals, dismantling equipment and anything that could be accomplished in the light of the tent. She was right—the commotion was so big that no one noticed him walking across the camp. When he worked his way to her wagon, he realized he forgot even to ask her name. Anyway, here he was.

Nervously, he looked about once more and with his heart pounding fast, reached for the handle of the door. Just as he touched it, it swung open almost hitting him in the face. She pushed the door from the inside and with her strong, athletic arm hoisted him up by his reaching hand, into the semi-dark wagon. "Hurry, what took you so long, my parents are almost back from their chores." Before he could reply she said, "My name is Ildiko, come let's hurry and go to the back of the wagon. You can hide among the clothing and go to sleep near me."

She laid down in what seemed like an open trunk with lots of linen beneath her. He burrowed under more cast-aside clothes in a bigger pile in the adjoining corner. "What is your name, runaway?" she whispered coyly. "I am sorry, it's Balazs." "Don't be sorry, it's a nice name and unusual, I never met anyone called Balazs... Goodnight." "Goodnight and thanks," he replied as he covered his body and head in the scent of dried lavender just like the type used by his grandmother. He fell asleep.

EIGHTEEN

THE END OF THE RIDE

THE HARD JOLT and the abrupt push of the locomotive as it banked, shook the sleeping occupants of the last wagon. Balazs opened his eyes in the dark but fell instantly back into deep sleep. The colorful wagons slowly and quietly pulled out of town—leaving behind only traces of trampled grass and many pleasant memories. This one night seemed to many villagers like a day of sunshine in the midst of a bleak and dreary winter.

The cabin's temperature began to rise rapidly from the bright noon sun that beat down on the metal roofs. The sweat was pouring from his temples as he slowly woke from the movement of the train and what he found to be a loud family quarrel. The sun shone brightly into the back of the wagon through the small window. He listened to the familiar clanking of the train tracks in an even regularity.

"Ildiko, you know better than to do such a thing to your parents. How many times do we have to explain that there are AVO men among us and anything that brings attention to us can endanger all of our lives!" It sounded to be what Balazs presumed was her father's voice. "But Karcsi, (pronounced, Karchi) it isn't a political thing. The little boy is just filled with fantasy for the circus like so

many children are, let him stay a while. We can make up some story that he is a visiting nephew and return him in a few days," pleaded the mother. "Yes, please, Papa," implored the little girl now that she felt she had her mother's support. Ildiko was desperate for a play-mate and eager to be part of a little adventure. After all, her days were spent as an adult filled with the rigors of daily practice with her parents and a few hours of studies, but hardly anyone to play with in her free time.

The three of them were still debating furiously as Balazs appeared in the small door of the "main everything room" of the wagon. A variety of shiny theatrical costumes hung decorating the walls. Trunks crammed with personal things under lock and key and several kerosene lamps filled the cabin. On the walls posters featured the young couple as star acrobats. A small table and a few chairs took up most of the floor space. The three of them were having a typical Hungarian breakfast of smoked sausages, rye bread, green and yellow bell peppers, with hard-boiled eggs. A small kerosene burner heated the teapot in the middle of the table, which was shooting out streams of steam like a miniature locomotive.

"So, young man, you are the runagate causing us all the fuss?" Balazs, embarrassed and feeling very guilty for not having thought this all out clearly, just stood there blushing beet red. "Yes, sir, I am sorry." He hurriedly added, "I can take the next train back to Fuzfo if you want. I am sorry, I don't want to cause you any harm by this." "Well, come on in and let's have breakfast first before we make another foolish decision," said the father as he comforted the boy with a warm and winning smile. Balazs sat by the table but did not dare to look the couple in the eye and hid in his shyness. He began filling his hungry belly with sausage and bread.

The conversation went on regarding the dangers and the chances they were taking with a runaway child. Never mind harboring one. The AVO was quite aware of the number of people in the circus and every detail about their private lives. To pretend that he was a visiting nephew could only be done for a limited amount of time before it was found to be untrue. Then what? Any bending of

the rules was punished through the sadistic AVO. Of course, all this was done in the interest of the people and the protection of the workers' paradise from the capitalistic elements trying to undermine the success of socialism.

However simple and poor their lives were, the family considered themselves lucky to be serving in a state-run circus. They received salaries from the government and by most standards they were free. They traveled throughout the land and performed often in neighboring Soviet-occupied countries. There was talk of perhaps performances in Austria in the near future.

They sat for many hours deliberating and getting to know each other. Balazs told them his life story and about his grandparents. They, in turn, told him about theirs. He liked them and the feeling seemed mutual, so soon the young couple began to entertain an approach to help him stay with the circus, since he really showed such enthusiasm and desire.

Karcsi suggested that the best way was not to hide Balazs just to be found out and punished. Better, he thought it was to ask the circus manager, whom he liked and trusted. He knew the manager could not be one of the AVO men since he was an attorney in the former regime; he could decide what to do. If he decided against the child's staying with them, Karcsi would personally take Balazs back to his grandparents and smooth things over for him.

The train pulled to a stop near a village station, where it was granted permission to park on tributary tracks. The main kitchen was communal and a circus cook prepared the two main meals of the day for everyone. This was done to avoid fires caused by cooking in the wagons. Despite the simplicity of the government-supplied provisions, Hungarian ingenuity worked its magic. Everyone ate well and the aroma of his cuisine was appreciated as it permeated the little camp. Some came to fetch the meals in stacked aluminum canteens and others brought their folding chairs to eat communally. Hungarians are very social people and love company. All the meals were accompanied by good local wines.

Karcsi invited the manager to have lunch in their wagon hoping to enhance the situation with a good bottle of Eger's Bulls Blood, a specially cherished Hungarian red wine and a rare commodity under communism. It was given to Karcsi by a government worker and admirer after a Budapest performance. He thought this to be an excellent time to pop the cork. The spectacled old man arduously and slowly pulled his portly body up the steep narrow stairs of the wagon. Jolanka (pronounced Yolanka), Karcsi's wife, set a lovely table with a bouquet of wild poppies Ildiko picked by the train tracks.

There were three wine glasses for the adults and two for the children for their homemade raspberry syrup and soda water. Balazs was hiding in the back and agreed not to come out until he was called to do so.

As the old gentleman entered the room, he wore the pleasant smile they knew him for. Graciously, as was the custom of the old days, he kissed Jolanka's hand and slightly bowed. "Well, it has been a while since we dined together; it is so nice to be here again, but why the sudden invitation?" He asked, slightly suspicious and with a faint smile at the corner of his mouth. "Karcsi, you go ahead," said Jolanka. Before he was able to proceed on his wife's passing the ball to him, the old gentleman, who noticed the five-table setting, asked, "Are we expecting another guest?" "Well, sir, this is exactly what we would like to talk to you about." So, the cat was out of the bag and within a few minutes they told him what was happening and called the frightened Balazs to come out.

Balazs was totally terrified and expected the worst, but his fears were unfounded. The old man was actually very kind and receptive. He offered Balazs the job of helping the caretakers with cleaning and feeding of the animals. After a few glasses of the good wine and delicious food, he said there was a chance to consider Balazs, if he showed any talent, to do one of the stunts. Everyone was pleased. The fear of doom was lifted. Ildiko, was so delighted to secure herself a permanent playmate that she rushed into the old man's arms and kissed his round face all over.

Thus began the happiest days of Balazs's childhood. The dreams of every child had fallen into his lap. Everyday was filled with adventure and learning. There were so many things to see, so many things to help out with, including preparations for the show and dismantling the equipment. There was also the anticipation coupled with the excitement of travel. Each town received them with much love and mostly people came bearing gifts to show their appreciation. Hungarians loved theater, arts and sports, admiring anyone who excelled in these endeavors.

Balazs was not only happy to help, but was tireless and could not be grateful enough. He offered to help wherever they would have him. One day he was allowed to help the engineer in the locomotive to shovel coal with the other man. They fed the hungry steam engine and as a reward, he was allowed to pull the lever of the train's whistle. His heart nearly burst as he stood on a ledge pulling the lever as children and grownups alike observed him while lining up near the tracks to greet the rushing circus train.

He spent the evenings with his new young family when there were no duties to perform. They made campfires at night and hung bacon on sticks letting the juicy fat drip on the fresh bread below. He sang songs with them and listened to the circus people tell great stories with much humor making everyone laugh.

As the week passed and he missed church on Sunday morning, he felt guilty thinking about how much joy he had in his life and how his grandparents must be worried over his disappearance. He decided to write a letter to comfort them and tell them not to worry. He sat at the table and began composing a letter while chewing the end of his pencil wondering just how to begin. Suddenly, he noticed the most unexpected scene from the large window of the wagon.

His grandfather was standing outside in the middle of the camp immersed in a jovial conversation with the manager of the circus! He held two little fryers, which were tied together at the legs, hanging upside-down wings apart, combs bright red with the rush of blood. The two old men, arm in arm, walked together toward his wagon as

Eugene handed the other the two chickens. Balazs could not believe his eyes! He got just about the biggest surprise of his life. He didn't know what to do, run or hide, but what difference would it make now? How was he found out, how could his grandfather know where he was and what was all that backslapping between the two old men? He felt helpless and confused.

NINETEEN

FAMILY REUNION

BALAZS MATURED faster than most children of his age—maybe because he was raised by an elderly couple who gave him much wisdom and knowledge of the world around him. He was a political child, aware and informed about conditions in Hungary and was taught by his grandparents about the democracies in the West. He understood not only in theory the differences of the totalitarian communist regime in the East but knew it by first-hand experience. The ideas of democracy he understood only in theory and as a dream, as it was for millions behind The Iron Curtain.

While the poverty deepened and Hungary sank into economic despair, likened to the times after the Turkish Wars, the Communist Party members and the privileged AVO continued to enjoy luxurious lives at the expense of the people. None of the promises of communism had been kept and by now not only the intelligentsia, but the "beloved" working class, began to see hopelessness and became disillusioned with the system. Yet, the Workers' Paradise was persistently promised to them, if they would only be more patient. However, slowly but surely, it became evident to all that the system

fed off the people, as did the feudalistic systems before in the Middle Ages with one major difference—the terror.

Under no other system was the political and ideological persecution so acute. The Soviet system not only rivaled the Nazis, but managed to surpass them. The tortures, executions, forced labor to Siberia and China were all the result of a nation unwilling to submit to Soviet imperialism. Out of fear, more and more people reported each other to the authorities. They were afraid that they were being tested by a secret member of the party and if failing to report antigovernment, "subversive" behavior, they would be the ones to suffer or languish in torture chambers.

Balazs's uncle, Eugene Jr., after his release from an "ideological correction center" where he was beat up and tortured for several years, was so destroyed mentally and emotionally, that he refused to offer any information on what happened to him. He feared that his family might suffer the same fate if the authorities found out that he talked.

Despite all of this, children, under any harsh conditions will find ways to play and find freedom; Balazs was no different. He enjoyed his short stint at the circus and the reunion with his grandfather ended in good spirits. They spent two more days at the circus together before departing for home. Eugene, knowing Balazs and the capacity of his imagination, coupled with his recent disappointments, anticipated his next step. At the circus reunion, where he encountered his former colleague, now a circus manager, Eugene revealed his suspicions of Balazs's possible flight.

They made a pact to allow it to happen; it would be a good break for Balazs considering the recent events. Eugene was to pick him up with the local government's permission at an appointed town after a week's time. The two chickens for the pot, which he saw Eugene carry, were payment for the favor. Balazs was not upset at Eugene. In fact, he saw it as a demonstration of his deep love, understanding and the humor that he kept through the worst of times.

In the middle of a sizzling hot July, Balazs was informed that he was to visit the Szabo family two towns away. The information sent

an incredible jolt through his system. He knew of his father's par-
ents' small summerhouse. In the summers, his brother, whom he
could not remember well and all the boy cousins gathered. There
was a single girl cousin, but she was much older.

It all happened so fast that before he realized it, he was on the
train with a small bundle of clothes his grandmother packed for
him. He waved to the two old people as the train pulled slowly out
of the station, all the time wondering what brought on all this
change between the families. He knew quite well how the families
disliked each other. Nonetheless, he was not really concerned, for his
desire was to meet his brother and father again.

The train now entered the grove of weeping willows, which
formed an almost perfect tunnel of foliage, blocking the ever-shrink-
ing image of his grandparents. He continued to hang out of the win-
dow examining his well-traveled landscapes from previous trips on
jumping trains. However, this time it seemed to take much longer to
reach the tunnel, which cut deep through the hill that divided the
towns at the corner of the lake. Finally, it pulled into the much
smaller, white stucco train station. The red wooden benches ran
along the front of a long row of thick honeysuckle and acacia trees.

Five cheerful boys were jumping up and down the benches wav-
ing and calling out his name. Since he was the only child getting off,
the train, there was no mistaking him to be the right one. They were
all bigger than him. There was one skinny little blond kid, kind of
introverted, who stood back from the others. Two older boys were
brothers—Csaba and Atilla—the children of Sandor's closest sister
in age, the other two each from older sisters, one called Domi and
the other from the oldest sister, Lorant.

With the backslapping and general welcoming over, the broth-
ers Barna and Balazs drifted timidly toward each other to hug and
get acquainted. Balazs felt a painful yet wonderful sensation of
belonging. One memory flashed through his mind, but it did not
have his brother's face attached to it. After the war, when the family
returned from a short escape into Austria, the bomb-damaged apart-
ment in Budapest was not repaired for several years. A bomb took

more than half off one of the corner bedrooms of the building. The ceilings in this elegant building were four meters high. Two glossy, white heavy doors were generally locked to keep everyone out of the half-existing room.

The children were strictly forbidden to go in there so, naturally, they were curious. Even adults dared not enter for fear of crashing down into the apartment below or falling to the street. Consequently, the wooden rocking horse was still in that room, because no one dared to fetch it. The children were unattended for a few seconds and they managed to make their way to the door with a large, black iron key. They were unable to reach the lock, but with the aid of a low footstool, they succeeded in unlocking the door. They pulled many old rags away from the front that were stuffed under the door to keep winter's howling cold drafts out.

They entered the bombed-out ruin of the bedroom. Balazs, then 3, and Barna, almost 5, were thrilled and excited. The snow was falling outside and in the room covering everything in it with drifts! They could see the entire avenue with the yellow streetcars and the people below. The little rocking horse was there, too, so they wasted no time brushing the snow off and mounted it immediately.

They were so engrossed in the joys of play and adventure with the novelty of the open room in snow that while wildly rocking the horse they didn't notice the edge, almost falling to their deaths three flights below. Someone from the street noticed the children and rushed to their aid by ringing the apartment's doorbell. They were saved by their mother and the stranger. They got severe spankings that neither child ever forgot.

There was one other memory of his brother that Balazs recalled vividly. The young couple was planning an evening out and as they were getting ready, the children became difficult and cranky— unwilling to part with their parents. It was past their bedtime, but they found excuses not to stay in bed. Balazs whined that he was hungry; Barna insisted on going to the bathroom for the tenth time! Their mother, Jadda, was unusually impatient and easily exasperated. Barna was standing on the edge of the bed that butted to the wall

next to the bathroom door, with his little fingers in the crack of the door. Jadda shouted at him and slammed the door, crushing his small, delicate fingers! The blood sprayed on both children. Barna wailed from pain and hung by his small fingers from the shut door, from which he was not able to free his hand.

Horrified, Sandor, entered the children's room to free Barna's crushed fingers. He was in such excruciating pain and shock that he temporarily went mute. He was only able to utter silent screams and this was the face that Balazs remembered as it was etched in his memory. Barna lost all the fingernails on that hand, but not permanently.

They ran up the hill almost a kilometer to the small summerhouse. Balazs knew the way since he had spied the town the year before in hopes of getting a glance of his brother or cousins, but his timing was always off—the kids were either at the lake or at other relatives' houses. Since this little house had only one bedroom, it wasn't subject to state confiscations—neither were the small summer homes of their cousins' parents.

On one of his afternoon adventures, Balazs was able to spy on his paternal grandparents. He saw his grandfather, a handsome but shorter man than Eugene with a full mustache, working along the raspberry patch that lined his fence. An obese, slow-moving woman approached the path from the direction of the local patisserie with her aluminum take-out lunch set. Balazs stood by the fence watching the old man inside the garden working. Upon seeing him there, the fat woman gave the intruder an unkind glance and gruffly inquired of his intentions. Balazs looked at her terrified and ran all the way back to the train station to board the next train back home.

Coming near the house with the noisy gang, he saw to his dismay, that the same mean woman who questioned his presence before, was the one now welcoming him. By some good fortune, this grandmother did not recognize him; he was greatly relieved. He gave his respectful hugs and kisses to both, but he felt no sincere emotions. They were strangers to him.

Grandpa Szabo seemed pleasant with a nice voice and the yard

he tended to was beautiful. There were roses, cosmos and other flow-ering plants. Weeping berry, cherry, apple and walnut trees complet-ed the yard. It wasn't even an eighth of the yard his grandpa Eugene had, but it was immaculate and it made him respect his grandfather. Grandma or old Kati, on the other hand, was overweight and had a screechy, sharp voice—not to mention her unpleasant body odor.

The children ran from house to house introducing Balazs to his many aunts and uncles in the Szabo clan. Though shy, he made it through all the obligatory introductions. They raided the fruit trees like locusts and ran to the lake for swims that lasted the whole day. On their return, they ate the restaurant food, which they were sent to fetch by their grandmother who did not particularly like to cook. Three days went by fast, but on the morning of the fourth day a small car pulled up to the front gate.

His heart leaped. It was his father, Sandor! He got out and tow-ered over the small Czechoslovakian car called Tatra. His radiant smile and light summer outfit made him look like a star from the West rather than an actor from poor communist Hungary. Barna jumped through the door from behind him screaming, "Dad, Mom." As Barna ran toward the car, his father came around and opened the other door facing the yard. Balazs was sure this must be Kati the "witch," the "whore" and the "evil woman" who was accused of breaking up his parents' marriage.

Sandor reached out for a slender white alabaster arm that ended in a graceful hand of clear fingernail polish. She was beautiful, with her sparkling, silky, thick, blond hair. Her cheekbones were high, her lips full yet not exaggerated, with fine contours that needed no art from a lip liner. Her chin line was gentle with a defined cut ending with a sensuous neck. Most of all, she had a perfectly straight nose—with just a slight, ever so slight, aquiline bend to it. Her green eyes, which played in the changing light, shone of intelligence and a capacity for deep thought.

By all measure, a lady—with such grace, charm and poise, the kind not taught or borrowed. It was a special, inborn quality—an inner refinement of birth that comes from the luckiest mingling of

rare and exceptional genes. She rose from the car with Sandor's help and kissed Barna, who gave her a tight, loving hug. Then she approached Balazs directly with total and unexpected openness. Not sentimental, not trying to win him, but simply with sincere warmth and genuine feeling. She reached toward him and gently stroked his head just once and said, "I have been looking forward to meeting you in person for a long time. This indeed is a special day."

Balazs was stunned by her presence and her unfathomable beauty. She seemed to him like a goddess. If it were not for her one-piece, light, flowery summer dress and sandals strapped high around her young ankles, he would have thought she floated from the sky. But no, she was real and positively the most beautiful woman he could imagine. Her voice was unexpectedly deep, somehow musically deep.

His father shook him back to reality, picked him off the ground to his height and warmly kissed him. Balazs returned the affection and felt complete—so much part of something; something he should have had from the start; his family! It was all there, all around him, yet just a taste, not really his. It belonged to his brother, but why not him? He was seized by a deep, sickening feeling; the happiness that he felt momentarily was swept away by his jealousy.

Fortunately, it had no time to linger for everyone gathered in the little house for a happy reunion of sharing tales from the city life and stage life. All the uncles and aunts arrived, as well, who admired the young couple. This was not simply because they were famous and well off, which brought hope in their hearts under such a regime, but because they were such a magnetic couple. They were well matched and full of robust, youthful life.

Kati had everyone laughing as she spoke of Sandor's recent performance. In one of Shakespeare's plays, Sandor had to stab his opponent to death. The actor's hard backward fall to the ground resulted in his releasing a loud fart. All heard it, actors on the stage and the audience. For a millisecond, there was shocked silence. Then Sandor composed himself and loudly responded, "Are you still

groaning, you swine?" And with a grand theatrical gesture stabbed the man on the ground again. He brought the house down with such uncontrollable laughter and applause that they had to start the play over six times before the audience got hold of itself.

Balazs was caught up in the audience of admirers, but Kati reached out for him to sit by her side. As the hours passed into the night, he fell asleep against her lap. After the other children retired to their homes, Sandor laid the two sleeping boys side by side, looking at his wife with wishful thinking.

TWENTY

KATI

TWO SLEEPY BOYS squinted into the bright summer morning. Waking next to each other was a new and strange feeling. However, within minutes this newly formed family gathered at the breakfast table to make plans for the day.

After their second cup of black espresso, they decided to drive to Tihany, a famous summer resort of old. This postcard-picture town was high above Lake Balaton. Built on rich, red volcanic soil, striped by blankets of green vineyards that looked like a Persian tapestry from a distance. On its summit stood a 17th-century baroque church. Its earthy, cadmium-yellow walls could be seen miles across the glittering lake. A kilometer from the church was a popular lookout. From this strategic point, people yelled or even whistled to receive one of the clearest echoes from the church walls.

He was thrilled to be riding in a private car. Not just any, but his father's! He could not help wondering how rich his father must be and with typical children's innocence he posed the question to him directly. Instead of getting a satisfactory reply, they all laughed at his inquiry. As they continued toward their destination, Sandor decided to take the scenic route which passed Fuzfo.

Balazs sat in the back seat next to Kati in the cramped little car as it puttered along the lake's one-lane deteriorating highway. Though well built before the war, the road was poorly maintained since the occupation. It looked like snails of tar left their black oil tracks behind.

Balazs was proudly pointing out all the familiar landmarks of the region, spicing his commentary with anecdotes to impress Kati with his knowledge. This was his world and with the help of jumping trains or of biking long distances on his grandmother's rickety bike, he boasted of keen familiarity of the area.

By the late morning's heat they took the turn around the bend to his town. Balazs pointed toward their villa, which stood on the hilltop protruding above the rich vegetation of healthy fruit trees and thick foliage of the weeping willows. In the distance, rolling hills glowed in soft cobalt and azure blue. Nature's paint-brush tinted this mixture and slightly mixed it in crimson and varieties of green, to challenge any French Impressionist.

The two towers were in direct sight as Sandor slowed to point out the medicinal spring with its stone cross that overlooked the vegetable garden. Below it, in the garden, bent over the soft dirt with hoe in hand, toiled a lonely figure. Balazs felt strange—looking at his grandfather as he pointed him out. It was as if he were looking at him from another world, another time. He seemed very small, lonely and far, far away. There was silence in the car for a moment that seemed eternal. The car pulled to the side of the ditch, but when Barna suggested they stop and say hello to the grandfather he didn't remember. The atmosphere turned tense. Sandor felt uneasy and Balazs was gripped with a sense of guilt watching Eugene at a distance—all by himself, working hard as usual. He turned to Sandor, who suddenly looked terrified.

The noon train came rumbling around the corner like a black devil pounding the rails, shaking the earth and spewing a black steam of soot. In the little church, the boy appointed to assist the priest was bouncing up and down on the rope to toll the heavy bronze bell. The altar boy had to pull with his entire weight in order

to wrestle the rope to the ground. With the return of the pendulum, the bell would swing him high into the air.

Eugene heard the sound of the train and the church bell converging—slowly, he straightened his stiff back. Sweat poured from his forehead to his eyebrow and into his eyes stinging them a little. He reached for his white lavender scented handkerchief in his back pocket and wiped the perspiration from his eyes and face. Removed his pocket watch from his vest and with a satisfied look that everything was in order, glanced toward the train. He observed, a small, gray Czechoslovakian sedan challenge a race with the steam engine. A strange sensation passed through him. Something inside him stirred; he looked around, but saw nothing out of order. The strange feeling subsided as fast as it came. He used his hoe like a staff to support his weight as he made his slow progress up the hill to Paula's kitchen of inviting aromas.

To avoid the tense moment, Sandor suggested to race the train. Both boys screamed with delight, distracted and engaged in the challenge cheered their little car on. The tracks that ran parallel to the road for many kilometers offered them a long race; sometimes the train, sometimes the car would take the lead. They blew the horn to get the attention of the smiling conductor and engineer who waved back playfully at the excited occupants in the little gray car.

At breakfast the next morning, Kati sat by Balazs in the small hotel restaurant. Her perfume brushed his face whenever the morning breeze changed direction. She was very curious about Eugene and Paula and asked many questions. It pleased Balazs to talk about his grandparents whom he loved. Kati was genuinely interested about the feelings and depth of people. Same with Balazs, who was an introverted and reflective child. What pleased him most was the fact that Kati spoke to him on his level and valued his opinions on things as if he were an adult. After a short while, they discovered their similar childhoods and were lost in a deep conversation.

Kati's mother, Eta, a petite brunette with a fiery personality, was also an actress. Many years ago she fell in love and married a young

Jewish aristocrat. This affluent gentleman traveled Europe frequently with Eta, which led to Kati's birth in Abazia, a small Italian resort town. The marriage did not work out and as a child of three, just like Balazs, she was taken to her grandmother in the small town of Oroshaza, situated in the Hungarian prairie. She grew up in poverty, but like Balazs, she was loved and surrounded by farm animals and nature.

Her actress mother, who was the sole support for her daughter, worked in far away theatres and could seldom visit her daughter. Kati's grandfather committed suicide long ago and her step-grandfather abandoned his wife and Kati for America. In her teens, Kati went to the city of Gyor to live with her mother, who had remarried. This time it was the director of the theater she performed in. This gentleman, Rado, Lazslo, also Jewish, loved Kati and treated her as if she were his own.

Naturally the theater became her life and blood. By age 16, she began starring in films and became successful. Her arranged marriage to a young chemist and owner of his own drugstore was looked upon as a suitable match by the standards of the times. Society did not take artists of any kind seriously, no matter how successful and renowned. She was forced to live under the same roof with her mother-in-law, who was disdainful and jealous of her.

When Kati was pregnant, the woman forced her to sleep in the hallway on a cot, because she said her pregnancy disgusted her! Both of her pregnancies ended in stillborn birth. Years after their divorce, there was strong evidence that her husband administering questionable medications caused her to lose the babies. The two boys she lost, were born coincidentally, in the same year and months as Sandor's two children.

After her failed marriage, disillusioned, Kati returned to the theatre totally consumed by her work. She finally met and fell in love with a young man. The Count, Cziraky. A dandy and sweetheart of the Hungarian and Austrian society. He was a few years younger than Kati. Thereafter, her life changed considerably. Although she

continued her theatrical appearances, she now lived in elegant grand residences in Budapest also in the mansion at Lake Velence, a short car ride from the capitol.

Hundreds of servants maintained the properties, stables and residences. They hitched up her own set of white stallions to the family carriage, which were presented to her as a gift (one of many lavished on her). Kati entered the life of the cultured and the elegant. With her fame as an actress—she had it all. Certainly, great material for movies!

Second World War broke out and was followed by communism which was like a tornado that swept the land barren of everything. The Count lost everything in the confiscations and ended in jail for life, proclaimed as the enemy of the people. Cziraki later escaped from jail and settled in Canada. Kati told Balazs incredible stories about how the servants helped to bury valuables from the communists before they took everything from the mansions. Unfortunately, the loyal servants stole all of it later.

TWENTY ONE

THIEF

THE FEW DAYS went by faster than any of them would have liked. Kati and Sandor returned to Budapest. Barna stayed on in Akarattya to spend the rest of the summer as usual. Balazs was to stay a few more days, but even though he enjoyed the visit with his brother the guilt of leaving his grandparents was too strong. He told Sandor's parents that he wished to return home. To his surprise, old Kati, Sandor's mother offered to accompany him home. Balazs, who was aware of the ongoing conflict between the two families, strongly protested. He knew how much Eugene disliked his in-laws. So, he told her that he was familiar with the trains and would not mind going alone, but she was insistent.

The next morning, after hugging his brother goodbye, the two of them boarded the train. Their grandmother took much longer to board. Two station managers struggled with her huge weight and pushed from behind as she mounted the stairs. She got this special attention strictly from the accomplishments and fame of her son. They respectfully called her the mother of the "Maestro."

Balazs was looking forward to coming home to Fuzfo. But with old Kati with him, he worried about the intrusion on his grandparents'

privacy. He was protective of the two and wanted no harm to come to them. They were the center of his world and he loved them deeply.

When the awkward moment arrived with old Kati's entrance to the villa, Balazs felt bad and was apologetic. He tried to convey to Paula that this was not his idea. Eugene was visibly sick to his stomach, but Paula true to her tactful and amiable character made every effort to welcome this visitor. With civility mingled undoubtedly with feminine curiosity, a dimension and talent many men lack, she began her diplomacy…

Balazs and Eugene freed themselves from the strained atmosphere by pretending to do chores outside. Paula, a wonderful hostess, put out some cookies and pastries on the table (despite the shortages). Old Kati, a sweetaholic, wasted no time sampling the sweets. The two then entered into a strategic conversation of trivia cloaked and loaded with interpretable meanings only women's complex minds are capable of—no doubt a foreign language as far as men are concerned.

After a little while, Eugene asked Balazs to go and check on the two ladies in the house. He used the excuse of bringing in their hen's freshly laid eggs, which he placed in the usual basket of the sunny veranda table. The ladies seemed fine as they chatted about the prices of things and the many hardships of the present-day life. Wishing back the good old days.

Paula left to fetch some more tea from the kitchen and Balazs was on his way back to report to Eugene. On his way out, he glanced over his shoulder. He was shocked to see the heavy, slow-footed, old woman swiftly getting to her feet. She reached toward the eggs in the basket like a fox in a chicken coop! She filled her blue apron quickly with the freshly laid eggs and returned to her chair as if nothing had happened. She was unaware that Balazs saw what she did. Balazs, of course, could not believe what he just witnessed.

This shameless woman, who received a handsome monthly stipend from her successful son and who lived every way more affluently and securely than his grandparents, actually stole freshly laid eggs! From the poor Eugene and Paula! He returned to the garden where Eugene was—sitting under an apple tree smoking his self-rolled cigarettes. Balazs decided not to say anything about it.

The time arrived when old Kati had to make her slow trek to the train station. Balazs decided to say goodbye and thank her for her hospitality. With Eugene and Paula standing by, he ran into the arms of old Kati surprising her with a hug as fierce as he could muster. Pressing against her tremendous bulging stomach, where he knew the eggs were. Her apron containing the loot crunched under the pressure applied to them. The yellow yokes popped. They squirted and oozed in every direction. The apron went limp and wet.

Balazs looked with great satisfaction into the face of the greedy old woman as he dealt out the final strokes of his loving goodbyes! Unveiled, embarrassed and angry, Grandma Kati, was lost for words. She spun about and with what seemed like wings of youth she flew down toward the station. In the distance, they saw the her liberating herself from the puckish apron, which she angrily discarded into a nearby ditch.

TWENTY TWO

STALIN IS DEAD

NO ONE FELT safe and everyone was isolated from their closest friends. Rumors of disappearances continued to sweep the country and everyone lived in fear. The old couple turned the lights out and huddled in silent fear of the darkness that engulfed their lives and the country's. Few families were left in Fuzfo, of their generation and their class—all now expecting their turn of deportation. Across the street lived a family who, like them, were middle class and successful in the previous regime. They had two boys. These friends often came to join Eugene and Paula for some nights of bridge and hushed political discussions. It was a small support system for both families.

One morning, Balazs ran to the house to play with the boys. As he rushed through the already open door, he found himself in an absolutely empty space—void of furniture and all. Balazs stood bewildered and saw what looked like a hurriedly abandoned house; a strange chill went through his body. Spooked he ran in panic to his grandparents, who froze upon hearing Balazs's discovery. They hugged each other tightly, surrounding Balazs as if the invisible and the inevitable danger were to befall them right then.

Finally, Paula spoke in a whisper, "My God, Eugene, are we

next?" He was asked to stay in sight of them and not to go anywhere. No matter what they did, every sound and every gust of wind brought shivers of fear through them. They felt vulnerable and helpless—waiting for something that no one could prepare for. "They" come and take you away! That's it! Then without a trace you are gone, no one ever hears from you again!

On sleepless nights, Eugene and Paula tried to strategize. What should Balazs know and "never forget" in case they were separated. It all became a muddle in his frightened mind as the panic sank in with images of being taken away from his grandparents. That night no one came with the feared knock. Balazs remembered from reading Hungarian history how the Turks had captured and enslaved Hungarian children. Took them back to Turkey and trained them into "Janicsars" warriors. They converted them to Islam and raised them in camps to be the fiercest fighters—marching them back to fight against their own people, the Hungarians!

The next morning, Balazs cautiously peered into the yard through the shutters of the bedroom. The garden clear of danger was empty save for the chickens scratching and pecking invisible things out of the dirt. After the morning sip of tea and usual hugs, despite the warnings from his grandparents, his curiosity got the better of him. He headed toward the empty house. He imagined all the tortures and beatings his friends must be enduring somewhere, perhaps in Russia.

As he took a second look across the street, he could not believe his eyes. He literally had to rub them to look again. The neighbors' yard was not empty. There were two little girls playing—screaming and chasing each other with laughter and shrills.

The house was alive once again—as if nothing had changed. But something had. There was this strange family living there now as if they belonged there.

A tall, robust young woman appeared in the doorway calling for the girls to come in for hot chocolate. When she saw Balazs's face plastered to the iron gate of his yard, she called out to him with a familiar grin. "Hey, Balazs, you can come for hot chocolate, too, if

you want." Balazs while spying felt unveiled. Too confused by her calling him by name forgot his fear in his surprise and obliged.

He found himself in what was his friends' house before —then an empty space yesterday, now filled with the smells of good cooking in the warm kitchen and with complete furnishings in every room. He stood there dumbfounded, drinking "real hot chocolate" for the first time. The girls sat at the kitchen table beaming with smiles and waiting for him to join them; a baby boy was in the next room. He did not dare ask any questions and no one offered explanation. The woman's husband, a tall, good-looking man, came in, smiled at Balazs then went about his chores. The mother happily chatted with the girls and talked to Balazs, like someone who had known him and his family for years. He could hardly wait to tear himself away, run home and tell his grandparents all this incredible news. It made him quite dizzy. After he laid out all the details to the worried couple, Balazs was told the terrible news.

The new family, they told him, was most likely planted by the communists and they were probably Party members themselves! That was why they knew everything about Balazs and the old couple. They were also the ones who probably destroyed the lives of the family that lived there before them. Balazs understood now why there was such an abundance of food. Sugar hot chocolate and who knows what else that he had not seen in anybody's house in town before. They were informants! They were there to spy on people. He was completely trained about what to say and what not to say. Eugene hid his short-wave radio again in another secret place lest he was reported for it. In anticipation of a future surprise visit from the new government informants. Eugene combed their entire living space for any incriminating clues.

Eugene and Paula had not invited the priest to the usual Sunday luncheons; they were afraid of the consequences. They felt grateful just to be allowed to stay in the one room of their villa. They protected Balazs with every ounce of their strength and cunning. He was the very center of their lives. For the past six years, one purpose alone kept them sane—the welfare of their grandson. During

moments of their deepest fears, they exchanged glances. Seeing their grandchild renewed their strength to face another day in an existence of terror.

One gray dreary day, the local drummer shocked the small group of people waiting for the daily communist propaganda. He had big news to announce—Stalin is dead! As if an enormous burden had lifted from the group, they straightened up to hear it over, again and again. Either they could not believe their ears or they could not get enough of the good, most welcome news. It seemed as if an eclipse of freedom under a black decade had been lifted. The emotions were felt unanimously across the land. Over the borders in four directions of the globe. The world was liberated from a ruthless dictator—it reminded them of the same feeling they had when the news of Hitler's death was announced.

What would follow next was not a concern, because life could only be better than what they already endured. A sense of hope like a tiny seed sprouted which was felt by all those who suffered under this regime. Paula and Eugene immediately contacted their friends in town to verify the news and rejoice with them. The country was in an invisible wave of positive emotion that no one dared to express in public—only in the most trusted circles of devoted friends.

The communists of the Soviet Union and in the rest of the Eastern Block countries prepared for an international mourning in homage of "the loss of our great comrade." Black flags draped every building and every photo of Stalin on classroom walls. All places of work were decorated with black ribbons. There was news, that his body would be preserved and placed into the mausoleum on the Red Square in Moscow. Next to their great leader Lenin, the very one he murdered. Thousands of brainwashed Russians who benefited and became the privileged class through the party came to view his body. A hysteria swept the ruling class of the Soviet Union. Meanwhile a new leader was already chosen by the Politburo—a man of "peasant birth" who many hoped would be moderate and less sadistic than his predecessor.

TWENTY THREE

JADDA RECLAIMS HER SON

EUGENE AND PAULA continued to struggle through the six years they had Balazs. Even with the changes and the release of some political prisoners from the Gulags of Siberia, all real hopes for the future of Hungary were nonexistent. The eight-year promise at Yalta was a lie for certain. The Soviets were well entrenched and continued to rob the country of all its resources.

One of their ingenious ways was to remove the raw materials from Hungary and take it to the Soviet Union "free of charge." Also-called free service from the comrades of the Soviet brothers was the manufacturing of agricultural equipment and trucks from these raw materials, which they sold back to the Hungarian government at premium gouging prices. Most of these machines were poorly built and not functional. However, Hungary was only allowed to purchase Soviet-made products. Throughout the years these things piled up in rusty heaps abandoned industrial dumps and were a total loss to the Hungarian economy.

Before Stalin's death, the Cold War had reached its height between the USA and the Soviet Union. Stalin felt powerful with his

possession of the secrets of the Atomic bomb. He played a direct role in the Korean War to weaken the United States and spread communism. Unbeknownst to the American Air Force until later, it was the Soviet Air Force that they encountered in the skies over Korea.

The great blunders of the questionable leadership of FDR sealed the lives of millions behind the Iron Curtain after the war. Stalin was totally successful in infiltrating FDR's presidency with spies both American-born and Soviet, either through their mercenary greed or their incredible stupidity and gullibility regarding the benefits of communism. For that reason FDR became the laughing stock of the noncommunist population behind the Iron Curtain. Now the Soviets were openly hailing their KGB-reared babies—Julius and Ethel Rosenberg—and hundreds of their associates as heroes of their cause. They named boulevards in their honor throughout the land and arranged forced, much publicized protest marches on their behalf against America, through all Russian-occupied countries and in Russia itself. These protests were aired worldwide and believed as legitimate!

Meanwhile, the media and the American pseudo-intellectuals were busy sympathizing and protecting these traitors in the USA who sided with the communists. The very people who enjoyed and prospered in the free U.S. system, worked toward its demise. They attacked to destroy Senator Joseph McCarthy, an American patriot who sacrificed his career, life, and family to defend the country by warning the American people of the great dangers of communism. It was incredible how Eugene and the small group of his friends, despite the lack of free world news media, were able to piece together a very clear picture of what was going on in the USA and the West. They worried for the survival of democracy. They were glad when FDR was gone, too. From the beginning, the American leaders would not listen to Churchill's warnings regarding the dangers of trusting Stalin and the consequences resulted in the Cold War that followed. So, things became bleaker and bleaker for the future of Hungary.

The income from making artistic lampshades was indeed small. They had their chickens and every three years they slaughtered a pig with the neighbors' help. Balazs's shoes still had to be cut out to give space for his growing feet. He suffered them through the cold months. Eugene labored in his small vegetable garden with help from Balazs and tended to the fruit trees. They added beast corn for animal feed. After an incident with a fox that took some chickens and killed many they erected a small knoll out of mud and hay with a solid door to it.

Eugene's older son survived the prison and was released. A broken man, he went back to his family in Budapest. He and his pediatri- cian wife now worked for the government like everyone in the country. Despite their small incomes and their additional third child, they managed to send some money every month to Eugene and Paula; so did their younger son whose wife suffered from tuberculosis and was unable to work. Balazs's mother, Jadda, had a job in an architectural firm but claimed to have no money left. She lied to Eugene and Paula that she was not receiving alimony or child support, so she was off the hook as everyone felt sorry for her.

The law had changed regarding the payments which Balazs's mother was allegedly not receiving. Parents who did not have children living with them became ineligible to collect. In fear of losing that money, which she actually was receiving all along, she was forced to move her son into her carefree, single lifestyle. She made arrangements and miraculously got married overnight to an engineer some years younger. Jadda then appeared at her parents' door-step and without warning tore her son from their lives, just as abruptly as she dumped him there years ago.

Before Balazs knew it, he was being hurriedly ushered onto the train for Budapest—with hardly a moment to bid his grandparents goodbye. He hugged Paula and Eugene who, stood next to him lovingly running his fingers through Balazs's hair. Eugene was unable to contain his emotions and allowed his tears run freely down his cheeks into his white, bristly mustache.

Hanging out the train window, Balazs etched into his heart and mind the two loving figures, who nurtured him through the most painful period of his childhood. He never imagined his life without them, never for a moment would this sad and unexpected separation occurred to him. The whistle blew three times as the train huffed and puffed. The wheels began to roll on the iron tracks. Clouds of white steam blew from the sides of the locomotive engulfing and erasing his grandparents from the scene.

They stood there lost and broken, torn from the most precious reason to carry on their struggle.

As the train sped into the distance, Balazs felt a heavy pain in his heart and a sense of emptiness. This woman, his mother, was practically a stranger to him. Her visits were rare, but always included the company of some strange, male friend, never allowing them time to bond. Balazs did not feel comfortable in getting consolation from Jadda, so he continued to glanced out into the familiar landscape which was rapidly vanishing with every passing moment.

When he finally wiped his tears, he sat back onto the old, green leather seat and starred at the familiar filthy, oily floor of the cabin.

Next to his, stretched his mother's long, exquisitely shaped legs and as usual, fitted with expensive honey-colored silk stockings from the black- markets of Budapest. He coiled from the thought of his beloved grandparents, wearing more than 40 years old clothes, mended over and over. Eugene's sweet image in his old Austrian hunting britches and hundred-times resoled boots flashed through his mind. Balazs tried to hold his breath to prevent inhaling her expensive and stifling, perfume. Slowly he found consolation with thoughts of Budapest where he could be near his father and Kati, his stepmother.

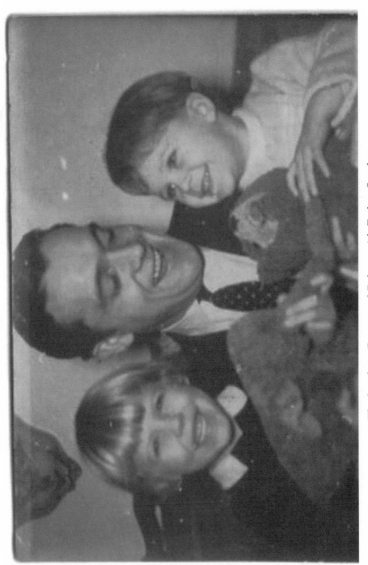

The brothers Barna and Balazs with Father Sandor, (taken in 1946 before their separation).

Paula and Eugene.

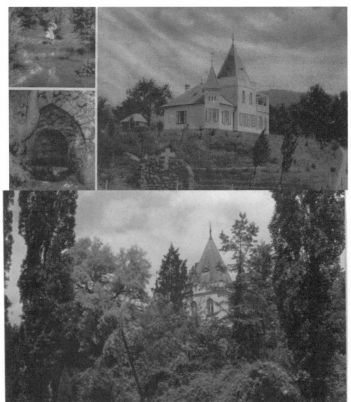

Eugene and Paula's villa and nearby healing spring in 1930.
The villa in 1948 with full vegetation.

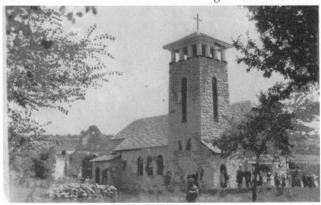

The church at Balatonfuzfo, established by Eugene and Paula
In the background stand the ruins of the original church,
destroyed in 1520 by the Turks.

Balazs at his First Communion with Father Lajos at center at the church in Balatonfuzfo.

Balazs with brother Barna and Kati, whom
he met for the first time on this occasion in 1950.

Balazs, age ten at the shores of Lake Balaton in 1953.

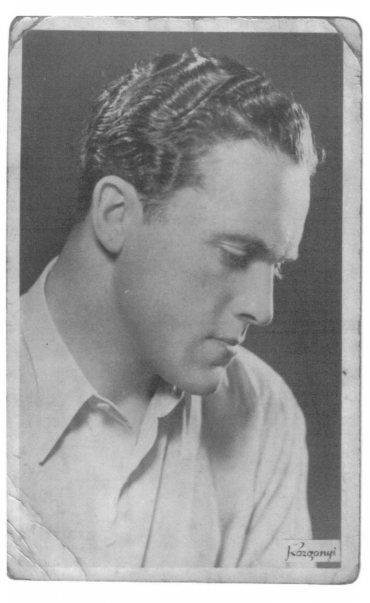

Sandor in Budapest in 1938.

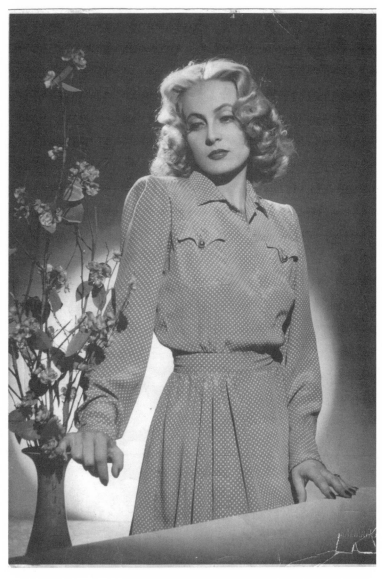

Kati was as popular and in
demand onstage as Sandor. Taken in 1950.

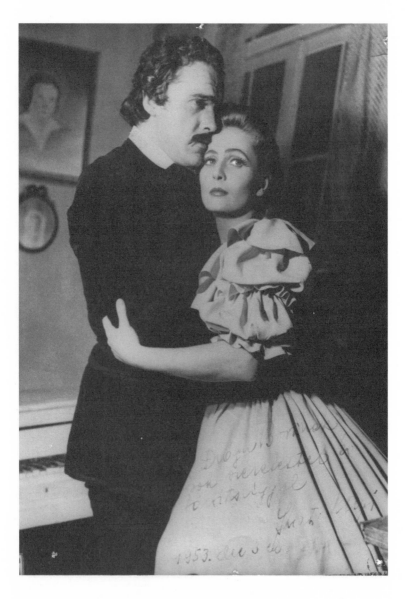

Sandor and Kati onstage together in 1953.

Kati, 1951

A room filled with antiques at Sandor and Kati's Budapest apartment.

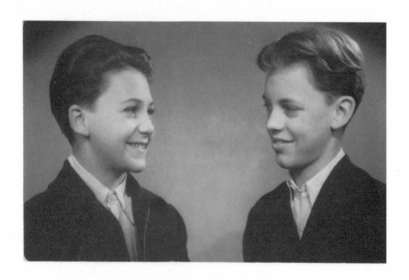

The brothers Balazs and Barna 1955.

Eugena with Balazs, Jadda, Barna, and Sandor, at Eugene's home in
Budapest before the communist confiscation.
Unidentified child in the foreground.

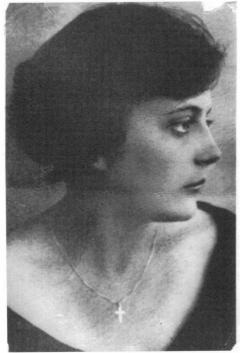

Eta, Kati's mom also a celebrated actress. (Taken in 1930)

Sandor as the prince in Shakespeare's *Hamlet*.

Sandor, a classical actor and recipient of the famous Kossuth
Award, in Rostand's *Cyrano de Bergerac* in 1955.

Balazs on a Russian tank, captured by the freedom fighters (1956) Photo courtesy of Mr. Laszlo Papp.

The avenues of Budapest littered with the ruins of Soviet tanks and armored vehicles, destroyed by the freedom fighters in 1956. Photo courtesy of Mr. Laszlo Papp.

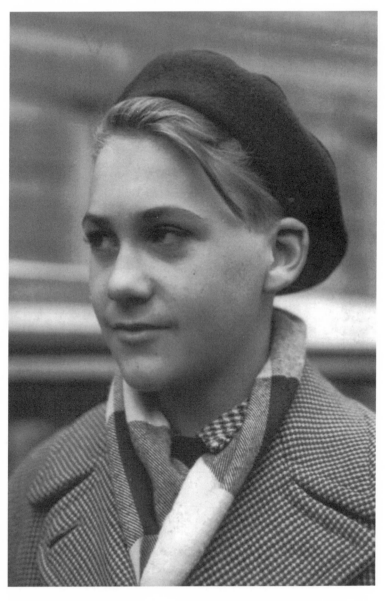

Balazs, reunited with his family in Vienna 1956.
Photo by Sandor Schwartz

TWENTY FOUR

CITY LIFE

LATE AT NIGHT they arrived at the South Station, then took a cab. He held onto his small luggage containing a few personal things. Balazs would have rather brought his cat Cindra along, but knowing full well that the city life for a country cat would have been its death, as it might be for him, he abandoned the idea.

Budapest was a dark, gloomy city ever since the communists became the custodians of this once bright capital, the last bastion of Western culture. It was likened to and nicknamed "little Paris" before the war for its gaiety and nightlife. The silhouette of the king's castle on the west bank loomed darkly against the clear, night sky. Beneath it, Balazs saw the well-lit monument of socialist realism. A tumult of workers, with rolled-up shirtsleeves, rushed forward into some imaginary wind, hammers and flags in their powerful grasps representing the false aspirations and idealization of Socialist collectivization.

Their cab continued its route on the West bank of the Danube, passing two bridges and an ancient Turkish bath built by the Sultan Suleiman, The Magnificent (one of many the Sultan built in Budapest). After more than 400 years, the baths were still in use. At

the foot of the waterfall and the statue of St. Gellert was the third bridge, the Elizabeth, named after an Hungarian queen. Bombed during the war, it was still partially submerged in the currents of the Danube. Its wreck, with its ornate, twisted metal, looked like a modern sculpture. This side of the rocky hill of Kelenhegy, above the ruins of the submerged bridge, stood a dark, unlit bronze figure holding a small cross in his right hand toward the city.

The cross, of course, was and is an important symbol of Christianity, which the country embraced through the efforts of St. Stephen. After his death, there was chaos and confusion, including the question of succession. The German-Roman Emperor, who long wanted to subdue Hungary, helped Peter, the king's half Italian nephew and the heir to the throne, who was unable to rule without German support. He humbly knelt before the Emperor and pledged his whole-hearted allegiance.

Hungarians were infuriated by Peter's declaration of loyalty and openly rebelled—provoking a pagan uprising as well. Pagan rebels, believing that the country's problems were caused by foreign influences, began detesting all foreigners and Christians. One casualty was the saintly and loved bishop, Gerard. The rebels captured him and put him in a barrel pierced with stakes—nailed it shut and rolled him down the steep hill called Kelenhegy. Later in history he was canonized and renamed St. Gellert. Many considered it a miracle that the Soviets did not demolish this statue with the cross in his hand.

The dome-shaped roof of the great Art Nouveau architecture of the Hotel Gellert nestled against the hill of Buda. At a distance, the somber sound of a solo Gypsy violin could be heard from its presently run-down and shabbily furnished riverfront restaurant. This 100-year-old, world-famous architectural work of art boasted the world's first artificial wave pool; also the world's first almost Olympic-size "champagne" pool, a precursor to whirlpools. Designed in the 19th century, it had hot Turkish baths, separate for women and men, offering massages and medicinal baths, which were fed by natural geysers beneath the city. The pools inside and outside were exquisitely decorated in the styles of the times.

Throughout the land and especially concentrated in Budapest, there were many such ancient baths built by the Romans before the Hun- Magyar occupation of Pannonia, a Roman province at the time. Later in the 16th century, during the 150 years of the occupying Ottoman Empire, baths and minarets were built while constantly fighting and converting the resisting Hungarians to Islam in order to gain access to Western Europe.

Two blocks down from this great edifice, the cab pulled over to an ornate, large, hand wrought-iron gate. Jadda paid the cab and together they hauled up five flights of stairs (the elevator had not worked for years). She rang the doorbell that was deafening even from the outside of the hall way. An old, skinny, hook-nosed lady's face appeared in the safety of the window's frame. After a few clicks, the door quietly opened to a dim, long hallway.

There was a strong, trapped smell of long-ago fried onions reminding Balazs that he had not eaten and was famished.

The hallway led to an old-style, elegant living room typical of the gentry. An exquisite crystal chandelier (somehow saved from government confiscations) hung in the midst of Biedermeier furniture untouched by age and wars. The dining table was set with ornamental silverware. The heavy and decoratively carved, crystal glasses, water decanters were surrounded by the finest hand painted Herend china.

Balazs only heard of such beautiful things from his grandmother Paula, whose entire possessions were confiscated and distributed among the legal Communist Party looters after the war. The old woman reminded Balazs of the lady who took in the little elephant Babar, in the story "Babar The Elephant." She greeted them with reserved warmth. The door to one of many bedrooms opened and a handsome young man in his early 30s came out. With a smile, he announced himself as Balazs's new dad and hugged Jadda flirtatiously. This was completely the wrong beginning, Balazs thought, but he let it slide because of the young man's sincere warmth and candor.

Balazs noticed a peculiar relationship between the elderly mother and her son. Even though all three shared the one room—Jadda,

her husband and Balazs—the mother insisted every night to hot iron the sheets in the bed for her "only" son before he retired. Balazs was spoiled by his grandmother, but he never saw anything so ridiculous in his life as this and felt sorry for the man.

Several other tenants lived in the apartment. There was a government ruling on a determined number of bedrooms—if the original owners of the intelligentsia had not been deported yet, they had to allow government-assigned families to move in. Decidedly these families were hostile working-class people already prejudiced against the upper classes. They were brainwashed by the propaganda machine—convinced that they were the rightful owners of the people's democracy and everything that was in it even if they had not earned it as the previous owners most certainly had.

The next morning he was glad to find out that Jadda's brother, his wife and their two daughters (the family Eugene saved from the Nazis) lived across the hall. One of the girls was older than he and the other younger. The older girl resembled the father's family in complexion, but the younger was a little dark Sephardic beauty looking like her olive-skinned, stunning Jewish mother. He played with them on many of their visits in the summers at his grandparents' home.

Soon, Jadda's marriage fell apart. She was offered to share her aunt Eugena's apartment. Paula's sister who lived near the East Train station on the Pest side of town, facing the largest animal hospital built before the war.

TWENTY FIVE

EUGENA

THIS APARTMENT building consisted of three flights of stairs, with Eugena's apartment on the second floor. She shared it with her half-sister Brigita whose drunkard husband, a former history teacher (a bad "kader") now assigned to the coal mines. He would come home from the pubs at nightly and beat Brigita senseless. Balazs hated hearing the screaming and the sounds of the thuds and blows on Brigita's frail body. This building shared a courtyard with another identical building, but was divided by a high wall. A large chestnut tree grew next to the wall and reached all the way to the rooftops. In the hot summer it provided a green, thick canopy against the hot sun. The branches were a haven for many species of birds, which kept the courtyard echoing with lively songs.

Eugena was a petite, lovely woman, with a round face of goodness. She radiated the same sweetness and sharp intelligence of her older sister Paula. College-educated and liberated, she taught art at the Fine Arts Academy of Budapest, while Paula taught at the school of philosophy before the war. Now the government forced her into retirement and re-evaluated what would have been her legitimate retirement income to a level of starvation. This was part of the

communists' plan to starve out the intelligentsia. Having Jadda there with her son now helped her a little.

There were three bedrooms. Jadda and Balazs stayed in one room using Eugena's furniture, sharing one bed. Next to them was the room that used to be the living room, which they now had to cross to get to the hallway. Eugena slept here among giant, beautiful tropical plants she tended for more than 25 years and through the war. Her beautiful watercolors decorated the walls. Some of them were painted in Hungary and some during her travels and schooling abroad in Italy before the war. The forth room, was naturally occupied by a government-appointed person, another in-plant. Next to it was Brigita's bedroom.

All seven people shared the facilities—one toilet, one kitchen and one bathroom. The hot water for the bath came from a wood-burning stove with a water tank in it. (Balazs loved this luxury, because they had no bathtub on their side of the house at Lake Balaton.) When the water was heated in this boiler the bathroom also became hot as a sauna.

Eugena was formally introduced to a young Japanese student living in Budapest. He finished his studies at the university and became as fluent in her language as any native Hungarian. He remained in Hungary beyond his language studies to soak up the culture as well. He fell in love with Eugena, because she reminded him of the petite Japanese girls back home. She was shy and had the tiniest and most beautifully shaped hands and feet.

Her unusual talent in painting impressed him as well. His visits or "calls" at the parental home were always restricted. Tea was served and the chaperones were never beyond earshot of the young couple's whispers. On every occasion, Imaoka Iushiro would show up with a white lily no matter what the season. Their passion grew as the years passed.

Unfortunately, Imaoka was called back to Tokyo at the beginning of World War I. He braved to ask Eugena's parents for her hand in marriage and their departure to Japan. The heartbreaking decision of her parents, to allow their marriage only with the condition that

Imaoka remained in Hungary, hit both of them hard. They were loyal children to their own culture, respecting parental decisions, but did not abandon their love. Imaoka left, but vowed to return and live with her in Budapest. The collection of 30 some years of love letters was tenderly stored in a drawer.

Imaoka, who became stranded in Japan with the events of history, was forced to remain in Tokyo. He eventually gained the position of Director of International Studies division at Tokyo University. He married, had two daughters and yet remained faithfully in love with Eugena. She did the same thing—married a young man of breeding her family arranged for her— like in the Japanese tradition—so it was in old Europe.

After an uneventful but respectable 20-year marriage, Eugena's husband died. Childless and a widow, she tried to carry on and survive the difficult war years. Meanwhile, in Japan, Imaoka was busy translating the Hungarian classics to his own and completed the first concise Japanese-Hungarian dictionary. His wife also passed away leaving him with two daughters. Through the years, of his marriage Imaoka continued his intense correspondence with Eugena. Now, with both spouses dead, they could communicate guilt free— although Eugena was concerned. Receiving letters from a foreign country, she feared the communists would accuse her of collaboration with the enemy and awaited the "knock in the night."

Balazs and Eugena became very close and spent much time painting together. They read the letters from Imaoka and the beautiful love poems he composed for her. When Balazs needed help with school, Eugena was there to assist him. Balazs found school in the big city more challenging. His classmates were very self-assured and felt superior; the teachers were more intimidating. In the larger classrooms learning was more difficult. Eugena proved to be a big help with his schoolwork.

Jadda wasn't dependable. She was preoccupied with dating and wasn't around much. When she did come home, Eugena and Balazs had to leave the apartment to sit out the "visits" at very cheap news

theatres. (The government knew that many people had no heat in the winter and were forced to sit in the 24-hour movie theatres all day just to stay warm. They were a captive audience of the Soviet propaganda machine. These theatres projected ongoing "documentaries" of the Soviet Army defeating the Nazis and liberating Europe without ever mentioning the Allies. They also fabricated films of American capitalists torturing blacks and using them as guinea pigs for scientific experiments.)

Because Jadda was always on the go, the two never bonded. She was impeccably made up and had "good" clothes, relatively speaking for the times. She always had expensive French perfumes, silk stockings, French lipstick, none of which were available or affordable for the public. These items were still only in special stores reserved for Communist Party members and their families who were the only ones allowed to travel out of the Iron Curtain. Ironically, they were the ones supplying the black markets at home. The country was filled with "off limit" stores where only Party members were allowed to shop, but they could only shop with U.S. dollars! If non- Party members were caught with currency other than Hungarian Forints, they were arrested and never seen again.

Jadda's temper was incendiary and her hands even quicker. She slapped Balazs frequently, back-handed across his face at the slightest provocation. Many times Eugena had to jump between them to prevent these physical outbursts, which were totally alien to him. His grandparents, were kind, loving people; they never laid a hand on him. To him, Jadda's presence always meant unpredictable attacks of violence.

TWENTY SIX

SANDOR IS DEPORTED

BALAZS WAS LEARNING to adjust to city life filled with diverse new experiences. But his heart was still in the country. He missed the natural rhythm of life—the closeness and communion with nature. He knew the names of all the plants and flowers around him and understood animals, wild or domestic. He missed seeing the vast lake at the crack of dawn and at sunset.

Now a city resident, he had to remember street and boulevard names and which streetcar went where. He had to acquaint himself with all the tall structures and many historic places.

Today on his return from school, the scent of "poverty soup" (as Eugene called it) was in the air of the gangway. Times were harder for the city folks who depended on supplies from the inefficient collective farms of Workers' Paradise. So it was, too, for this little family as they settled down to their meal with caraway seed soup. The soup was simply hot water, onions, and boiled seeds of caraway seasoned with salt. They ate this for three days in a row at three meals accompanied by some Hungarian bread.

Balazs remembered that Eugene always tried to humor him while having trouble forcing it down himself. He used to say that it

would cleanse everyone's colons and medical researchers one day will discover that it prevents cancers and prolongs life. Today it went down easy for Balazs because he knew that finally his father prevailed over his mother's stubbornness about letting him visit. The law had a provision that he was to see his father regularly, but Jadda always invented some excuse for him not being able to make it there. Finally the threat of not getting child support from Sandor worked.

This was the first time since his move to Budapest that Balazs was allowed to visit his father and stepmother Kati. Up to 1950 from the end of the war, Sandor was a very successful young star even in the new Regime. He filled the theatres of Budapest whenever he played. His brilliance, energy and charm drew the depressed city dwellers to his performances. In 1950 the Communist Party saw the opportunity and put tremendous pressure on him to join the Party to set an example for the people in supporting communism. He declined using his art as an excuse not to meddle in politics.

"Look," he said finally to the Party delegation, "I don't meddle in politics and you don't meddle in the arts because I know more about my art. You know more about your politics." "You are totally right," replied the Party member. The next day, Sandor and his family were deported to a small, artistically insignificant city at the other end of Hungary. All their belongings were confiscated. Sandor and Kati took their small son Barna, then 9, to an uncertain future.

Meanwhile, the theatre in Budapest lingered in financial uncertainty in Sandor's absence. The communists were forced within a year to recall him. Instead of admitting defeat, they put him at the lowest level of a beginner's theatre, where he stagnated for a year. The Boy Scout Theatre was renamed by the communists the Young Pioneer's Theatre. Sandor and Kati slowly worked their way back to the top theatres by the sheer demand of their public. He was forgiven for the moment because instantly, he turned the theatre profitable with his return. They felt fortunate, knowing full well that many of their colleagues had been sent to Russia or prisons for lesser offenses and were still missing. The pressure to join the Party was eased for a while and his income was raised several times above the average

citizen's of the times because the communists continued to use the arts as their propaganda machine.

Sandor and Kati were passionate decorators and lovers of fine antiques. The black market of antiques (because you could not sell anything on your own and make a profit like a "capitalist") was filled with beautiful bargains. They purchased some of these bargains to furnish their new apartment in the middle of Pest. The room was filled with 500-year-old furniture carved by masters in the field both from Austria and the Hungarian Rakoczi era. Ceiling-to-floor, hand-made velvet drapes separated rooms that were four meters high. Silver chalices, crystals, and the finest Herend porcelain filled the three meter long table where they entertained. The dark, massive tabletop was covered with an antique gold, hand-embroidered cloak of a Catholic priest dating back several hundred years. A "maid" took care of the parquet floors covered with expensive Persian rugs.

The pomp and elegance reflected the privileged class of the former regime. Kati replicated a small image of the years she spent married to Count Cziraky showing her excellent taste in decorating. Only the communist members, the country's privileged elite, the sport stars and the theatre people in the Party's favor were living in such opulent surroundings. The only difference was that the Party members, the sports people and the Party ruling class were allowed to travel out of the Iron Curtain, but no one else. These privileges were out of reach for Sandor and his family for not joining.

The sparkle of wealth that greeted Balazs as he entered the apartment seemed to him out of place in this broken-down country. He could not believe his eyes, especially since he came from the country-side where the Soviets had robbed every village as they "liberated".

Balazs was deeply affected by the general feeling of depression of the city folks. He saw fear, hopelessness and poverty everywhere. The infrastructure of the city was in dismal shape after the war and the communists' bad management was evident everywhere. Without private ownership, no one cared and no one had incentives because it all "belonged to the other people." The government boasted to the

Western nations that they did not tax the people in the Workers' Paradise and there was no crime! Naturally, since everyone was paid by the government, who decided on salaries, no one actually knew how much was withheld for taxes. So, the tax was a secret which only the officials knew.

Crimes were never reported since all the papers and radio stations were owned by the government. There was only rosy propaganda, 24/7, about how well things were in "The Workers' Paradise." They claimed that the oppressed poverty-stricken people exploited by the Capitalists of the West tried to cross the borders into Hungary in order to escape. "For the protection of the people," all the borders were barb-wired and trapped with minefields and machine-gun towers to prevent entry. Funny thing, everyone knew that the minefields and towers were on the Hungarian side of the border, to prevent escape out!

However, on the Soviet side it was done correctly and the minefields and towers were all on their side of the border. No one would be mad enough to escape to the Soviet Union from the Hungarian side. To the poor Russians who fared even worse under the Bolsheviks than the Czars, Hungary was sheer heaven if they succeeded.

Kati, his stepmother, was reinstated too and played at a first-rate Budapest Kis Madacs theatre just across from their apartment building. She was enjoying the conveniences, the fame, and the pleasure of working alongside her mother, a celebrated old-time actress.

TWENTY SEVEN

WRIGLEY'S SPEARMINT GUM

BALAZS WAS LOOKING forward to Christmas, his first with his father. The brothers were excited as Sandor, a Christmas enthusiast, began preparing the living room for the event. Wall-to-wall and floor-to-ceiling the antique glass doors divided the living room from the rest of the apartment. One could not see through them clearly but could make out the blurred shapes of things. A beautifully trimmed Christmas tree stood in the room.

Sandor was quietly whispering in the company of angels as they brought the gifts and placed them beneath the tree. (Children held on to their beliefs in angels as the Europeans don't combine Christmas holiday with St. Nicholas day.) The boys could hear the sounds of their wings and could smell the fresh winter air as the draft streamed through the open windows. The small candles were lit on the very ornately decorated tree—laden with lots of angel hair and thin strips of silver foil. It was a dazzling spectacle under Sandor's creative hands.

The sparklers were lit as the little crystal bell was rung for the third time. The family would enter the room together and recited

prayers in honor of Christ's, followed by the sad lyrics of the out-lawed Hungarian anthem. All this delay was a torture for the already highly excited kids. Balazs entered the living-room of Heaven and without observing the traditions rushed past the entire setup to the open window totally convinced that he just caught a glimpse of the last white angel, fleeing the apartment. There was still evidence everywhere as small, white feathers fluttered in the cool winter's breeze of the open window, landing on the pane.

Balazs had never been the recipient of so many wonderful gifts and much-needed "new" clothes. His thoughts went back to his grandparents' home and their small Christmas tree sparsely adorned with homemade things and gifts "from the angels." He received a lit-tle red apron for helping with the dishes and a wonderful scooter. This evening in Fuzfo, Eugene and Paula sat alone by their Christmas tree in the small room, while the howling bitter winter wind blew off the frozen lake rattling the villa's shutters.

Among the many gifts he received from Kati and Sandor was a pair of ice skates. It could be fashioned and adjusted to his boots with a key as he grew. He tried them out right away at the nearby City Park, which had an ice skating rink and a frozen pond sur-rounding the small castle converted into a museum of history. A hooded monk out of dark bronze, holding a pen, sat near the entry on guard on a massive granite block. As his face was mysteriously hidden inside the hood, he was called "Anonymous," A proper and fitting name for the unknown author of the *Gesta Hungarorum*, which chronicled early Hungarian history. Later studies supported the suggestion that he was most likely Peter Posa, who served as a notary for King Bela III and finally became the bishop of Bosnia.

Situated next to it was the Heroes, Millennium Square, which erected in 1896, is actually a circle, occupied by gigantic bronze sculptures of the conquering Magyar ancestors riding on powerful, thundering steeds. Over the warriors' shoulders hides of animals were draped and horns decorated their helmets and horses. This enhanced their fierce appearance causing panic to the Western

Europeans on the battlefields. The figures, 15 in all, of the House of Arpad, the original Hungarian line of kings, surrounded the center-piece. Flanked on the left was the famous Art Nouveau zoo with its elegant architecture and world-famous healing spas.

Balazs was surrounded by history and culture wherever he went in his ancient land, which began more than 1500 years ago. He found it demeaning that with a grand history and past, the Hungarians were overrun by such low lives as the Bolsheviks of the violent Soviet system. Eugene talked to him and Paula about this and his analysis of the Russian spirit. He believed that the Russian people, after defeating the Czarist rule, had every opportunity to build themselves a democracy equal to the American model. They had all the information and the experience of 200 years of the United States to guide them. However, he felt that the Russian people, as a whole, were so behind the civilized world that they did not comprehend the values and the ideas of "individual freedom." They only understood living in bondage or enslaving others.

They chose to create an evil system as destructive and violent as that of the Nazis. It duped and corrupted the most innocent. The intellectuals in false beliefs that communism actually served the good of mankind and the masses, creating economic equality among the masses. All the while, the ruling political party committed all kinds of atrocities, including genocide, to control people with fear. While exploiting the people, the communists enjoyed unequaled wealth and freedoms. He said, "The Russians never missed an opportunity, to miss an opportunity for a democratic government and I am convinced that if ever the Russians shake this system of theirs and become free, they will sink back into corruption. Groups of gangsters from the old KGB will not only run the lives of the Russian people, but will be a considerable threat in the world."

Balazs became knowledgeable about politics early in life as many of his generation. They felt the pain of their country and lived with the deep desire to be free of political persecution. They wanted the Russians and their system out of their country.

The schools were broken down and the heavy scent of the urine

and methane gas from the unkempt toilets lingered in the class-rooms. The wooden desks were old and worn, carved with names from generations before him. He had to bring bread to school, not for lunch, but to make an eraser by pressing it tightly and molding it with some spit.

There were continued shortages of thousands of items in the "Five Year Plan." The communists decided to produce things by alternating industry every five years. They would manufacture items of heavy industry, then turn to light industry the following five years. So, for five years they manufactured shoes, then in the next five, tractors, etc. Therefore if the people ran out of shoes before it was time for them to manufacture them they had to wear tractors on their feet or vice versa. These were many ingenious economic solutions with which they were to compete with Western economy and the hated capitalists. Everyone always wondered, if the West was so awful, why was it that we communists always wanted to catch up with them?

There was a big hush and much to do in one corner of the dark school hallway at lunch break. Balazs was eating the lunch Eugena packed for him—two generous slices of fresh Hungarian bread (bought at the baker's every morning) with a scrumptiously light, honey-brown crust. The oval-shaped loaf was about three kilos. Two slices of this bread, smothered with a thick layer of pork fat, sliced raw onion rings sprinkled with Hungarian red paprika and salt, were quite filling.

He continued to eat his lunch as he approached the commotion with reserved curiosity. One of the kids had a great treasure in his possession—American chewing gum! Coming from the country, he didn't have the slightest idea what they were talking about. What is chewing gum? But when he heard American, he tuned in. He had never seen anything American—let alone dare to utter the word in public. These streetwise city kids were braver and savvier than he. Secretly, they passed the black market treasure around for everyone to smell. All carefully took the little shiny yellow package, pulled out the silver wrapping and its thin, light-gray contents.

It was Balazs's turn to smell the gum. He almost dropped it in his excitement and fear of touching something so illegal. Something from the enemy, the Capitalist America. What consequences could come to him or his family if they found out? He quickly turned and scanned the hallway which appeared safe and free of adults. He lifted the gum carefully to his nose and deeply inhaled the fresh scent of Wrigley's mint gum. Balazs realized that this was his first encounter with the free West. As he inhaled the fresh scent for the first time he wondered if all of America smelled like this. He felt a rush of excitement, from the first scent of freedom!

The deal was struck—whoever took the gum home and chewed on it for one day had to pay one Forint (the Hungarian communist currency) then overnight he had to soak the chewed gum in water, sugar and toothpaste to renew its taste for the next fortunate chewer. He had a hard time understanding the concept—why would Americans chew something without swallowing it and still pay for it? He was so nervous that he might accidentally swallow it that he passed on the chewing. Besides they had no toothpaste., He decided to just smell the wrapper all evening and left the pre-chewed gum sitting on his night table.

In the following weeks, the school was hit by an epidemic of influenza, no doubt caused by the germ-infested gum passed through 200 kids' saliva. The school nearly shut down and the school officials had no clue what caused it. Only the kids knew. The irony of this whole experience was even more subtle. It was one of the Communist Party members' children who had access to such items and brought it to school. With a dose of healthy capitalistic incentive and natural instincts for profit he duplicated his money and gained capital. This was an enterprising kid, who practiced supply and demand. One was made to wonder how the communists could succeed in suppressing this natural human drive.

TWENTY EIGHT

RUNNING FROM THE LIBERATORS

THE CITY BECAME more and more a part of Balazs's soul as the seasons passed. He discovered all the parks, all the indoor and outdoor swimming pools of which there were more numerous in Budapest than in any other city in Europe.

One of the favorite swimming pools he began to frequent was the Olympic competition pool on Margit Island, situated in the middle of the Danube. The entire island was dedicated to leisure activities some centuries ago. An old Roman hot-geyser bath was modernized in the 19th century with six major pools, including a wave pool. Thousands of the city dwellers would soak through the cold winter months in the hot shallow-geyser pools, some playing chess and turning into prunes while snow caps formed on their heads.

Balazs enjoyed the ancient Turkish baths with pools of varying temperatures and colorful glass-studded domes. The dim ancient steamy pools were alight in the colors of the rainbow—as the band of rays cut through the steam inspiring his soul with magic.

He took many unauthorized visits to his father's house. He relished the times spent with Kati and Sandor, who always made it a point to do something meaningful with him, such as going to art museums. They were very impressed with his talent of sketching and wanted to expose him to the great Hungarian artists. By this time, Kati and Sandor were in great demand by the public, which meant many film engagements, radio, and dubbing of foreign films. Naturally, none from the West.

Balazs was encouraged to catch up with his brother's education and was signed up for all kinds of lessons, including dancing. Because of his shyness he hated it and managed to attend only three sessions. Sandor didn't realize how introverted Balazs was. He rushed too fast to make up all the time lost in their relationship and Balazs's development in the arts. When he was taken to a film studio to join his brother in a reading for film dubbing, he was so overcome with stage fright that he hid himself in a large garbage can outside the building. He nearly froze to death before the stagehands discovered him.

His parents decided he should take piano lessons instead. Geczy Dorotya, a beautiful, young and talented actress-friend of Kati's, offered her mother's services. The winter was bitter cold and the central heating in Dorli's mother's building did not work. She compensated by having a tiny electric heater behind her in the ice-cold apartment where their breaths could be seen. If she had the heater behind her thin frail bones, Balazs froze; when it was the other way around she caught cold. It was miserable even to hit the cold keyboards with frozen fingertips. In short, the teacher lost her student, but Balazs gained Dorli as a lifelong loyal friend.

Sandor's last attempt before giving up on his son of ever becoming an actor, was in a film where the two boys played brothers in a short script. Balazs made it absolutely clear to the family that he hated all this and never wanted to do it again. However, in their living room hung a beautiful pastel portrait of Kati, which Balazs admired. He asked his father if he could take art lessons from the man who signed the work Fried Pal. To his dismay Sandor told him

that his friend Pal who lived in Paris in 1941 was forced to leave for the U.S.A. before the war. He was a Jew.

Sandor and Kati lived a very rich cultural life. Like many of their colleagues, they enjoyed city living. Cities are the nucleus of culture and energy of nations and naturally drew people, especially artists—actors, filmmakers, poets, musicians and sculptors. They congregated in coffee houses and art clubs inspiring each other. Balazs was totally immersed in this kind of life as his parents included the boys in all their activities. Just being behind the stage whenever Sandor or Kati performed was an incredible experience for him. He loved everything—the stage sets, the colorful costumes, the rushing about of actors, beautiful actresses leaving trails of powder and perfume in their wake. A magical world, different from the depressing life outside. It was a great escape for everyone, actors and audience alike.

Going home to the little apartment was an anticlimax even though he came to love Eugena very much. He still passed the time doing watercolors with her. They played with his funny green parakeet she had given him as a gift the previous year. They delighted in the little feathered friend's ability to learn and memorize countless words. Balazs also had gotten a small pet leaf turtle from his godfather.

His godfather Lajos and godmother Margit, were chosen for the honored appointment, because of their devotion to him. In early1943, Budapest was under siege while Jadda was, pregnant with Balazs. The family often hid in dark, unventilated bunkers with other city dwellers, existing on meager rations of food and water.

Between raids, they got out of the bunkers in search of something to eat. Sometimes they were able to find food in blown-out stores and houses. Everyone was near starvation; peasants were not able to make it to the city and sell their goods. These were difficult, desperate times. Fortunately, Jadda made it to a nearby hospital in Buda and gave birth to Balazs, almost a month late.

He was a tiny, three-pound baby and his mother was unable to nurse him. She had no milk. A young physician friend of Eugene, offered to take care of the infant. He and his wife had no children, so they were able to devote all their time caring for him—totally

removing him from Jadda for the time being. The two concocted a healthy diet for Balazs so, he began to develop fast. In fact, when it was time for him to walk, he was too fat to do more than just crawl.

Out of gratitude, his parents asked Lajos and Margit to become his godparents. Traditionally the child receives the Christian name of the godfather as his middle name. Balazs sometimes wondered in his moments of pain and anger (after his mother's outbursts resulting in beatings) that perhaps the early separation from her caused this rift and distance between them. Whenever there was an opportunity, she exhibited her preference of her first born often in the presence of Balazs.

Shortly after the war, as the advancing Soviet Red army was in pursuit of the defeated, fleeing German soldiers, rumors of Russian's cruelty and ruthlessness preceded them. Thousands of Hungarians, including Sandor and Jadda, fled—on foot or by every available means possible—to escape them. With their two infants, they managed to be swept onto an open cattle-car, headed for Austria. Through this harrowing experience they were exposed to painful cold, with no stops to relieve themselves or any space to change baby diapers as bodies were tightly pressed to one another.

After many hours, their train finally approached its destination in the Austrian mountains. A German fighter pilot spotted the refugee train from the skies and descended to spray the hundreds of terrified passengers with a barrage of machine-gun fire. Warm blood sprayed into the couple's faces as the bullets hit their mark around them. The plane was like a hawk on its prey, repeatedly diving out of the clouds with its rattling machine guns. On each dive, more people were killed. Packed against each other the tight formation prevented the dead and wounded from falling to the ground. They hung headless and lifeless between their companions like butchered, red meat.

Amidst the screaming wounded came a chorus of shouts to the conductor urging them to stop the train. People wanted to get off and run under cover. Naturally the conductors could not hear the pleas, but were keenly aware of what was happening. They went into a robotic mode as fast as they could to shovel coal into the already

bursting furnace of the steam engine. Faster and faster they shoveled with one purpose in mind. Behind them in the wagons, people began jumping off the speeding train into the ditches taking the chance of survival with a fall rather than to die a sure death on the next passing shower of deadly bullets.

Sandor glanced at Jadda and without a word he knew their next move. Each held an infant as tightly as they could and pushed through the dead or panicked people to reach a side opening and make their fateful plunge. Just as they were ready to jump everything turned dark. Smoke and steam filled their throats as the train rushed into a narrow valley, carved out of the mountain long ago for the passage of the train.

Two cliffs rose high and tight creating a crevasse making it too dangerous for the plane to attempt further attacks as it lost visibility. All along, the conductors were planning for this to deliver their passengers—knowing if they stopped before reaching the valley they would all be facing death.

Nearby, in a small Austrian mountain town, an elderly widow took them in. They passed more than six months in this quiet village. They slowly sobered up from the bombardment of Budapest and from their near-death experience on the train. They listened intently to the radio for news about Hungary. Jadda was fluent in four languages and was able to communicate with their hostess too.

When the false news came that the Soviets were not staying in Hungary permanently, Sandor immediately decided to return with his family. After all, his career was still something to go back to as the Hungarian language was the tool of his art. Having little knowledge of other languages, save a little Italian and German, he would not attempt to live in another country. With the Germans finally defeated, he was one of millions of other Hungarians hoping for an independent country.

Upon their return, Sandor's father in-law, Eugene, thought it would be better for them to keep a low profile at his country villa while things settled in the destroyed and ruined city.

TWENTY NINE

BATTERED

SANDOR AND KATI led an exciting but hectic life. There were many after theatre parties and other social obligations, but they always found time to spend with the boys. Balazs observed with great pleasure their romantic, loving relationship and the genuine affection they had for each other.

Balazs's frequent unauthorized visits infuriated Jadda. However, her jealousy did not result in more love and attention to win him. Instead, she fabricated the usual stories about "the Jewish whore"—who began her career topless display in public and in circuses. Jadda claimed that Kati viciously disrupted her marriage and stole Sandor and her favorite child from her.

Balazs was sick of listening to these fabrications. He knew the truth that Kati and Sandor met after they were already divorced and how Kati's career began with the help of her stepfather who was the theatre director in the city of Gyor. He listened to her ranting about Jew this and Jew that, Gypsy this and Gypsy that, and he became disgusted. Did Eugene and Paula not raise her? They not only raised Balazs without prejudices, but they set good examples with their

open-mindedness and their respect for other people's beliefs and values. Their example did not prevent the bitterness that engulfed their daughter after the divorce, as her permanent anger struck out against the world around her.

The sun shined radiantly on a clear autumn afternoon. With his spirits raised he hurried home. After a small injury at the gym that earned him his early release, Balazs was looking forward to the extra time to himself. After jumping off the electric trolley he rushed into the building and mounted the stairs by threes. Burst through the hallway to Eugena's room. In his hurry he took a giant step into the room. Suddenly, he tripped and was hurled across entangled naked bodies on the floor in embarrassing and compromising positions. Jadda was there naked with a man! His books flew in all directions as did his mind, which he was unable to collect.

He heard Jadda scream at the top of her lungs, "What the hell are you doing here? You are supposed to be in school," as she tried awkwardly to disengage herself from him and her even angrier partner. She reached out in her fury toward Balazs, caught him by his pant leg and flung him towards the door. He fell across them again, so she came down with a fury of blows onto his face. He was terrified and attempted to break away, but suddenly, he felt a heavy fist in his stomach and then in his groin. The pain struck him down immobilizing him. Balazs saw the angry man's hateful face while he was exposed to Jadda's repeated blows.

He closed his eyes and when he opened his mouth to scream for Eugena's help, he felt his lips split and blood squirt in every direction. Tiny Eugena, with God's speed, rushed onto this impossible scene dropping the groceries all over the floor. "Oh my God, Oh my God," she screamed as she tore the child from the grips of the rabid, enraged couple. Balazs was shaking and held onto Eugena's small frame while spitting blood and was overcome with a nervous hiccup attack. He could not breathe for a moment almost losing consciousness. Sometimes after regaining his senses he heard the entry door to the apartment slam. Eugena's loving hands tended his wounds with

cold compresses. He kept crying, as did Eugena, who was traumatized to see Balazs in his battered condition. She muttered, "This can't go on any longer." Balazs knew it was the truth.

He slowly got to his feet. Without looking into the mirror to examine his battered face, he took some necessary garments out of the 300-year-old colorfully painted Hungarian folk armoire. Eugena followed behind with a small suitcase and laid it on the couch. She did not help with the packing, as she was traumatized and distressed beyond her control. She went to her room and fell face down on the couch to cry. He threw his few belongings into the suitcase while some still hung randomly out the sides, then slammed the lid closed.

He went to Eugena's side. He felt a hundred years old as he gently kissed the back of her head. Before leaving he heard his little parakeet shout out some obscenities, which he recently taught him. He swept up the small cage with the bird and the leaf turtle then headed for the streets.

Across the street was the No. 5 blue bus, which, if he boarded, would stop a few blocks from his father and Kati's street. The brakes of the large bus squealed as it came to an abrupt stop. Balazs stood at the open door with a cage and a suitcase in hand, the blood still trickling down his swollen cheeks and split lips. He was definitely the sight of a severely abused child. The driver and the passengers stared in shock and instinctively got out of their seats to help him up. The passengers were quiet as Balazs announced that he forgot his money. The driver said, "Never mind, where to?"

"To my dad's home," said Balazs, through his swollen lips with much pride and a newfound sense of belonging. "He is the famous actor Szabo Sandor, the Maestro. My mother beat me and I want to go to my dad!" Balazs noticed the instant respect the mention of his father's name brought to the passengers and the driver. There was no vote when the driver announced that the bus was re-routed and would go to the Maestro's house and that anyone who wished to get off should do it now. No one got off, so the bus proceeded to the address. Some peasant ladies removed their scarves and with the help of some caring spit, began to tend to Balazs's wounds. He could

smell their onion and garlic breath from sausages, but he experienced much worse recently.

Within a few minutes, the bus found its way to the apartment building. The elevator did not work again, as usual, and as Balazs took to the stairs with the birdcage in hand, the driver was behind him with the suitcase. The remainder of the 40 or so entourage of passengers, followed in tight formation. Balazs rang the doorbell with their family code of three short and two long rings. Kati answered the door as she wondered why Balazs would be visiting at this time of the day.

Sandor, on his way to the kitchen, stopped behind her too, quite unprepared for the scene. Balazs stood in the doorway, with his face monstrously swollen, one eye nearly shut and his bleeding lips double their normal size. The little mob behind him filled two flights of stairs as the hijacked uniformed bus driver, suitcase in hand, made this theatrical event utterly surreal and comical. Balazs broke the silence and even he was surprised at what he said looking up at Kati's loving face framed in her blond locks, "Mother, if you take me in I will be grateful to you forever."

Her knees gave way in an instant in a wave of emotions, as she embraced the battered Balazs in her arms. He held on and wept too. Kati could not help thinking that fate had given back her two sons she once lost as a young mother. The bus driver wiped his tears, as did the entourage behind, not knowing whether to laugh or cry. Sandor was thankful to everyone and in his sweet, endearing way, went down the stairs and hugged everyone.

Late that night, the phone rang and Balazs felt Jadda's evil presence as Sandor picked up the receiver. "Is my son there?" Came Jadda's demanding voice on the other end. "Yes, he is," said Sandor calmly. "Well, slap him across the face and send him home immediately," was her angry demand. Sandor deliberately and slowly replied, "Under the circumstances I don't think so." He hung up and disconnected the phone from the wall to prevent her further abusive calls.

It was difficult for the family to rest that night—only Balazs slept, one of the best sleeps he had in a long time. The trauma left

him exhausted and being with his father finally, even though not legally, made him relax. The next morning, since his father and Kati always slept late, he dressed himself but did not wash off any more of the evidence of the beating. He had a definite purpose and knew what to do. He knew the city's main courthouse was near the "secret" underground torture chambers. It was well guarded with machine-gun toting soldiers. Balazs put on the bloody clothes he was wearing the day before. With the second day of his ordeal, he looked much worse. He was more swollen and blue from the blows. One eye was totally shut and his lips were purple with coagulated blood.

He approached a surprised armed guard and begged to be taken in to any judge because his mother nearly beat him to death! The effect must have been powerful because without a word, the soldier said, "Wait here," and motioned to another guard. They spoke and Balazs was taken up several marble floors to the judge's chambers. Without hesitation, he practically told his life story to an old judge, who listened patiently. Soon after, the judge called the guard and requested some files to be brought in. They waited a while and he asked some questions about his father. He added that he had seen his father many times in the theatre and admired his great talent. Too bad, the judge remarked, your father has not yet joined the Party.

When he arrived back at the apartment, he realized that everyone thought he went back to Jadda's. Balazs was beaming as he held out the signed legal papers his father had not been able to obtain in all the years from the courts. The papers, signed by the presiding head judge, gave permanent right for Balazs to live with his father without a court hearing!

THIRTY

THE APPARITION

IN THE BEGINNING of spring 1956, before they were informed of their trip to Austria, Sandor and Kati were extremely busy fulfilling their many commitments. They often got home exhausted to the bone.

While they slept soundly, they were awakened around 3 am. by the loud ringing of the phone—so loud that everyone in the entire apartment was aroused. The dog barked into the darkness and the boys heard Sandor muttering something as he tripped over his shoes to reach the irritating and insistent ring. He picked up the phone and after a moment of silence, he heard his mother's panicked voice on the other end begging him to please come over immediately. He said he would be there right away and hung up.

As old Kati and Erno were sleeping lightly, they heard the rattle of their triple lock on the outside door. A moment later they heard it creak open and close again. The frightened couple, suspecting burglars, sat up and held each other's hand and listened intently. They thought perhaps it was their time to be taken, but without the "knock." The room was pitch dark with the blinds and curtains tightly drawn, they could see absolutely nothing. Frozen with fear, they did not even attempt it and kept their eyes closed.

Methodical, heavy steps approached through the hallway toward their bedroom. Opening their eyes their vision slowly improved, they strained into the darkness, still totally petrified. The wings of the three-meter high doors were unlocked from the outside and opened slowly toward them as they waited for some horrible fate. There was eerie silence. They could finally make out the shapes of the furniture in the darkness, but saw nothing moving. Again they heard the slow, heavy steps approaching the foot of their brass bed, then they stopped.

The bed shook firmly almost giving them instant heart attacks. Frightened, old Kati let out a sharp, terrified yelp at the invisible something standing at the end of their bed. They saw nothing at all! By now, Erno was frightened beyond his wits and yelled at the top of his lungs. They both felt a presence of something beyond fear, something heavy and painful. "Get out of my house, whatever you are right now. NOW," he demanded.

There was no response and the persistent silence heightened their fear, yet the entity that filled the darkness somehow reached Kati in a warm, mysterious way. Catching her breath, she carefully leaned forward and with a crackling, but loving voice whispered into the dark, "Bobby, is that you, my dear son?" There was no reply, but as they waited a while the bed moved again slightly several times.

Silently, they waited in the darkness, as the beat of their hearts calmed. The heavy steps slowly withdrew from the bed and headed back toward the tall bedroom door. It closed gently. The key turned back to the locked position. The steps continued down the hallway toward the outside door, which opened and closed with the three safety locks relocking.

The couple found themselves drenched in tears. Old Kati was unable to move, paralyzed by her thoughts and suspicions. Erno finally turned on the nightlight, looked at his wife in disbelief. Got out of the bed and walked to the locked bedroom door. He carefully unlocked it and cautiously walked down the hall leading to the outside double doors. He pressed down on the brass handle and

tried the door. It was locked. Then he checked the three locks, but also found them secure as he left them the night before. He examined the entire apartment but everything was in order, there was no evidence of anyone or anything. He wondered about his wife's intuition of addressing the unknown as Bobby, who had been gone since his arrest after the war. He dialed his son Sandor on the phone and handed the receiver to his wife.

The next day everyone in the Szabo family heard about the event and no one could come up with any explanation. Some even dismissing old Kati's notion regarding her son. Erno was not so cynical realizing that they shared this nightmare together and after 50 years of marriage this was the first time anything like this happened.

Nikita Khrushchev was now in power and people were under the illusion that things were getting better. Perhaps because Stalin was so horrible in comparison. But he opened the Gulags of Stalin and many of the survivors began to show up in Hungary, too. They might as well have been dead people as they looked like wretched, walking skeletons in rags.

They were starved down to their very bones. Their eyes were sunken deep into their skulls without the slightest glimmer in them. They remained silent and unapproachable. Some were seen at the shores of the Danube sitting for days on end simply staring at the passing water. Their faces were ashen gray with deep grooves weighed by gravity and the scars of their suffering.

One such apparition rang the old couple's doorbell and simply stood there for a time before uttering a word. He stared into nothingness facing them, then almost inaudibly said, "I am Zsolt. Bobby and I were in Siberia together after they took us off the Chinese rice fields. We were there for years. He was very weak and could not get used to the bitter cold and caught pneumonia. We had no medicine, no food but a small daily ration of bread. Bobby developed gangrene, too, but he traded his last ration of bread for a cigarette from me. I am sorry, but he is gone now. He did not suffer in his death."

They stood there for a moment—old Kati suddenly lost her

footing and leaned back pale against the wall then slunk onto the floor. Shortly after the initial shock, she regained her composure and inquired about the time of his death. Zsolt said it was recent, just before the news of amnesty and their release. She thanked him as she cried with grief that shook her entire body. When Erno looked up, the man was gone! They felt cheated and miserable. There were so many things they wanted to know and now, all vanished with this broken man. The visit on that unusual night was no longer a mystery; they understood now and it comforted them.

THIRTY ONE

TASTE OF THE WEST

THE SCHOOL HE attended was just a few blocks from the Parliament building. It was also two blocks away from the office where Jadda worked. Before the ugly incident that caused him to run away to his father, he used to visit her there after school. Now he hoped that she would not try to nab him at the gate to reprimand him or inflict whatever abuse she might have in store for him. He feared her, but he was obliged to see her because it was the law. These were the most uncomfortable days for him. To ease the situation, it was decided that his brother would accompany him on these visits.

Balazs entered the apartment and rushed to Eugena's arms in order to avoid any physical contact with his mother. Jadda planned to play the "pain game" again—giving special, thoughtful gifts to and overdoting on Barna. She made sure that Balazs heard comments about his brother being her favorite. Eugena's loving attention made up for the emotional abuse by his mother. Balazs ran to visit a special group of little friends as Eugena pointed out some good news.

Directly under their window was an acacia tree whose topmost

limb was home to a pair of gray, ringed-neck doves. In the spring of every year they would lay two little eggs whose hatchlings Balazs and Eugena waited for. They spent hours watching from the windowsill. Two new eggs were there again. Within two weeks, little gray, fuzzy doves would fill the poorly built nest made of twigs. It was a miracle that they never fell out of the nest during the wind and rain onto the busy street below.

He felt relieved and energized after departing. In a few days the exams would be over and they were going to spend the entire summer at the lake. His father's family, was still not his favorite. Fortunately, he knew that 15 kilometers ride on his new bicycle, which he got for Christmas, would take him to his grandparents.

Summer by the lake would be fun, he thought. As the train raced through the towns toward the lake, he could reach out the window and grab the cherries off the trees by the tracks. As the cherries ripened in the warm, summer sun, the plum and apple trees bloomed in pink and white to catch up. Balazs saw a striking painting from a Dutch painter in the art museum, which captured exactly what he felt seeing this scene. The painting was not as well done as the others in the museum, but it had strength and heart as it conveyed even the smell of the flowers.

The Szabo clan of the six boy cousins was at the lake town of Akarattya. Sandor's father, Erno, had helped to establish a "workers'" summer spa before the war. (Sandor did not know that his father was secretly a communist nor did anyone in the family.) The madness began with all the shouting, laughing and fighting of six wild city boys. They could not get enough of the lake, the cherry trees or of the blackberry tree that was laden faithfully every year. They would spend so much time in the shade of the weeping blackberry tree eating the fruits that they all had the runs at the same time.

They would ride to different towns at the lake and see the sights. On clear, starry nights they would build campfires and roast bacon. Now that Balazs lived among the affluent he had pocket money and was able to go to the town's movie theatre. He could not get enough of seeing his father in films.

Balazs, biked over to Eugene and Paula as often as he could and stayed the night cuddling with them. They could not understand why he left his mother's home and as he tried to explain it a rift came between them. They could not imagine anything negative about their daughter, so Balazs dropped the subject. This time he came with great news to share with them. His father and stepmother were invited to play at the state theatre of Vienna, outside of the Iron Curtain, for the summer!

No civilian before was allowed out to the "West" as tourist or under any other circumstance, save for the athletes. The government agreed that as long as the children stayed behind as hostages in Hungary and didn't accompany them, they were allowed out. Sandor and Kati left for a short stay of stage production in Vienna then returned to the lake.

They related stories about the freedom and happiness of the people there. The recent departure of the Soviets, from the occupied portions of Austria, totally changed the spirit of the nation. Balazs clearly remembered that day of their liberation. The church bells in Austria rang in jubilation. The winds carried the tolling of bells that rang out for freedom across the no-man's land and across the border towns of occupied Hungary. The hearts of the Hungarian people sank realizing that their time of freedom would never come. They took to the churches too and rang their bells. They rang them for the Austrian's freedom and they rang them in protest of their own bondage and hopelessness. Like a domino effect, the bells were answered across the nation in every town, throughout Hungary.

As Sandor talked about the freedoms and the wealth of Austrians, he unpacked a suitcase of treasures with Kati. They were able to bring in things the boys had only heard of. Balazs got two bananas and a brown liquid in a beautiful bottle that said Coca-Cola on it. He almost dropped it as he read the embossed glass label. He was taught in school that the Imperialist Capitalist Pigs in America gave this drink to the people because it's a barbiturate and they can get more work out of the masses to exploit them. His father now looked at him and said, "Come on, open it and try it." Balazs was

not very impressed; it tasted kind of bittersweet, so he passed it to his brother. He hid the bananas and the orange in a sack.

After the chewing gum experience at school, this was his second exposure with items from the West. Kati said that Sandor took an incredible chance with their lives by smuggling wrist-watches across the border. He bought a vest in Vienna and purchased 100 watches which he had sewn into the lining. As they drove back the border police thoroughly searched them. The guard kept giving the Maestro familiar slaps on the back. Sandor and Kati were literally sweating bullets and would have been taking some right between the eyes if the guard had touched him any lower.

As Kati cut open the seams of the vest, beautiful, sparkling new watches poured out onto the bed cover. Plastic was not yet a common material in Hungary. These watches were floated in clear plastic, so one could see the mechanism on the back and a clear plastic embraced the face of the watches, too. They were in many colors and Sandor was hoping to get a great deal for them on the market. All this worried Balazs, because if Sandor got caught, he would most likely be sent to Siberia like his brother before him. Kati and Sandor bid goodbye to everyone and departed again for Vienna for a longer stay of stage appearances.

Balazs went to his hiding place and he took out the banana. Before he lifted it to his nose he could already smell its unique aroma. He ran his fingers on its smooth yellow skin and admired it, but as he was going to take a bite into it he thought of his grandparents. He put the banana back into the sack and took out the orange. As with the banana, smelled the citric aroma so alien to him. He ran his fingers on the bumpy skin and as he did so, he accidentally scraped it with his nails. The oils of the skin seeped out with a wonderful scent. He could not get enough of this, so he kept scratching the surface over and over and inhaled deeply.

When he arrived at the villa to rattle off all the news about his father, Vienna, bananas and oranges he spread out his valuable stash on the burned-out vinyl tablecloth. His grandparents had not seen

tropical fruits since the war began. Neither of them wanted to deprive their grandson of the experience and declined to join in on the tasting. Balazs finally grabbed the banana, making sure to bite into the top end not where the stem was, but Paula stopped him and with a smile began to peel the fruit first for its soft exposed white inner meat.

"Now you can begin to taste it," she said to him awaiting his reaction. He took his first bite and exclaimed, "It's like eating flowers, Grandma." Eugene began to peel the orange for him as well. Balazs would only continue if they joined in. He was delighted as the three of them huddled together over the tasty fruits of the tropics, a place they may never, ever get to see. A month later, Sandor and Kati's second trip to Vienna was cut short by the death of his father. Erno fell asleep in the yard, sitting on his favorite bench, under the apricot tree, during his afternoon snooze—never to wake again.

THIRTY TWO

A NATION RISES

WHILE BALAZS enjoyed the elitist lifestyle of his father, he felt guilty knowing that the rest of the country, especially the masses of the working class, were getting desperately poorer.

Sandor still had not joined the Party, no matter how many hints or direct requests he was given through the theatre director's office. He was at the zenith of his career. He had the main role in Rostand's *Cyrano de Bergerac*, the greatest hit ever to be in the theatres of Budapest. It brought incredible revenue to the government coffers. Tickets sold out for many months ahead, as people went multiple times to see it.

Sandor was nominated several times for the highest award, the Kossuth award (the equivalent of the Academy Award in the U.S.), but in retaliation for not becoming a communist, he was repeatedly denied. This was now perhaps the only disadvantage he experienced under this regime. Balazs had seen the play a dozen times and found himself crying every time at the death scene his father played so well.

On his second trip to Vienna, Sandor was fortunate for he earned so much income from his appearances that he was able to

purchase a beautiful brand-new Austrian, Opel, Cadet. It was a large, beautiful cream colored convertible with rich, red leather interior. Only the Communist Party members were running about Hungary with cars (the rest of the vehicles were trucks, public transportation and bicycles) disguised under government license plates. All were somber black. This bright symbol of capitalism was a sensation, which brought crowds around it every time he parked on the street. While onlookers stroked it and smelled the new shiny leather, Balazs felt ashamed to get into it in public. Incredibly enough, when people recognized Maestro Sandor, they smiled with approval. It was nice to see a non-communist having a piece of the good life.

Despite the communist efforts to raise previously poor, working class children into devout Marxists and give them extensive education with powerful positions in the government, the truth began to appear. Many of them began to realize the tremendous gaps between the promises the communists made to the people when they were trying to get into power and what they actually delivered when they had it. Eugene had often remarked, "The way these communists educate the masses will eventually backfire on them. These new and fresh intellects will go beyond the brainwashing process, asking questions independent of the Party, then the system will be unveiled as a lie and it will collapse."

The process began. The workers got nothing but propaganda and promises while they noticed who got hold of the goods, the food, and the luxuries. The Hungarian culture decimated on every level when everyone had to learn Russian, read Russian books, see Russian plays and Russian movies. Cultural contact was totally forbidden and shut off from the West. They were taught how capitalism humiliates the worker and how communism exalts him. They began to see that Hungary was used as a disgusting experiment to strengthen Russia. They could not remember a single decision that was made for the good of Hungary as everything benefited the great leach, the Soviet Union. The terror disseminated by the secret police, the AVO, which was employed by the Soviets, had multiple levels in

their organizations each checking the other. The supreme AVO group checked on the setup and it was checked by the Russians.

The suspicion culture was built into every level of life to control people with an invisible leash. Finally people began to see the truth; life under communism was bleak and meaningless, without hope, without future. Wages were so meager that no one could make ends meet and become proud of being able to take care of their families. All family members worked and lived under conditions of poverty. Communism was a big fat lie.

On October 23, 1956, the days were already short and darkness came fast on Balazs's last class. Their literature teacher was a former nun deposed by the communists. As she read one of her favorite poems to her pupils, the class was disturbed by noises from outside. The disturbance accelerated with the sound of thousands of marching boots. The roar of a mob shouting was heard—"Russians go home, down with the Soviets." Everyone looked at each other first in horror, then as if given permission they all sprang to their feet totally without their usual discipline and respect for their teacher. She too was already at the window opening it wide into the cool October night. The air was fresh with the scent of autumn leaves and the four windows instantly cooled the room.

As they all hung out the windows to better see the commotion, the crowd of thousands—young people and workers alike—marched and chanted anti-Soviet slogans. Many of them were waving the Hungarian flag of horizontal red, white and green, but curiously the center, where the hated Russian sickle and the hammer in a wreath of wheat used to be, was now defiantly ripped out. Such daring was suicide! How could this be possible, was the question on everyone's mind.

They all expected to hear the rattling of machine guns and armored cars running down the protesters. There had never been a protest against the Russians in Hungary or against the communist government. No one would dare risk their life and the lives of their families. Yet as the hundreds grew into thousands, Balazs and his

entire school found themselves abandoning their books and joining the brave people in the streets.

Balazs knew where they were headed as the procession faced the direction of the great Parliament. The Gothic towers loomed into the dark sky with sharp points—no longer the symbols of beauty and freedom with its present occupants of tyranny. They looked menacing and evil. The spirited crowd, brought with them a list of demands that a group of young communist intellectuals (as Eugene predicted) had drawn up. They demanded that the Soviets cease Hungary's occupation, open the borders to the West and allow trading and many other reforms. Balazs was not able to hear well through the roar of the crowd.

They arrived at the gates of the Parliament as the people began to shout the name of Nagy, Imre a moderate communist who, like Khrushchev, was of peasant birth. As he was not a puppet to the Soviets he held no great power in the Party, but the people were aware of his loyalty to the Hungarians. They wanted him as president knowing he would not to sell them out.

The chanting of his name lasted at least a half-hour when finally Balazs saw a side door open slowly on a balcony above him. A portly figure stepped out and after great cheering he addressed the people— "Dear Comrades." Immediately, echoes of enormous groans and boos came from the disapproving crowd below. He paused, cleared his throat, then began again, this time shouting— "Dear Friends." The crowd approvingly rejoiced and cried out his name over and over again. Balazs could not hear any of the remaining words that were spoken.

Nagy, Imre solemnly began to sing the Hungarian Anthem as the entire assembly of people resoundingly and freely joined him for the first time in public since the Russian occupation. They sang together the Anthem that meant death before. Balazs, had as much a dose of patriotism as anyone. He sang with passion the song he knew well and tears ran down his cheeks as it did on everyone else's.

Then the cry came, "To the Radio Budapest! Let's go to the

Radio." They wanted to read their demands so the people could hear them. The dark mass of humans with flags waving marched with high spirits and grew like an avalanche. The radio station was the main horn of the communist propaganda in Hungary and heavily guarded by the AVO. Like in a swift river current, Balazs was swept along and deposited a few buildings from the radio station.

The shouting crowd was loud as the reflector lights of the AVO began to sweep into them. Everyone knew that they were being photographed for later prosecutions. The students demanded to read the 17 points of reform and were let into the building by the secret police who immediately arrested them and closed the gates behind them. The mob went berserk at the trickery of the AVO. Balazs did not know from where, but he heard the sharp echo of a single gunshot that reverberated off the surrounding buildings.

Balazs saw missiles of rocks now being hurled at the bright lights without success. Behind him the people were yelling, "Make way, make way." Some trucks were arriving with government soldiers who surprisingly began handing arms and ammunition to the people. Men from Csepel arrived with trucks loaded with weapons. Balazs could not believe his eyes. The workers from Csepel Island were the very pride of the Communist Paradise.

Csepel was the main industrial center of Budapest and its workers were pampered with all the glory of Soviet propaganda. Yet they were living in poverty awaiting the fruits of their labor somewhere in the distant communist heaven. Balazs thought they must also have figured out the lies. The AVO began firing their machine guns from the radio station into the crowd. People fell to the cold concrete and cried out in pain. There was blood everywhere.

Balazs was horrified as he realized that this was now a revolution. The Csepel workers immediately engaged and began to shoot out the lights and fired at the AVO on the rooftops. People ran to cover trampling each other. A car was burning in front of the gate. An ambulance came crushing through the crowd indiscriminately without care, injuring many. The Csepel workers stopped it near the gate. By now Balazs was standing near the doorway watching the

driver dragged out by the crowd. He did not comprehend why the crowd began to stomp and beat the driver until the men opened the ambulance and exposed the weapon supplies the driver, an AVO man, was trying to smuggle to his cohorts in the Radio building. The AVO driver was shot a few minutes later.

The battle for the radio station began in earnest with the people now equally armed. Suddenly, Balazs remembered his father was inside the studio scheduled for some poetry recital. He became terrified at the thought that he would get in the crossfire and get killed. The powerful doors were blown out and armed fighters rushed the building firing their guns. They took over the first floor, Balazs thought, when the Hungarian flag without the Russian symbol in its center was placed in a window. He stayed and waited for what seemed an hour but actually ran into dawn until the ensuing battle was won.

A rumor spread through the crowd that the fighters discovered an old tunnel leading from under another building into the studio. Finally the men of Csepel attacked the AVO from within by surprise and took the building, but not before a grenade brought down one of the studio's front walls. The abandoned broadcast equipment was dangling from wires between floors. A reinforcement group of young men with more weapons and supplies set up positions across from the station and opened fire continuously and in earnest. Grenades were hurled into the studio building; the white dust of plaster and smoke was flying everywhere covering everyone's clothes below.

As the building was taken and things got quieter, the crowd dispersed joining other groups headed for the hated 8-meter high, giant iron statue of Stalin in the park. Balazs ran up to one of the men coming out of the blown-out doors of the radio station and asked if they found any actors in the building namely his father. The man said they only found the AVO men. He was relieved and now feeling the freezing cold without the jacket he left at school, he ran home as fast as he could.

THIRTY THREE

GLIMMER OF HOPE

THE WARMTH and safety of the apartment felt good on his frozen ears and fingers. His step-grandmother Eta, a jovial, slim lady in her late 50s, was already doing her daily visit from across the street. She was excited about all the news circulating concerning the revolt. As she hovered over some tasty Hungarian chicken soup, Balazs inquired about his father. She said he was still working at the radio. He was bewildered and told her that was impossible, there is no radio building; he was just there and witnessed its destruction. She said, "You are crazy, the station is airing right now and I am waiting for the news on it, since there was some trouble on the streets."

She reached out and turned up the volume. Sure enough the hated Gero, Rakosi's criminal partner, was making a statement to the Hungarian people about how some "fascist groups and reactionaries had attacked our great nation, but they are being dealt with as we speak and the country is safe. The Radio Station is safe and will continue to broadcast to the people." Balazs was disgusted to hear the usual lies when he saw with his own eyes the destruction of the building and the AVO men shot.

As he explained to Eta what he just witnessed and expressed worry over his father, Sandor and Kati burst into the apartment. Both were covered with the same white dust as Balazs. Kati looked at Balazs with mixed emotions of fear and elated excitement and asked, "Were you outside the Radio Station?" "Yes, Mother, I was there from the very beginning and I was so worried knowing that Dad was inside; I didn't know you were there too." His brother came running into the apartment now with news of people marching on the streets and running to the Stalin statue.

Sandor interrupted to tell them what happened to him. He was to recite poems on the air, Kati joined him because later there was a meeting scheduled by a group of artists and intellectuals regarding their lack of freedom of speech at the exclusive artist club called the "Feszek," the nest. As Sandor prepared to review his work, got his espresso and lit his cigarette, there was a hard jolt and vibration to the building. Everyone thought it must have been an earthquake — no one inside had a clue of what was happening outside on the streets of Budapest. The AVO, who were always stationed in the building, suddenly came to life—running throughout the building and gathering extra arms. Minutes later the regular government guards were doing the same and ushered the artists and technicians into alternate studios and rooms.

There was pandemonium, but everyone was being assured that it was just a small disturbance outside and it was handled without incident. The programs could go on in the next studio. As preparations were made to refit the studio for a change of venue and Sandor reached for the mike, an enormous blast shook everything. Sandor felt the pressure of air in his face that hit him so hard, he found himself back in the opposite end of the room next to his wife. Everything in the studio went dark.

As the cloud of dust settled and the light filtered in from outside, they saw a great gapping hole where the wall used to be facing the street. They saw occasional streams of lights and herd the rattle of machine-gun fire. Before they knew what happened, Kati and

Sandor were lifted to their feet and whisked off through dark hall-ways. The State Guards held flashlights and guided them through all sorts of underground tunnels into the open, on the streets a block away. They were told to go into the safety of their homes.

Sandor wanted to find out what was going on and grabbed a young man running by him. "We are taking over the radio station and there is fighting with machine guns and grenades." Before coming to their senses they were swept along by a mass of people rushing toward the Millennium park. The target was in the City Park, where the Soviets razed the Regnum Marianum Church to the ground, loved by Hungarians. In its place they erected a huge monstrosity of Stalin's statue. They were now caught up with the revolutionary spirit, along with the rest of the country. They learned from demonstrators about a meeting that began at Bem Statue, which led to the Parliament and continued to the radio.

By the time they reached the park, there was a sea of people chanting, "Down with the Stalin statue," "Out with the Ruszki!" A rope was being tugged, which was tied about the statue's neck, and some welders were busy with their equipment at the back of the knees. The behemoth came down, with a big thud, face first into the concrete, almost injuring those gathered around. People—men, women and children—cheered and wanted to defile it with spit and kicks.

The falling of the hated symbol of oppression brought great satisfaction and a sense of relief to everyone. Balazs and his family could not believe the coincidence that he was outside the radio station just when the wall went down. Sandor was almost laughing as he said that one minute he was holding the microphone and the next he was holding his butt, which hurt so much from being blown clear back into the room well over seven meters.

They were gathered around the table eating hot soup and excitedly discussing the future. They knew that the Russians and the AVO would retaliate and many people would die, the living would be sent to Siberia. The phone rang all through the morning as the

rest of their excited friends and colleagues kept calling Sandor's home. By the time they fell into their beds exhausted, everyone had convinced Sandor to stand the following day on the steps of the Parliament and recite the revolutionary poem of 1848 written and recited by the poet Petofi, Sandor at the time of the Hungarian uprising against the Austrian oppression.

They requested that he do this, as he was the most popular figure as an artist in Budapest. (Petofi, Sandor was one of Hungary's foremost poets and revolutionaries who perished in that event before the age of 27.) There was to be a major non-violent demonstration the next morning to bring the demands of the people to the government. This was drawn up by the communist youths of the "Petofi Club" the night before. These were the same demands they were attempting to read over the air on Radio Budapest, but were denied.

THIRTY FOUR

GENOCIDE AT
THE PARLIAMENT

AS THE EXCITED family entered the streets on a gray winter morning, they did not notice the chill in the air. The city was in a buzz, unparalleled in their memory. The buses were filled and the packed yellow streetcars had people hanging off outside of the open doors and on the iron bumpers. Everyone headed in the direction of the Parliament.

When they arrived they could not believe the mass of people already there. The mood was electric, so positive that Balazs felt everyone's heart was connected by their desire for freedom. He saw thousands of children and complete families turned out, even with infants. It was the happiest and most encouraging sight to behold. He felt very proud to be a Hungarian and taking part in such an historic event. An event that just might be the beginning of a free Hungary; no Russians, no terror of the hated secret police. Sandor was concentrating and focused. He reviewed the poem of 1848, which began as the young poet called to the nation, with the famous words "Talpra Magyar."

Magyars, rise, your country calls you!
Meet this hour, whate'r befalls you!
Shall we free men be, or slaves?
Choose the lot your spirit craves!
By Hungary's holy God
Do we swear?
Do we swear, that servile chains
We'll no more bear?
Etc.

The significance of the moment gave him chills. He felt it his utmost duty to deliver these sacred lines to further lift and direct the people to their destiny and freedom. He pressed on with his family tightly behind him through thousands towards the steps of the grand Parliament Building. The neo-gothic structure, erected in 1896 on the Hungarian millennium, is the largest in Europe. As the public recognized the handsome six-foot-three frame of their favorite star, they parted the tight formation with approving smiles and cheered him as he passed. The people were proud of Sandor's resistance for not giving in to the communist pressure to join them. He chose instead the consequences and risked his career.

The noise increased and the power of the masses gave everyone a sense of security and strength. They were nearing the steps. The mass of people were like rough waves of the sea, lapping at the shores. Pressing, en masse all the way, up to the walls, through the main decorative wrought-iron gates. His family was carried forth on the crest of each wave.

When they finally passed through the gates, Balazs reached out to steady himself and avoid being crushed against it. As he got hold of the gate he felt one of the ornaments give way under his grip. He withdrew his hand, but not before he clenched his fist to recover the black-metal flower decoration, which rusted off the gate. He had the rush of a typical treasure hunter as he quickly stuffed it deep into his pocket. He felt this was a historical piece given the circumstances.

On either side of the stairs were two high walls; on top of each sat a menacing lion of bronze. This side, with the wide stair entrance,

the building faced the city, not the Danube. Balazs looked up. Next to the giant lion stood a young man above them, waving a large Hungarian flag with its missing communist symbol of hammer and sickle. The large red, white, and green gently lifted into the cool breeze on its long pole. He was a handsome, muscular young man in his early 20s, wearing the heavy boots of the working class. His shirt was undone despite the chilling breeze, which caught his long hair along with the flag.

Kati froze suddenly. "Sandor, something is wrong! I don't like this. This can't be!" Sandor, now turning to his wife who looked very pale, said, "What's wrong?" "I don't know, but it's too perfect, I don't want you to go up there yet!" A few people about them began to chant Sandor's name, then more joined and soon thousands joined calling upon him to stand and deliver the revolutionary words. He turned, encouraged by the crowd, with his singular purpose and extended his arm toward the young man holding the flag. He would need to be pushed from below and hoisted from above to get to a position where everyone could see and hear him.

Suddenly, like thunder from the sky, a deafening burst of machine-gun fire rained down upon the unarmed innocent people. It came so unexpected that people stood frozen. Sandor fell back still holding onto the severed arm of the young hero who was no longer standing above him. He became a mass of warm, bloody flesh torn asunder and spread all over Balazs and Kati and everyone below the blood-covered lion. Horrified, Sandor lay on the ground not knowing whether it was his own blood or not, that covered him. Balazs saw him drop the arm reluctantly as he separated his fingers from the boys. The blood-soiled flag slowly slid off the lion to the ground covering the remains of the young hero. The terrifying scream of bullets came flying by penetrating through layers of people. They fell all about them, dead and wounded.

Earlier the AVO set up their machine-gun stations across the rooftops of the government building to deliver death upon the unarmed, defenseless people. There was no shelter in the open park for anyone, save for the person in front of them. Sandor was grabbed

by someone and dragged to the left side of the wall as the family crawled and scrambled amid the flying bullets behind. Balazs could see the missiles that missed their mark hitting the pavement with sparks. He could smell the ozone in the air. He knew he would get hit, too. There was no chance of survival from the rain of bullets. All about him people were falling. They fell in front of him as he stepped on their bodies. His feet sensed their flesh beneath as they slid over crushed bones.

He and his brother were shoved into the corner of the building where two walls converged. Five or six layers of people collected there—following behind them, pressing backwards for shelter to avoid the onslaught. He heard his Barna scream from pain as the pressing mob shoved him into a wrought-iron frame covering a basement window. Balazs, at this age, was stronger and more fit than his older brother and was able to free himself enough to stand up at the last row. His father and Kati were somewhere on his right—he could sense but not see them in the maddening chaos.

The firepower increased and he saw the front row fall down to the ground. Balazs faced totally out and the pressure of the frightened people pushing backward actually pressed his body upward so he could see the whole park. It was filled with thousands of people running in all directions—screaming and yelling. There were fallen everywhere. He saw parents who were still clutching their children's bodies in their arms and children who held tightly to their dead parents next to them soaked in their blood. It was incomprehensible!

A white ambulance with a large Red Cross sign pulled up from the direction where the shots came. White-robed medical emergency people with stretchers rushed to pick up the wounded. As they ran they were mowed down with bullets and dropped dead to join those they were about to save. The wave of machine-gun fire came toward them again with deliberate deadly accuracy as the metal ricocheted off both walls. The plaster and the sharp broken stone bits penetrated the victims in the face before entering their chest and vitals. Again, another layer of people in front of him doubled over dead.

There were only three rows left as buffer in front of Balazs and

his family who were facing certain death like the others. There really was no escape; it was only a matter of time. They wondered how long it would take. Kati turned to the left from the tight squeeze and saw Balazs just standing and staring expressionless, observing every detail. She wondered if this were the last time they would ever see each other.

While Balazs was looking at the carnage and the devastation, he noticed a man running at great speed; behind him the bullets were tearing up the ground. For a moment, he seemed to be winning, but then a string of fast bullets caught up with him and in an instant separated him from one of his legs. His inertia continued to carry his body forward causing him to roll many times with one limp leg flopping with him. The horror hit Balazs even more when he noticed that the leg the man left behind severed from the thigh, kept kicking and moving in the running motion bending at the knee, jerking at least five or six times in the dirt in a reflex, attempting to catch up with its owner.

Again, the inevitable wave of bullets returned to seek out the small crowd. This time he saw a woman tightly squinting her eyes ready to take the bullets since she was the next in row to die. The shouting stopped, the guns went silent then she opened her eyes thinking she was already dead. Incredibly a Russian tank pulled up the side street—its cannon aimed at the AVO rooftop position and with a single perfect shot blew out the miserable murderers. A loud creaking came from the right side of the group as Sandor and some of the stronger men began to break a door down to escape into the cover of the building.

Another group of AVO men began to fire from where the first ones left off, but several more of the Russian tanks joined in and a small battle ensued between them. Miraculously the Russians decided to take sides and protect the unarmed, innocent people. Another Russian soldier guarding the Parliament opened the door from within. Quickly the group poured into the stairway. All in all, about 30 were left alive out of countless souls jammed into the corner of the

building. Some were wounded and bleeding badly. Sandor gathered his family. The soldier smiled and kept pulling the people in. This was the first time they ever saw a Russian do something good for the Hungarians. Almost two hours passed before the Russians overcame the AVO with their cannons and machine guns.

There was permanent silence from the guns; smoke lingered over the brown grassy knoll like fog. Bodies were lying all over the steps, the grounds and piled over each other in every direction and position. Red blood splattered and flowed everywhere, from the stones and the steps of the Parliament. It soaked the brown blades of the dead winter grass in the park. Hundreds of people were coming in from everywhere to help the wounded and to care for the dead. Doubtless, this was one of the most horrible genocides in the history of Budapest and of Hungarians in general. The city was shocked into mourning and now thirst for revenge!

THIRTY FIVE

PEOPLE UNITE
FOR FREEDOM

THE CITY WAS armed overnight. Now it didn't matter that civilians were not allowed to own weapons of any sort. If discovered doing so, before it was punishable by death or the Gulag. Hungary was manufacturing much of the arms and munitions for the Soviets. Naturally the workers at Csepel and elsewhere in the city and in other manufacturing plants opened the warehouses for the fighters of the resistance. The streets were filled with multitudes of youth— girls and boys, from 12 and up—armed to the teeth. Katica, Sandor's older sister, her husband and two teenage sons Csaba and Attil lived in Pest, across the street from the Killian Army Barracks. She went to dial Sandor on the phone.

In the meantime, the government called upon the commander of Killian Barracks, Pal Maleter, to crush the revolution and join their "Soviet brothers." Maleter met with his men of 400 well-trained but not so well-armed young officers. Generally, the fortified barracks held more than 2,000 in its four-foot thick walls, but it was not so now. The decision was unanimous to support and protect the

people, against their orders to stand by the Russian army. This was, despite the fact that the consequence of their actions would result in death.

Not long after their decision, preparations were made for the battle. The information about the officers' defection was passed to the authorities and the Russians responded immediately. The first armored Russian car appeared from the Petofi Bridge, across from Buda, headed for the Killian Barracks. The reconnaissance car approached from Ulloi Street. The officers nervously waited until it crept into range. Within seconds it was ablaze by "Molotov" cocktails hurled from the soldiers stationed on the roof.

Ironically, the Russians taught this tactic to them. A simple homemade device of a gasoline-filled bottle and an eight-inch fuse lit and thrown at the intended target. Several other armored cars followed the first, but seeing that the resistance succeeded in destroying the first they were more cautious. They began to fire on the barracks from a safer distance. This time the Russians were surprised by attacks from all sides of the street by young civilian fighters.

The convoy was destroyed at the front and at the back trapping the remaining Russians inside the barricades created by the already burning wrecks. The fighters, recognizing the situation, put 15 armored cars out of commission killing their occupants within a few hours. The attack on the inner convoy was effective and thorough. Despite the gunfire from the armored cars, that killed and injured many, it resulted in a victory for the Hungarians. This became the first real battle of the revolution in Budapest.

One ingenious civilian who joined the fight of the officers realized that one of the big guns on a Russian vehicle was not totally destroyed. It was quickly dismantled and dragged off to be restored. He was successful and this gun was placed in a strategic position at the corner courtyard in front of the Corvin Cinema below the apartments where Sandor's sister lived with her family. This was an excellent position, with views of three boulevards, yet, the gun itself was undetected. As the fourth armored car came in sight of the barracks, this civilian carefully aimed, hoping that the gun, yet untested,

wouldn't blow up in his own face; he fired and blew up the Russian armored car with perfect accuracy.

One by one the convoy was destroyed. This massacre seemed too easy for the resistance with only a few injuries on their side. Maleter knew that from then on the Russians would return with tanks realizing that the Hungarian people were determined fighters. No one at this point in the history of communism ever challenged the Soviet army in the occupied countries.

The soldiers were correct—the following battle was against the tanks, which were now fast approaching the barracks from every direction. From better positions and with better guns, shooting from greater range, the Russian tanks began methodically to pound the building where the officers awaited the attack. Huge parts of the thick corner wall came tumbling down with the first barrage of the cannon along with the bodies of the dead and wounded Hungarian soldiers and civilians. With the continued attacks, the casualties became enormous. The defeat of the Killian Barracks, which was a significant symbol to the resistance, meant the lights of freedom would be extinguished swiftly by the superior and invincible tanks.

The Russians felt the same way and the tanks' drivers, emboldened by their easy victory, began rolling closer toward their targets. No sooner had they made this fatal move when children appeared from buildings with buckets of soap and water and with cooking oils from their kitchens. They ran beneath the sights of the guns and splashed the pavement of the approaching tanks. The massive iron treads began to slip and slide on the slippery road heaving the heavy machinery in every direction.

Another group, brave and fearless girls of about 13, ran to roll grenades between the treads which then blew asunder in every direction, but the metal debris injured many young attackers, too. The tanks, thus disabled and anchored, forced the Russians to open the hatch for an escape. In that instant, a barrage of Molotov cocktails flew through the air from windows above. Some hit directly into the opening and some over the tank. The Russians were scrambling in all directions out of their vehicles, screaming and running

as living torches. Some were shot and some were allowed to continue burning.

The city was filled with identical episodes everywhere that day. Many children and fighters died from the guns of the tanks. However, all the tanks that were dispatched by the Russians were destroyed and their occupants killed. Sandor picked up the ringing phone as the family returned from the nearby streets. Katica told him about the incredible fight the Killian Barracks put up against the Russians and that their apartment was totally destroyed by a tank's cannon shot. They had lost everything! Yet, they felt fortunate in being spared. They were at their neighbor's apartment watching the battle from a better venue and moved to Sandor's oldest sister's home to make the call.

Although many of the fighters' positions were spotted by the tank commanders and simply destroyed by well-aimed cannon shots killing hundreds at a time, the battle went well. Many Russians were killed and much of the hated AVO flushed out too. Sandor and his family had just returned from a gruesome exhibit of desperation and suffering. Down the street from Madacs Square, where their apartment was located, stood the headquarters building of the AVO. Throughout the night they heard the heavy fighting that took place as the people attacked the building killing most of the defending secret police. In the pursuit of the escaping scoundrels through underground tunnels, the fighters came upon the torture chambers the city residents long suspected were hidden beneath. No one who survived and was released knew where he or she had been taken.

This was constructed many levels below the street and filled with hundreds of political prisoners, men and women. This is where the tortures or as the communist called it, the "rehabilitation," took place if you did not stay in line or if you were the target of an informant. The conditions and the suffering that the liberators beheld were sickening beyond their imagination. The cells were immediately opened and the captives released. The cornered AVO men who surrendered to the victors were typical of cowards begging for their release and mercy. They were dragged above ground to a

small peaceful park with benches. This was always kept manicured with flowers and trees, deceiving the people of what horrors took place below.

It was October, the trees and bushes lay barren of leaves. The angry, revenge thirsty fighters tied the legs of a dozen or so, kicking, squealing AVO men and strung them upside down from the trees. On this cold morning the crowd looked calmly on, remembering all their loved ones and fellow Hungarians who were murdered and tortured by these sick, vicious, dogs. They were literally the bloodhounds of the Soviets and their dark regime.

The crowd was quiet at first. They had never seen these monsters so exposed out in the open, helpless and vulnerable, dangling from trees with torn clothes; their white flesh looking tender. "They don't look so tough now," remarked a bystander. "What the hell," said another as he approached to spit into the face of one of the frightened AVO men.

Then the crowd ignited and lost control, closed in on the victims to pay their homage, too. In a very short time they were kicked and punched, spit upon, defiled with urine and shot many times through their flesh. The bodies writhed in pain as they tried to free themselves knowing that the inevitable was approaching. They screamed the screams of their victims echoing the years of suffering which they had dealt out to the innocent and the helpless.

By the time Balazs and his family were able to push through the crowd and fill their curiosity most all of them were dead or near dying as some were used as knife-throwing targets. As awful and inhumane as the sight was, not even Balazs's family felt compassion or sorrow in their hearts as they looked at the fate of these killers. They knew there were still thousands of these genocidal bastards running around Hungary, disguised and infiltrating every level of their life. As Balazs stared at the bloody, hairy white body dangling in front of him, he wondered if this could have been the one that hurt his uncle.

Eugene's older son, Eugene Jr., was shoved into a cold underground cell. He could tell by the smell of mildew and the dampness

of the wall, which his naked body was thrown against. The humiliation began with the stripping of his clothes and while tightly secured, he was forced to face an incredibly bright light. He could not see his assailants. Someone held his eyes open by pulling on his sparse hair. The lights made his eyes tear so much that he could feel them streaking down his cold skin.

Someone kicked him in the stomach and the thrust brought vomit into his mouth. The AVO could see that his delicate frame could not take much. "This one is not going to be much fun," said one, while another laid a heavy fist into Eugene Jr.'s mouth breaking some of his front teeth. Before he could taste his blood pouring out of his loosened jaw and remaining teeth, he felt an enormous buzzing sensation in his head and loss of hearing.

He came to, not knowing when. He felt his lips swollen and split. One of his eyes was stuck shut with blood. The AVO method of breaking people in was first to deny them the knowledge of time. The intolerable bright lights were always directed into the face of their victims and the very small feedings were irregular to confuse them, sleep was deprived and interrupted. He felt the pangs of hunger and thirst. He dared not ask for anything knowing that a beating would substitute the request.

Somehow he understood, even without previous experiences of captivity or torture, the sense of evil. After what seemed an eternity he could smell the food before he heard the tin plate hit the ground. Eugene Jr. knew they would keep him alive with food in order to continue the torture. He could not imagine at what price was life!

As he reached with chained hands toward the perimeter of the light, where he recalled the plate being dropped, a stream of warm urine hit his face, body and hands. His plate was contaminated; the AVO men laughed. He was given nothing more for what seemed like days in the silent solitary room. Endlessly he heard excruciating screams of suffering victims through the walls all around him as he tried to prepare his mind for his turn. He knew he was innocent of collaboration with the fascists and the imperialistic capitalists of America and he also knew that his captors were aware of his innocence too.

While delirious, from the beatings and tortures, he recalled faintly, voices from some lost time informing him of his crimes. He knew this was going to be one of the mock trials and the "softening" process is what he must endure. He also knew that the trial would end in a guilty verdict no matter what, because like thousands before him who were tortured, he would sign all the confessions to end the pain.

As the cruel AVO men knew from practice, the survival drive would take over Eugene Jr. Out of starvation he consumed some of the food causing him to vomit his insides out. He had been living in his urine and excrement for so long he could not smell the rotten food that he ate. His humiliation began on his genitals and rectum. The team alternated the methods by gender. The female AVO were feared the most because they caused the greatest pain and humiliations to the prisoners. Some burned and scorched the scrotums of their helpless victims or probed an object into their rectum breaking it inside.

These despicable creatures would force them to perform cunnilingus on them while their vaginas were unclean and then defecate into their faces. They often ended their so-called "fun" by inserting thin glass tubes up into the urinary track—smashing their penis to break the glass into smithereens. There were no doctors or any care for these poor victims—if they did not die from shock or infection, their broken unset bones would mend into contorted monstrous shapes.

Only the Nazi female prison guards paralleled the female AVOs' creative methods. In the eternal inferno of time Eugene Jr. suffered from bucket drowning, standing for hours on one leg or not being allowed to urinate. Beyond the unimaginable and inhuman pain, he was forced to drink his own urine or eat his own excrement. His captures were not done with him yet. One of the AVO men relished in the act of fingernail pulling after he beat his victims senseless.

Eugene prayed for his death after surviving each torture despite his thoughts of his family. He thought of how much he wanted to care for them and love them, if he survived this hell, but he wanted

no hope! Having hope was a trap to suffer further and it hurt so severely that death was more beckoning than life; death was becoming the sweet liberator. When his time came for the trial, he signed papers consisting of many sheets of confessions of guilt and collaborations against the good working class of Hungary and therefore he was a traitor to the Soviet Union. Guilty as charged, he waited for the firing squad.

With Stalin's death, many surviving prisoners were released. One day the doorbell rang and Elizabeth, his wife, opened the door.

An emaciated figure of an old man stood there hardly able to hold himself up. He stood, unable to speak as he stared through tear-filled eyes at his wife who did not recognize him. His abused body could not embrace the powerful emotions and he lost consciousness. She screamed upon realizing that this was her lost husband, Eugene Jr. Her sorrow mixed with incredible happiness nearly cost her sanity. Quickly, she dragged his listless, frail, light body inside the apartment before fate would rob her of him again. He survived, silent and speechless for years.

Balazs searched for sympathy for the hated AVO man hanging before him, but only found void. The bruised body was turning blue in the cold air and his blood brown. A large, gaping wound dripped clear liquid and dark blood, mixing it into the dirt below. As he stood there deep in his thoughts he was engulfed with feelings of hatred and dread. A man in his work clothes with blood-soaked band on his wounded arm, walked up to the body. He took a long, deep drag off his cigarette and adjusted the strap of his machine-gun slung over his shoulder. With an expressionless face and a deliberate move, he stuck the still burning butt into one of the gaping wounds.

The flame sizzled against the moisture and extinguished with a small puff of smoke, which streamed past Balazs's senses. The smell of burning human flesh nauseated him. He quietly turned toward the man and said, "He deserved worse." But, the man already disappeared and melted into the crowd.

THIRTY SIX

THE STORM CLEARS

THE MOOD WAS jubilant at the complete victory over the AVO and the Russian occupying forces. The farmers from all over the countryside poured into the city. They came on horse-drawn carts, on horseback and in trucks from collective farms laden with supplies. People showed their gratitude by gifts of abundant and free food for everyone in the city, especially for the fighting families.

People everywhere joined to help the unfortunate families who had lost relatives or had wounded members. On every street corner were posted empty, unguarded donation boxes inscribed "For the Families of the Fighters." In the evening, children collected the revenue to distribute among the needy. No one ever touched the collection boxes and they were full by the end of each day. Hundreds of stores were wide open, either with their storefronts broken or their walls demolished by tanks and cannon fire, with the goods thrown everywhere. People restrained from looting despite their needs and actually put the often-precious items back into the stores.

No one was going to taint this revolution in any form, despite the fact that the still-operating government radio broadcasted from

some hideout expected propaganda: "Dear comrades and faithful citizenry of the Communist Revolution—we have been attacked by underground fascist and reactionary forces supported by American Imperialists. We will prevail and protect you with the support of our faithful Soviet brothers so be patient as this is a temporary situation."

Everyone chuckled at this predictable communist propaganda and the usual spin of the truth. The revolution was fought by the disillusioned proletariat and youth communists "pampered" by the system and by ordinary citizens who were fed up with the tyranny of the Soviets and the Hungarian puppet regime. There were no outside imperialist forces as much as the people hoped that the UN would get involved.

There were many overtures to that end from the Hungarians to the West, so Vice President Richard Nixon of the United States pushed for an intervention by recognizing Hungary as a free Republic. Gen. Dwight Eisenhower, the President of United States, refused to send any military divisions to be stationed in Hungary or even to recognize the new government as "legitimate." The Hungarian Revolution, which caused a terrible blow to Russian international politics, was totally undermined by Eisenhower's decision. It sent a message to the world that, indeed, the Russians are right and this was not the uprising of the people in Hungary, but rather what the Russians called a fascist movement undermining the "legitimate communist government."

People of Hungary still hoped that the West and the USA would come to their aid before the Russians returned in force, and return they did!

Sandor took his family again through the streets of the city. The damage was tremendous; many buildings and stores were destroyed. Thousands of dead Russian soldiers and AVO men were dead everywhere covered with white powder of lime to prevent decomposing and disease.

On October 24, with Rakosi, Gero slipped out to Russia. Nagy, Imre was appointed by an emergency committee as premier of

Hungary with Janos Kadar who assumed temporary leadership. Hungarians agreed that many social services, if reformed, would benefit the nation and would be kept. They were hoping to build a new government modeled after the Swiss and the Swedish systems.

The new revolutionary Workers' Council and local committees prepared lists of demands, including the removal of the Soviet Union and its troops from all of Hungary. They called for the dismantling of the secret police, AVO, and demanded the withdrawal of Hungary from the Warsaw Pact; they wanted free elections, freedom of speech, of the press, free assembly and free worship. They wanted Hungary's neutrality. Cardinal Jozsef Mindszenty, whose years of imprisonment by the communist symbolized religious oppression, was now liberated from captivity. This marked the highest point of the revolution along with the seeming withdrawal of the remaining Soviet army.

Western chronicles wrote, "It appears that little Hungary, in an incredible feat of national heroism, had liberated herself from the shackles of the Soviet tyranny without outside help. Admiration for Hungary is boundless all over the free world and hundreds of millions hold their breaths over the news coming from Budapest. Within a few days, the volcanic eruption of the indomitable Hungarian spirit had shaken the world in a way almost unexpected. Amid torrents of Hungarian blood, a new Phoenix of Liberty emerged from beneath the Hungarian soil."

Many free newspapers that were able to report the truth were hand-distributed to the population. The victories of the freedom fighters and also all the aspirations of a nation to be freed from bondage were reported. As people read the lines out loud they were overcome with emotions. Only Hungarians at that time of history could have understood what it meant to be free of Russian imperialism. **There was not a soul in Hungary that doubted the eventual helping hand of the Western Allies to preserve the hard-earned victory, especially with the constant reports of Radio Free Europe on the progress of the revolution.** There were rumors that the borders to the West had opened and the idea of no longer living in a political concentration

camp they called "Russian democracy behind the Iron Curtain" sent an indescribable emotion through everyone.

The large spontaneous march through the streets of Budapest was such a historical scene that one only sees on paintings from masters in the museums. The city's two million people, Sandor's family included, jammed the sidewalks as they applauded thousands and thousands of victorious freedom fighters marching together arm-in-arm through the avenues of Budapest. The fighters were an incredible mix of young and old, men, women and children who were solidly outfitted with "Russian guitars" and grenades. Many who were injured proudly wore blood-soaked bandages long overdue for fresh ones. His heart stopped dead on seeing several of his classmates, dirty and bloodied from fighting carrying arms and proudly grinning from ear to ear, many of them girls of 13 and 14.

He tore free of the crowd shouting their names and as they embraced he joined them to proudly march in their company. Large groups began singing the outlawed Hungarian anthem and it seemed that the cheering would never stop. As they marched past many destroyed tanks, guns and piles of the dead enemy, his classmates pointed out where they fought victorious battles and where they lost companions to bullets. Balazs climbed onto many disabled and captured Russian tanks to get the feeling of victory. He could not believe how shy girls who sat in class next to him became fighters overnight, handling machine guns and actually killing Russian soldiers and AVO men.

They became giants in his eyes, but deep inside he envied them. He found out from the girls that there were many others from his school who fought and died in the first few days of the revolution. They learned to take tanks out with Molotov Cocktails. Often, the only choice left to destroy the tanks' sensitive areas was to employ the ultimate weapon. The suicide bomber, who brought the homemade bombs all the way to the enemy. For hours the march continued until the early darkness of winter set over the city. However, the lights were lit in all the homes as everyone celebrated with their friends and families.

THIRTY SEVEN

THE RETURN OF
EVIL IN FORCE

THE GRAY LIGHT of winter's morning gradually separated the contours of rooftops from the sky. Slow streams of white smoke rose from thousands of chimneys in a straight line into the sky like ribbons connecting heaven and earth. Everything else was still in the usually loud bustling city of streetcars, trucks, buses and multitudes rushing to work. The streets were empty. A nation drunk with the taste of newfound freedom had a hangover and was in its slumber.

Suddenly, and without warning, Budapest shook into sobriety with incredibly loud explosions. Each loud thud shook the ground and the buildings. Lightning flashes lit the gray sky and black smoke rose in every direction, as buildings trembled and vibrated under their quake. Windows cracked if they were not already blown out from the rattle and the pressure in the air with each blast of explosives. Sandor and his family jumped to their feet, running in every direction of the dark apartment, terrified. In an instant, they realized that the Russians were back!

Sandor tuned in to one of the new, free radio stations called

"The Fox." The anxious voice of the reporter warned the citizens to stay in their dwellings or, better yet, if they had available bunkers to go there and prepare for a major bombardment! They should take food, water and kerosene lights with them. More than 2,000 newly designed tanks were sighted the night before on the perimeter of Budapest. These tanks were unlike the earlier ones which the freedom fighters were able to destroy with Molotov Cocktails. These new models had no blind sights at the gunner's station. Any adversary could be killed with the additional guns mounted on them. They were faster, larger and more powerful. They approached from Czechoslovakia, whose residents did not warn the Hungarians.

There were rumors that hundreds of young fighters, mostly school girls, rushed to the main boulevard leading to the city. Naively, they lay across the pavement holding white flags of peace to prevent the Russian force from entering the city. This compassionate appeal, that would have startled any civilized army into a moment of hesitation, had zero effect on the Mongol divisions that the Russian communists now dispatched to crush the Hungarian revolution.

They were ordered to kill anyone they saw and blow up anything that looked like a fortification for resistance. Most of these soldiers were illiterate and backward, vicious dregs of the Russian military force. The retaliation on the Hungarians for having unveiled the deceitful Russian communism to the Western world was going to be the bloodiest ever. Most of these soldiers were not even informed about the country they were sent to annihilate and many, when driving their tanks on the shores of the Danube, thought they were in Egypt by the Nile.

As if the youth lying across the pavement with white flags of surrender were not human, but only so much debris, the Russian tanks kept rolling forward without hesitation. Proceeding slowly, crushing bodies under their massive treads, tearing and separating flesh from bone as the unrelenting martyrs stood their ground to face their inevitable fate of dying one by one.

By the time the city woke, it was totally surrounded by tanks. The heavy artillery was set up on the highest point at the Citadel of

Buda, where the Russian monument was erected, ironically commemorating the "liberation" of the Hungarian people by the Russian army in 1945.

Balazs dressed hurriedly and put his coat on. This time he would not be left out; he would join his friends! Sandor, knowing his son well enough and quickly realizing what Balazs was up to, got physical with him for the first time. He was unable to contain him, so in his panic he called for Kati to get some belts. Sandor struggled to hold his adamant son down despite his large frame. He found it impossible to manage the determined teenager. With Kati's help, they tied him to one of the heavy antique dining room chairs with three of Sandor's leather belts.

Almost frothing at the mouth with frustration and rage, Balazs protested vehemently. He wanted to be with his classmates. He had the feeling of complete selflessness—not caring whether he lived or died. He wanted justice and freedom for his country. The same emotion for the cause, which swept the rest of the Hungarian youth to the streets and fight such a foe, also boiled in his blood. He loved his country and the people in it with a passion and he hated the Russians to their core. Balazs realized that whatever was accomplished by the sacrifices and heroics of thousands up to this point was now in jeopardy. He simply did not care what happened to him, he felt totally one with the fighters.

He cursed his father rudely and insolently for being a coward. He insisted that his father and brother Barna should join him— seek out a group to arm them and fight.

Just a few days ago Sandor was asked to drive a truck loaded with arms for the freedom fighters, but he refused to Balazs's dismay and shame. Now, he had a chance to redeem himself in his son's eyes. The explosions kept coming closer and closer with more frequency, so loud that they could hardly hear each other.

As Balazs was yelling at the top of his lungs trying to dislodge himself by rocking his body to tip the chair, Kati calmly walked over to him. She looked him lovingly in the eyes and with one swift

motion slapped him across the face so hard that Balazs thought his head spun off his shoulders. The sudden shock of her blow certainly drowned out the explosions outside and the unexpected sobered him into reality. Kati was not a sentimental type. She had great and deep love for Balazs, but she always knew when and how to act to meet any situation.

She looked at his stunned expression. Rubbing her aching hand as she explored Balazs's face to see if her action had accomplished the desired effect. Then Kati embraced and kissed him. She said, "God help us all now, Hungary is abandoned by the Americans and the Allies and we face the Russians alone." Whoever fights them now will surely die as a sacrifice to a lost cause! I am not going to lose any of you to that!"

Early in the morning, not long after the invasion of the city, they heard fighter jets rip the skies above. They flew so low to the buildings that people were convinced that missiles were being hurled at them. Everyone scrambled to basements and bomb shelters of buildings in panic, trampling one another down through dark stairs and corridors. In the deep cellar, the smell of coal and dampness chilled the bones and nauseated the occupants. It felt more foreboding than safe. He had the feeling that he'd rather be above on the fourth floor seeing what fate would befall him than be caught down below under the rubble of thousands of tons of concrete debris. To be crushed or worse, die a suffocating slow death.

Hundreds of tenants huddled together as they gathered with frightened faces around a couple of lit kerosene lamps. Children cried and women prayed aloud. It had been only 11 years since the war and the memories of the bombing of Budapest. They remembered the Russian soldiers who descended on the Hungarian population—raping, pillaging and murdering innocent citizens indiscriminately. This surely will come to pass again. The question was not if, but when. How long could the freedom fighters with their limited arms and numbers, hold out against the most numerous and powerful army of the world? The Russians dispatched 2000 tanks,

the same size of force against the Hungarians that Hitler used to invade France in 1940.

Finally someone connected a wire from a radio to an electrical outlet. The light was also turned on revealing age-old dirt and spider webs. Though it was a little easier breathing without the kerosene, the flickering of the lights frightened the children even more. Sandor looked at his grown sons as he remembered the war. They spent many months down in the bunkers then. There were no provisions left and the bombardment lasted long periods of time not allowing people to ascend to find food and comfort.

Everyone was sick from the cold and dampness. People had to relieve themselves in the cramped bunker in the presence of all. The stench was horrible to add to all else. It was winter then, too, and once the sirens went off indicating a lull in the raids, Sandor rushed out along with thousands to forage in the city.

He was lucky one day. Within two hours of searching, he came upon a dead horse half cooked by the explosion of a bomb. Already several men were carving at the carcass and since he did not have a knife, the others carved a sizable hunk from the rump for him, too. They were all starving from the meager rations of potatoes, salt and water. The horsemeat, more pungent than beef, tasted good to all. He relished being the provider of the bunker's population that day. Every one was quiet perturbed as they listened to the free radio stations still in existence broadcasting the gloomy events taking place above ground.

On the day before the new invasion, November 3, a Russian delegation was sent to Budapest, headed by General Malinin, asking for a Hungarian committee with whom they could work out the "details of the Soviet military's evacuation of Hungary." A short time afterwards, the committee was hastily formed and headed by the newly appointed Minister of Defense, General Maleter, who was driven to the island of Csepel. After a while, Maleter called his delegation in Budapest and told them that he was safe and everything was in order. When he related some of the discussions of the meeting, the Hungarians were appalled at some of the Soviet officers request that

a "rain of flowers" be showered upon the departing Russian soldiers at their withdrawal by the Hungarian population.

Their hopes were crushed soon after they realized that it was simply a ruse to lure the newly formed government leaders into a trap. Maleter was arrested shortly after. The day following the treachery, on November 4, Nagy, Imre the newly elected by the people, announced the Soviet attack to the Hungarians and to the world. He appealed to the United Nations for help. The Russian forces quickly occupied the bridges, highways, industrial centers, and the main prize for Russia, which they had been robbing since 1945—the Hungarian uranium mines, the third largest in the world situated in the southern city of Pecs.

Soviet paratroopers landed in the city of Gyor and at Budapest's four airports. Heavy fighting of resistance broke out all over the nation as the armed Hungarians—civilians, men, women, and children alike (who never fought before)—were joined by the local Hungarian military to defend the country. Until November 9 many of the free radio stations informed the residents what defeats the freedom fighters suffered despite the heroic defense of the freedoms gained earlier. The bloodiest battles were taking place at Csepel, where almost every one of the workers, save a handful from thousands, turned against the Soviets. While fighting off the Russian military might, they succeeded in destroying one of the attacking jets. They accessed fuel lines and oil to create homemade flame throwers and destroyed many tanks.

Meanwhile, the Killian Barracks suffered total destruction as it still remained a fortress after the first attacks. Outside of the severely wounded or dead fighters, the Russians could find no one, as many of the survivors escaped through the sewer system. Above the city on top of the hill of Buda, after a long battle, both sides sustained heavy losses. When a group of young freedom fighters ran out of ammunition and appeared with a white flag of surrender to the tank commanders, they were mowed down on sight by the Russians. This practice was prevalent throughout Hungary as the Russian tanks destroyed entire building blocks if they suspected one fighter

taking refuge. If not found, they rooted out the surviving residents instead and executed them on the spot. If they found none, they killed anyone they saw on the streets—women, children—it made no difference to them.

From time to time Sandor and his family quietly made their way up to the apartment for water, food and bathroom facilities. When they could, they crawled to the phone on the floor to avoid being seen and shot at through the windows. Sometimes they were able to contact some other family members to inquire about their welfare, but most of the time there was no service. When they realized that one of the windows was blown out, Balazs and Sandor braved the site by crawling to the window to spy on an approaching tank which they heard entering their street. As they raised their heads slightly above the windowsill, they saw from the right a huge tank speeding toward a telephone booth. It was across from an empty building site used for dumping rubble.

A lonely freedom fighter was running as fast as he could a few meters in front of the screeching, clanking tank treads. They saw the young man with his machine gun in hand quickly turn and take refuge in the open booth, then close the door. Sandor and Balazs could not believe their eyes. What an idiotic decision! All he had to do was take a short sprint to enter a building with an arcade leading through to the adjacent street and then to his freedom. He was obviously not from their neighborhood and was unfamiliar with the terrain. Father and son were petrified as they watched the Russian tank slow down to a crawl, then stop completely.

As if it were some live, intelligent metal creature, it seemed to look at the booth. Backed up, then turned again and continued slowly to face it. Its large gun was lowered inch by inch pointing into the young man's face. He was trapped. He looked down the barrel of the tank as the black diesel smoke blew from its backside in rapid succession. Sandor and Balazs knew that the next moment would bring the awaited, fateful blast of the cannon. There was no machine gunner atop the tank.

It was an eternity before the tank's sadistic commander engaged his gear cunningly and slowly, probably with glee on his ugly face. He began to crush inch by inch the entire compartment with the metal and glass door. The front of the booth cracked, warped, then the glass burst splintering into millions of pieces. The entire booth was ripped off of its concrete base and backed against the stone wall of a courtyard. The young man, realizing that his death was going to be slow and agonizing, tried to escape in panic through the broken side glass, slicing his already pierced flesh, but to no avail. Trapped!

His gray garment, soaked with blood, hung heavily on his young body. The tank, like a cat with its victim already injured beyond redemption, stopped for an ever so slight moment to lend its victim false hope of escape. But, as the man's arm struggled to extend through one side of the already tight, flattened wreckage of the booth, the tank came forth relentlessly and methodically crushed the metal box against his body, pinned and totally trapped him.

Despite the excruciating pain, the young man held his "Russian guitar" in his free hand as best he could, half crushed and probably by now pierced through several of his vitals by the splintered metal of the compartment. He raised it slightly and began to fire at the tank aimlessly. His listless body vibrated with the rattle of the machine-gun rounds. The tank stopped to enjoy its invincibility—allowing the sparks to fly harmlessly off the armor while the empty metal jackets fell impotently to the ground.

Again, the tank renewed its slow torturous maneuver toward its victim. More glass popped and broke and fell onto the pavement. The booth became imbedded, one with the fighter's body. Only then did they hear his horrible screams of agony and pain.

They could almost feel his ribcage being crushed into his lungs and heart as the gurgling sound of blood-filled lungs finally drowned out his scream to a silent gasp.

Balazs and Sandor were in such tight embrace they could have broken each other's ribs. The tears streamed down their cheeks as the terrifying scene penetrated their psyche. The sound of the tank's

sudden move made them alert again. It reversed and began to back up to the open park where the rubble was. It could not get read of the booth, no matter how like a bear it shook to rid itself of its victim. The cannon somehow got stuck to the carnage. It charged forward and rammed the wall to knock the irritating wreckage off, but to no avail. It went sideways and tried to scrape it off. All the while they saw the limp body bounce and hang within the crushed booth.

This was like some gruesome circus puppet show. The frustrated tanker with his dilemma finally turned back toward its original destination of the open boulevard then quickly rolled out of sight with its trophy. A few minutes later they heard an enormous blast. They knew the tanker found his solution.

THIRTY EIGHT

ELUSIVE LOVE

THE FAMILY SPENT less than a fortnight below ground. Despite the fierce resistance by the fighting civilians and the Hungarian military that joined them, they were no match for the power of 20 divisions and fighter jets. All who fought now knew they would die and die they did by the thousands. More than 25,000, that included thousands of children fighters, perished!

By November 14, most of the major fighting was extinguished by the ruthless Soviet army. The echoes of lone maverick, machine guns were heard here and there sporadically throughout the city. Everyone deducted that they would be silenced soon as the explosions of cannons roared. Then an entire building would fall, followed by a dust cloud and silence. Only an occasional, painful scream could be heard of injured and trapped survivors. Budapest lay in dust and rubble again as it suffered major physical damage.

There was much politicizing and philosophizing among the bunker residents over the ten-day stay underground. The country's free radio stations faded out like their hope as the broadcasters were methodically routed out, caught and executed by the Russians. The

dark overcast of Russian communism began again to eclipse the short lived blue skies of freedom over Hungary.

Millions of Hungarians and millions of free people in the West listened to the last pleading broadcast of a rebel radio station to the world, before it was silenced:

"Civilized people of the world: On the watchtower of 1000-year-old Hungary, the last flames began to go out. The Soviet army is attempting to crush our troubled hearts, their tanks and guns are roaring over Hungarian soil. Please do not forget that this wild attack of Bolshevism will not stop. You may be the next victim. Save us, SOS, SOS...Show that the United Nations can carry out its will and by its resolutions declare that our country shall again be free. We appeal to your conscience and call on you to act immediately...

"People of Europe, whom we defended once against the attacks of Asiatic barbarians, listen now to the alarm bells ringing from Hungary. Civilized people of the world, in the name of liberty and solidarity, we are asking you to help. Our ship is sinking. The light vanishes. The shadows grow darker from hour to hour. Listen to our cry. Start moving. Extend to us brotherly hands.... "God be with you and with us." **The plea for help fell on deaf ears in the western democracies.**

To the many captured, punishments were administered swiftly. More than 20,000 Hungarians were deported to the Soviet Gulags. Thousands were sent into the usual Hungarian torture chambers, political jails, and the clutches of the AVO's existing hives. Janos Kadar, a vicious communist puppet to the Russians, slipped across to the Soviets during the revolution and returned to Hungary at the helm of the Russian army that placed him in full power.

The population was devastated at the thought that communism was not defeated. **The West gave only lip service to freedom in support of democracy. Hungarians felt betrayed.** Sandor, who was very bright and intuitive when it came to politics, spoke to the group huddling now in despair of the news of gloom:

"Listen friends, the United States and the United Nations missed one of history's best opportunities to free Hungary after the Russians were beaten and the local puppet government

dismantled. We were an open, independent land for western democracies to recognize as a legitimate nation. Our country was free for them simply to walk across the reopened borders with a few divisions. With the world's opinion on our side— after our heroic bloodshed and victory—the Russians would not have dared challenge the entire world.

"The remaining satellite countries would have followed suit. I think now that the opportunity to stop the spread of communism was missed, there will be more triumphs for them in spreading to economically poor, gullible nations. I predict that there will be in the future more Stalins, and there will be more revolutions like ours where the statues of dictators will be toppled and their heads dragged through the streets of cities by the oppressed. The world stopped Hitler, therefore there will never be another one like him. But because they did not stop Khrushchev and his disciples there will be many similar repeats."

The talk went on about the defection of thousands across the temporarily reopened borders to the West, to Austria. Ironically just before the revolution one of the communist members of the government ordered the minefields to be cleared at the Austrian border. As the government did everything sloppily, much of it was not cleared and a considerable number of them injured and killed people on their exodus.

There seemed to be three waves of mass exodus out of Hungary. The first wave consisted of the opportunistic, selfish group of young adventurers and many criminals who were freed along with the political prisoners. The second wave was a large group made up of people who were fed up with the system and the economic situation. This group, comprised of the elite workforce highly valued by the communists, included doctors, engineers, other professionals, and highly skilled workers with their families.

The last was a special group that had the most difficulty in escaping, because the borders were by then shut down by the Russian and Hungarian AVO, who awaited them. This group held

deep love and were loyal to their country. A great number of them were freedom fighters who fought to the bitter end and knew if they remained they would eventually be rounded up and executed. Others like Sandor, who contemplated escape, were now the patriots who might be used as symbols as the "enemy" and executed to set an example and fear into the hearts of the population. This was the price that an Hungarian paid for straying from communism and being disloyal to the Soviets.

The news of the many horrors spread fast through the land. A brilliant young (white Russian) actor, Darvas, Ivan a good friend and colleague of Sandor's, was already arrested and being tortured.

The new president, Janos Kadar, rounded up the young freedom fighter girls and boys who were under 18. He jailed them and waited for them to reach adulthood. He simply had them executed on their birthdays. Meanwhile all the ones above 18 were executed immediately, without trials, for their participation.

Once above ground, Balazs took to the streets and inhaled the fresh November air. He did this several times to flush out the stale underground air which he has been inhaling for days. The city was still quiet of traffic save the Russian tanks that polluted the city. Suddenly he remembered Eugena. Before he realized he ran more than halfway to her apartment, which was within a three-kilometer range. As he ran he had to climb over high piles of rubble that were once buildings filled with hundreds of people. Occasionally, he saw piles of frozen bodies of Hungarians and Russians alike. He stopped to spit at the dead Russians, it made him feel good; it was but a small way of getting even and contributing to the failed cause.

He finally reached the apartment and ran up three flights of stairs. Eugena lit up with joy as Balazs embraced her. Both were jubilant in finding the other unharmed and alive. Despite much destruction to the neighborhood, her building was intact. They hurriedly shared much information uninterrupted by Jadda, who was out visiting her siblings. Balazs, who had been guarding the secret of the family's plan to defect, decided to tell Eugena about it. As if the walls had ears again, he whispered the secret to Eugena, who went pale

from the gravity of the news. Her first thought was that she would never see her beloved nephew again, but it was overcome by thoughts of Paula and Eugene.

"Balazs, your grandparents will die of broken hearts if you leave them at their age." Soon after hearing herself say that, she felt guilty burdening Balazs with the thought. She corrected it right away with the suggestion that they should have an opportunity to say goodbye to him. Balazs's thoughts immediately turned to his grandparents. He could clearly imagine the two frail figures of Paula and Eugene huddled day after day by the radio. The few revolutionary radio stations, mainly the FOX, situated underground somewhere beneath the citadel inside Gellert Hill, gave detailed accounts of the developments. The initial victory of the revolution was an unbelievable accomplishment in their minds, but knowing full well the nature of the Russians, Eugene knew that it would be followed by ruthless revenge.

Eugene and Paula had no communication with the family. They had no idea if any of them were injured or lost. The news of mass defections across the open and later closing borders of the "Iron Curtain" was of great concern to them. Did any of the family defect? What about Balazs, did he join the thousands of young freedom fighters and was he one of the ones caught, executed or fleeing across the border? All these were painful questions in their hearts without answers. The maddening questions persisted for weeks before they heard from anyone in Budapest.

There was only one phone in town located in the Party member's office where no one in his or her right mind would discuss anything like the revolution or defection. The trains were not running since there was a general protest strike throughout the land. This was also a first in Soviet occupied countries. Balazs realized that there was absolutely no way to ever see the most precious people of his life again. There was an eerie silence between them as their thoughts consumed them. Eugena's expression changed suddenly to a joyous smile. Balazs thought she had a solution to his dilemma, but no, that was not it.

"You will not believe that the other day my phone rang which had been dead for over a week and as I picked it up I hoped it was you calling. There was much static on the line for me to hear, but an excited, older voice with a familiar accent kept calling my name. Eugena, Eugena, my love, can you hear me? Good thing I was already sitting on the couch, because it became clear to me that the voice was no other than the voice of my love Imaoka! Can you believe it?

He said he was not in Tokyo, but was standing across a small bridge in Austria that connected the border towns of Hungary and he is coming to get me. My heart leaped right into my throat and I could not find words to even respond. He said that he attempted several times to pay people that brought others back across the border for money, but no one would risk taking him at his age, because he was too much of a risk."

Imaoka, after a life of unfulfilled romance, stood at the border in desperation unable to claim his denied love. The one thing that occupied his mind secretly throughout his entire life was to be with Eugena. He crossed continents to come this far at the news of Hungary's liberation, just to be cheated again by fate and politics. The frail, old Japanese man tried in vain to conjure up all his traditional masculine posture of honor by not showing his emotions in public.

Finally, he realized that his mission was impossible; he was fatigued and felt his age. He stood there weak, frozen in time, feeling a tremble from within his chest that overwhelmed his entire body. The anguish, which he felt long ago the first time he left Eugena, returned anew. Imaoka collapsed forward onto his knees in defeat and wept uncontrollably at his own tragedy.

Despite the gravity of the news that he was not able to come for her, Eugena, an ultimate optimist, held on to her belief that Imaoka would try somehow. Unbeknownst to her, after his call to Budapest, Imaoka actually gathered his strength and indeed made several attempts. On the first, at great expense Imaoka hired a guide to take him to Hungary. The two managed to cross the Hungarian border

and the guide, before departing, gave Imaoka specific instructions that would easily lead him to Budapest.

The next day, to the guide's amazement, a disheveled Imaoka was back in Austria. Imaoka ironically, successfully defected from Hungary on his own instead of ending up in Budapest. He became disoriented and unwittingly returned. At the final attempt both the guide and Imaoka nearly ended in the trap of the AVO. He finally gave up! Lonely and broken. He returned to spend his remaining unfulfilled love and life in Japan. He continued to express his love for her though letters and beautiful poetry written all in Hungarian.

Balazs was so excited by all this unexpected news that he forgot his dilemma concerning his grandparents. As they continued to discuss Imaoka's plight she led him with a somber expression to the window below where his favorite ringed-neck dove family lived. She opened it to the cold winter air with tears in her eyes. Balazs beheld the most heart-wrenching vision of the entire revolution. He did not understand why this seemed to be more painful for him than all the human suffering he witnessed.

The bare branches of the tree below the window were black and appeared to be petrified into onyx. The thicker ones reached upwards like a modern metal sculpture in a desperate gesture for help. He noticed in the wedge of a Y shaped branch, two small, charred, little objects, melted into what may have been the remnants of the poorly constructed doves' nest. His heart sank as he imagined the two little souls tightly huddled in terror together in their last moment of life. This minimalist art of horror represented his entire nation's scorched annihilation by the Russians.

THIRTY NINE

UNINVITED HOUSEGUESTS

BALAZS WAS increasingly frustrated. He heard news of many friends who had left the city to defect. He could not get America out of his mind and he did not want to live under this hateful system any longer. He could not imagine returning to school to further study the compulsory Russian language, the ugly language of these murderous barbarians.

His cousin, Szoke, Kati, a beautiful girl who competed in the 1956 Melbourne Olympics in Australia for swimming, "forgot" to come back to Hungary after slipping away from the watchful eye of her AVO guards. Her family later received a letter from her with a colorful card, showing palm trees from an exotic place called Honolulu. Balazs's heart leaped at the sight.

Days passed amid horror stories and news of much suffering under the hands of the Russian soldiers. Despite their defeat, the country folks held out and refused to bring goods into the city, they would only feed the fighters and their families secretly. No one went to work in order to shut down the economy. All systems failed as the trains and buses and every facet of transportation came to a halt. The Russian army began again to attack villages and plunder for food and provisions.

Sandor went back and forth daily trying to decide whether he'd take his family to freedom or not. Though he was a successful star, he was concerned about a future career elsewhere. His actress-wife was in the same predicament. His mother, too, was alone after her husband's death. Kati thought of her mother, who was her only close living relative. There was the country they loved so much and didn't want to leave this beautiful land. This nation with thousands of years of such proud, heroic history. As artists, they thrived on the beautiful poetry and literature, which ran through every ounce of their beings.

Just the thought of separation from that tore their hearts to pieces. Yet, what of their children's future in this terror-run hellhole? Perhaps, they would have to sacrifice everything in the end for them. Sandor Schwartz, a good friend in Vienna made a promise to them in the summer, which echoed in their minds persistently, "My friend, if ever you are able to defect I will help your family get to the American embassy." Yet they waited!

Balazs nagged daily as to when they were going to defect. He heard that the borders were getting tighter everywhere and soon it would be next to impossible to escape without being captured. Russians and the resurfaced AVO were already capturing thousands of families en route to their escape, immediately shaving their heads and loading them onto cattle carts bound for Mother Russia. If they happened to escape, their shaved heads would identify them. Balazs thought it was a good thing they did not circumcise them as the Egyptians had done to their slaves as permanent identification.

As Sandor's constant vacillation brought him no closer to any decision, fate came knocking on his door on November 19th dressed as two civilian armed AVO officers. After Sandor responded to the heavy rap on the door, the whole family stood in the hallway and felt the blood draining from their legs in fear. The one who spoke had the typical unhealthy, pockmarked face of some rejected human product as was generally the choice recruits of the AVO. People who hated the rest of humanity for the injustice done to them by their very birth now wanted to get even on the more fortunate through their evil power.

They needed no introduction. The family and Kati's mother, who had moved in with them during the revolution, stood in tight formation as Sandor automatically, like a protective hen, stood with wings spread backwards shielding his family from the danger lurking within these two evil entities. They were all stunned when the man informed Sandor that they were assigned by the government to "protect him." Sandor and the family instantly understood the double meaning of those words and that his appearance at the Parliament did not go unnoticed. Balazs felt ashamed and guilty for calling his father a coward and insisting on his involvement. In their minds, now all hopes of defection were sealed.

Before they realized what was happening, the two bullies herded them like cattle around the apartment. One pushed Kati into the kitchen and commanded her to prepare a meal. He said he knew she would be hiding food that the rest of the proletariat would have no access to. The other ordered Sandor to open his roll-top desk to examine his correspondences, prying for incriminating evidence. Balazs felt sickened, knowing that the more than 400-year-old antique desk held a secret drawer built into it by the clever Renaissance craftsmen. In that drawer his father kept his important correspondence, which didn't pass through regular mail. Many had been arrested as the result of letters they wrote and trusted in the privacy of closed envelopes. When the smaller fellow saw Balazs and Barna idly standing by, he barked at them to get their Russian language textbooks out because he would test them later.

Despite the wonderful smells Kati created with the fried onions, potatoes, sour cream, and sliced hard-boiled eggs layered with delicious Hungarian smoked sausage, none of them had an appetite for eating. The two seated themselves at each end of the large table. One of them shouted at the family who did not get further than holding their utensils from lack of appetite. "Eat!" he yelled so loudly that Kati nearly jumped out of her chair.

Balazs was looking down at his feet afraid to give away his thoughts. He was in a quiet rage contemplating murder. Secretly, he sized up the weaker one and realized that if he quickly jumped up he

could easily strike and stab the one sitting to his left, now busy gorging himself with the food. He imagined, turning the knife deep in his throat, so that the sausage would be regurgitated through his trachea onto his lap as his eyes bulged.

He could not imagine his father fighting for the man's gun because that was too dangerous. But then he thought Sandor had a huge fist and if he would strike out at the man's temple, Balazs would move in to stab him. They could shoot the unconscious one with his own gun and be free! They would keep the gun, take the identification papers, pack, get into the new Opel Cadet and show the papers at the border check-point or, if all failed, smash through the border patrol barricades. He had it all worked out in a flash and there was no time to waste as the pigs were eating fast. He looked askew at his dad from the corner of his eye, making certain that he was not noticed. Sandor saw it immediately and Balazs noticed panic in his face. He tried to understand why Balazs kept shifting his eyes from right to left toward the man next to him. Balazs slowly grabbed the sharp knife to get the point across and pretended to use it for eating.

As the men were busy over their plates, he caught his father's glance. Again, he made a leftward motion ever so slightly with his head and knife. Balazs looked him straight in the eyes to guide his father's glance toward the other man, near Sandor. Before Sandor had the opportunity to catch on, a powerful blow of a strong fist came crashing down onto the wooden table making the silverware lift high into the air like a magic show before they fell back. The AVO man barked right into Balazs's face with death in his bloodshot eyes, screaming while spitting food toward the shocked kid, "Don't you get any funny ideas you little twerp or I'll beat the daylights out of you!"

Balazs coiled back like a snake as he felt his venom flood his brain. He sat back and his mind went into overdrive thinking about overcoming these two criminals who certainly would be taking his father to the gallows. He did not consider that anyone else in his family would be working on the same equation.

FORTY

BOLTED

SANDOR AND HIS family were mute in the presence of the men who seemed to be everywhere at all times. They had no opportunity to communicate. They were in a limbo. No one dared to ask how long they were staying because the time of their departure probably meant the time of Sandor's arrest. These two strangers were their enemies by the true definition, yet in an instant, they settled into their lives.

After dinner, one of them closed the door of the family's main bathroom and relieved himself loudly as if he were at his own home. They were nauseated by his symbolic marking of territory with his defecation. This very act sent a message to everyone that the AVO men were staying the night. They thought it was time to do something. Everyone in the family realized that desperate measures were necessary; Sandor's life was at stake and his end imminent.

The man who was calling the shots demanded to see Sandor's wine collection. They knew that Sandor had excellent wines given to him by fans and admirers. Balazs and Sandor felt alarmed by the request knowing that violent minds don't mix well with alcohol. Now there was the possibility for physical violence too.

Balazs already noticed the shifty looks they gave his incredibly desirable stepmother. Yet to Sandor's and Balazs's surprise, Kati volunteered to please their demand. Not only did she become pleasant and talkative, but she patiently went through the entire wine list with them. She told them where the wine came from and chatted endlessly, totally out of character.

Shortly after, they decided which wines to sample. Kati spun about smiling with ever so much grace and pleasantry—making the creeps feel like her special guests. The family was flabbergasted at her behavior, but realized that she was up to something. The strangers, unaware that she was acting out of character, suspected nothing and became idiotically mellowed. She picked up the first bottle and disappeared with it into the kitchen, then four more, explaining to them that these wines had to breath a long time before serving. She emerged not with crystal, but with their finest silver chalices to distract them with the fineries. The drinking began.

Everyone now, including Balazs, thought this was a very good idea, perhaps using her charm and smarts to convince them into letting Sandor go. The night seemed endless and the two gradually became quite friendly. Now everyone in the household joined in the act. The comrades mentioned the plays they saw Sandor and Kati in and which ones they liked more than others. They began to brag and cozy up to the point of gossiping about the private lives of other stars since they were assigned to spy on them. They even revealed to them the times when Sandor and Kati were under AVO surveillance in the past and what intimate things they knew about them. This bizarre behavior clearly showed Balazs that if they revealed so much to them Sandor and his family were truly doomed. They obviously did not care what inside information the family knew since the outcome would be their end anyway.

Late in the night, the two were drunk out of their minds, but still in some ways with the awareness of guard dogs. Several times one fidgeted with his gun under his leather jacket. No one was certain who was acting better—the actors or the secret police. At one point, the aggressive one sat on the floor, his legs spread across the

open doorway leading to the hall. The other one posted himself totally against the front door barricading the only available exit out of the apartment.

Kati and Sandor kissed the boys goodnight in their bedroom and quietly assured them not to worry, it would all be all right. They felt frustrated by not having the opportunity to whisper with their parents in the dark. Kati's mother, Eta, retired with the boys, three into one bed. All was dark, but Balazs remained totally awake. He began to whisper to Eta and wanted to know if she had any plan of action. She tried to calm him and told him to sleep, tomorrow may bring better news. Balazs was totally unconvinced. His brother was either in shock or did not weigh the seriousness of the situation because he was already fast asleep.

Staring at the ceiling, Balazs's eyes got accustomed to the darkness. All the while his mind was churning furiously on the situation at hand. Should he sneak up to the one with the gun in his jacket and finish them both off in their sleep? Are Sandor and Kati planning to do something? What if he attempted something and the guy was just pretending to sleep and actually was waiting for an excuse to shoot somebody? If he made a blunder then the men would have an excuse to kill Sandor. As he was evaluating the odds, he drifted off into sleep.

Not realizing the short duration of his sleep he woke in total panic. Worried that he missed out on something. But all was as he left it, still and dark. No one stirred. An enormous urgency came over him. He must act now! Nothing would change unless he did something. Quietly, he rolled out of the bed after he freed his body from the tightly tangled limbs of the other sleepers. He looked through the old-fashioned gaping keyhole as the outside city lights diluted the darkness in the hallway.

The man against the door snored. It was real, not pretend. He could tell because when Sandor had too much to drink, then his snore was considerable and his breathing long. He slowly opened the door just a crack. It creaked, but nobody seemed to notice. The snoring went on. Great guards, he thought to himself.

"Eta, wake up! Wake up," he shook her several times gently as not to frighten her. She came out of a light sleep and focused on his silhouette created by the white wall behind him. "What is it did something happen?" she whispered in a worried tone. She felt with her touch that he was fully dressed and had his sweater and shoes on. "What are you doing?" "I am going to defect and get some help for Dad. Do you have any money you could give me?" "You are delirious and out of your mind, go back to sleep, I told you everything will be all right." "Do you have any money you can give me?" he insisted, but got no reply this time. He gave up on her and woke his brother. Annoyed at Balazs's moronic requests, Barna vehemently refused to join him in his plan to get some help for the family. He also suggested sleep as remedy and burrowed deeper into his pillow.

He had no choice and found himself totally alone like so many times before in his life. His mind was made up. The key to the lock for the two new bicycles was in Barna's pants pocket. He removed it without a jingle and approached the already opened bedroom door. He stood there a long time watching the sleeping men. As his eyes got clearer in the dark, he realized to his relief that the man at the entry door was hunched forward over his left leg, his head dangling. He was leaning away from the door. He saw that there was at least a 30 centimeters crack left of the front door if he opened it to slide through.

He took several careful steps forward, toward the door. As if on cue the guard stirred and frightened Balazs out of his wits, almost making him jump. With his heart pounding, he retreated into the darkness of the bedroom and removed his shoes all the while watching the man. He held them in one hand. Luckily nothing happened and the man settled back into the same position.

Balazs went into action. Like a shadow he stole back to the door and saw to his amazement that the door was left unlocked the night before when the AVO entered the apartment. The keys were left on top of Sandor's shoeshine box next to the door. He hardly could believe his good fortune. Before he knew it he was outside the front door, which he slowly pulled back into its original position carefully

easing back the handle without a click. He kept his shoes off and quietly went down the staircase until he reached the bottom floor.

Once in the lobby he saw the two bicycles leaning as usual against the radiator, chained together securely. He unlocked it as quietly as possible and took his brand-new, green bike his father bought him not long ago for the summer vacations. He loved his bike and thought it was the most beautiful thing in the world. Naturally having the background he had, he thought any gift was the greatest. His father and Kati always delighted in giving the grateful child presents.

After he cleared the heavy glass, wrought-iron door and stood in the street, he glanced up toward the apartment windows. Everything was dark as he left it. He felt an enormous rush. Hurriedly, he put on his shoes, mounted his bike and flew beneath the large archway of the building into the open boulevard. He was familiar with the road that led to Austria as most people had that road etched into their minds and psyche in the Russian-occupied Hungary. The road to freedom where no Hungarian was allowed to travel beyond the border.

His first and foremost plan was to get the city behind him. He pedaled furiously with infinite energy that only teenagers possess. He didn't notice the bitter cold that froze his uncovered ears and fingers. His favorite brown beret, which he wore almost always through the cold months, did not reach below his ears leaving them exposed to the bitter-cold wind created by his speed. In his hurry to dress, he neglected to bring gloves and look for his jacket. He thought finding his jacket would create noise anyway and wake up the guards, so he left without it. He gained distance on the deserted streets. In the dull light of the city, a dark mass appeared on the horizon approaching him. He jumped off the bike instinctively and hid beneath a gate. The object moved slowly and without the rumble of tanks. Just to be certain, he waited patiently for it to draw near.

Catching his thoughts, he realized how unprepared he really was for the 200-some kilometer trek ahead of him. No money, no clothes

and worst of all no identification papers if he was stopped. He knew, surely that was going to happen. Just then, he saw a man driving a cart laden with supplies and directing two frisky horses toward him. The cart wheels were made of auto tires which were often used by the country folks to keep their ride smoother and quieter on the city's cobble streets. It also made an easier pull for the horses. Close up, Balazs could see the friendly face of a peasant. Feeling safe, he ventured out into the open to inquire, just to be sure, that he was on the right road to Vienna, Austria.

He waved the man down. "Whoa…, whoa…" the peasant gently called out as he restrained his steeds. The white steam came rushing from their wide-open nostrils toward Balazs's face as he approached. The familiar smell of the horses felt comforting to him. "Sure you are on the right road, son, but that's a long way and you sure don't look to be properly outfitted for it," the man responded good-naturedly as he wiped the hard frost from his long trailing mustache. "Yeah, I know, but I left in rather hurried circumstances," said Balazs, avoiding wasting time now on long explanations.

"Well, good luck then wherever you are headed," said the man. As he was about to lift the reins and move his cart, Balazs quickly reached up and put his hand on the man's arm. "Just a minute, sir, please, would you do me a simple favor?" "Well that depends on what that is, son." "You see, I left in a bit of a hurry from home so my parents might be worried. Could you let them know that I am all right and that you saw me on the road?" "Sure I can do that, what's your father's name?" the man asked. With pride Balazs said, "He is the famous actor Szabo, Sandor and lives on Madacs Ter #3." "No problem, son, I know who he is and I am heading in that direction anyways. But before you go, let me give you this."

He tied the loose reins on the side of his bench and reached behind his seat. He pulled out a short-handled shovel and handed it to Balazs, "Take this with you, son, and if any authority asks you where you are headed, you tell them you are going to work in the next town or the one beyond, so be sure you always ask and find out

the names of families before you go. This may slow you a bit, but you have better chances of getting there. Too many kids like you end up in Russia; now we don't want that to happen, do we?" He smiled affectionately at the skinny boy and as he bid him goodbye he wondered how far the child would get before his capture.

Balazs mounted his bike again, crossed the shovel across his handlebars and pushed off on the most decisive journey of his life. He wondered if the kind man would really talk to his father.

FORTY ONE

ON THE ROAD

THE THOUGHTS flooding his mind prevented him from noticing November's bitter cold. The shovel across the bar was not such a good solution, because his hands were not large enough to maintain his grip for too long. He stopped for a moment and stuck the handle through his sweater at the back of his neck and lowered it through to hang out at his trousers. The cold air rushed up his shirt but he did not feel it. The hard, wooden handle rested between his shoulder blades as the plate of the shovel formed a peculiar shield on the back of his head. Since neither the peasant nor he thought of a method to tie it securely, this remained the only solution until later when he would get something to secure the shovel with.

He kept pushing ahead—passing through the ruins of the city, then the outskirts of Budapest with its industrial and ugly parts. People began to stir and move about in the early morning light. They went about their chores unaware of a determined 13-year-old speeding by on a shiny green bicycle, forging his destiny.

Once he was clear of the city, the buildings became houses, then the houses began to have gardens and larger spaces between them. The main thoroughfare of the Hungarian towns was always lined on

both sides with acacia trees, which were trimmed to their knuckles in the fall. The stumps of these amputated trunks looked like fist and had the appearance of congealed monster faces from fairy tales. An occasional, rusty iron well-pump between them broke the even rhythm here and there.

As the houses became sparse and open fields more prevalent, Balazs felt comforted by this familiar environment from his childhood. He passed through currents of warm air mixed with the smells of farm animals and freshly burning wood. Sometimes the lonely call of a magpie pierced the empty silence of winter. As he listened to his own heaving chest, far in the grooves of plowed, brown fields, hundreds of black crows picked at the frozen ground with their powerful razor sharp beaks.

As distance and time stretched between him and the city, the reality of what he had done, rose slowly to the surface of his psyche. The road ahead seemed so far when he searched the empty horizon. Where was the border? What could he expect to find? Would all the Russian tanks be lined up facing him with their guns while the AVO looked down from their watchtowers searching for easy targets, the likes of him?

He began to entertain doubts and fears. His concern for his family became acute. Did the AVO men carry his father away when they discovered his escape? Were they on the road in a speeding car in hot pursuit to capture him? Why was he attempting to escape when the borders were once more secured and shut down by the military? What kind of a coward might he appear to everyone for abandoning his family as they drag him back in shame? Worse, he saw himself being loaded onto a Russian train with bald head, destined to Russia never to see his family again.

He felt strongly about being Hungarian. He remembered his proud heritage of the Huns. He thought of his great ancestors-conquerors of the past, who fought for this beautiful land; then what good custodians they became defending Europe's culture and territories from the Tartars and later for more than 150 years against the Turks. The small nation of less than 10 million souls contributed so

much to the world's culture and betterment. He thought of the artists and composers, including Liszt, Lehar, Bartok and Kodaly.

There were the great Hungarian mathematicians who helped create the atomic bomb that stopped World War II. The Hungarian genius Edward Teller the father of the H bomb for America, that kept the Soviets at bay in the Cold War; Dr. Ignatius Semmelweis, who ranked in fame with Louis Pasteur, for saving women from the epidemic of mortality in childbirth. There was Joseph Pulitzer, in whose memory the U.S.A. hands out the annual awards for achievement in literature and who before his death bequeathed money to fund the eternal floodlights on the Statue of Liberty in New York Harbor.

How proud he was when his people won -16 gold, 10 silver and 17 bronze medals while competing in the 1952 Olympics in Helsinki, against nations with populations of 200 million (USSR) and 180 million (U.S.A.) and numerous other larger nations. In 1956 they performed equally as well. In soccer the Hungarian "golden team" was undefeated between 1950 and 1954. The team that dominated the international water polo for more than a quarter of a century was Hungarian. They had a bloody encounter with the Russians team at the Olympics. The Hungarians, as all of the other satellite nations, were "encouraged" to lose against the teams of great Mother Russia to save face for them in the global arena of propaganda.

The Hungarians, inherently proud and rebellious people, refused to give up their well-earned victory to politics, so the Russians committed all the foul underwater violence they could think of to assert their will. To the horror of the audience, the water of the Olympics ran red with the blood of the athletes. With these thoughts of passionate patriotism he ran up against an invisible wall. He felt the pangs of homesickness before ever leaving the land he loved.

He stopped his bike and stood at the edge of a small village listening as he contemplated his next move. Puzzled, he looked ahead onto the straight, long, paved road. At the end of it lay the horizon in a veil of soft fog and mystery. He turned his bike back toward the way he came and observed a similar view. The veil of fog camouflaged

an uncertain future if he returned. Beckoning smells of the small village filled the cold air about him.

As he stood lost in thought and time, the silence slowly eroded with a low rumble and vibration beneath him. He turned in both directions and saw nothing, but the still and undisturbed fog in the horizon. The sound became louder, more defined when he finally recognized that hateful noise etched deep into his mind. The grinding and clanking of the heavy metal treads of the Russian tanks. The earth shook and vibrated from their quake. Suddenly, from beyond a row of yellow farmhouses large Russian tanks appeared dwarfing the homes.

Balazs turned lightning fast and darted toward the nearest house for cover. The shovel slipped off to one side scraping the back of his head. In response to the pain, he twisted the opposite way and lost his balance, tumbling, bike and all, into the ditch. He panicked realizing how vulnerable he was. Images of the young freedom fighter's fate in the phone-booth flashed before him. He tore himself loose of the bike, then with the shovel still sticking out the back of his shirt appearing like some alien, Balazs dove through the already opened farmhouse door. Someone pulled him through. Immediately the door slammed behind him as he was dragged through several dark rooms into a pantry. Yet, another door slammed on him.

He could still hear the tanks outside, but the rumble gradually dimmed. Did they notice him and stop or are they still waiting outside to ambush him? He had no idea. All he could do is wait patiently in the dark. God, he thought, I hope these people will not get killed for harboring me! He heard small noises like wooden shutters being slammed or opened, he could not tell. As the nervous sweat dripped from his forehead, he smelled the scent of dry corn stored in the burlap bag beneath him where he landed.

The small room was filled with all the enticing smells of dried fruits, smoked sausages and walnuts, reminding him of his grandparents. The door opened slowly and a busty, little peasant woman greeted him, "You had a close call, young man, but don't worry, they did not see you." Still, his heart pounding loudly in his ears, the first

thing he thought of was his bike. Before he had time to ask, she was ready to calm him down. "Yes, I saw your trapeze act into the ditch. After the Ruszki drove off, I went and got your bicycle and leaned it next to the hen house. You must be some rich kid to have such a vehicle at your age," she observed; Balazs did not respond to her remark, but embraced her and thanked her for her help.

With the shutters now opened, the little house became light inside. Colorful country embroidery covered the cot against the wall and hand-painted plates hung on every wall of the little room. It had dirt floor. The tall, domed stucco stove, with a traditional round bench hugging it was a welcome sight. He put his open hands and body against it and it felt great. When she helped him get free of the shovel she remarked with a cunning little grin, "Identification paper?" They both laughed and felt better with the danger gone.

"Jancsi, my husband, is out with the sheep and will be in momentarily." Shortly after, Jancsi entered the room from the back courtyard of the house and put his smoldering pipe down on the old wooden table to greet Balazs. They turned out to be a chatty bunch. In a short time Balazs told them of his plans. Hungarian peasants, like this couple, are known to survive the harshest political times through the occupations and wars. They always fared better than the city folks. Though they labored on the collective farms, they tended to their own animals and had a small garden with vegetables and fruit trees.

Balazs was fed a wonderful hot meal, but was urged to continue on his road and not to turn back. They told him of the rumors about retaliations and they insisted he must be gone. Besides, the chances of escaping and making it through the border were diminishing hour by hour. The farmer gave Balazs a reversible, lamb fur-lined jacket. It was old and well worn, with two enormous pockets. The couple opened a small cupboard by the kitchen and removed three bills of 100 paper Forints and shoved them into the protesting hands of Balazs. That was a lot of money at the time.

"You have a long journey ahead of you, son, with many turn of events and no doubt you will be needing this." He fashioned a

leather sling on the shovel's handle so Balazs could comfortably swing it over his shoulder. For safety measure, the generous couple sent him off with the names of families three villages away.

Now determined and without a doubt in his mind to face the border, he mounted his bike. The jacket felt nice and toasty and had the smell of sheep. When he reached into the inside pocket to stash his money, he found a pair of two fingered knitted gloves. Balazs felt great and ready to brave whatever was ahead.

FORTY TWO

OUTFOXING THE FOX

SANDOR AND KATI returned to their bedroom after saying goodnight to the boys and Eta. They quietly closed the door between them and the room where the first AVO man with the revolver was lying, across the entry. She had no opportunity even to look at Sandor through the night's ordeal and she avoided it, too, lest she raise suspicion.

The past few weeks Kati was having difficulty sleeping, which she attributed to their busy and hectic lifestyle. Her doctor, one of Sandor's friends, prescribed a very strong sleeping potion in powder form and cautioned her to use it sparingly and only when absolutely necessary. She was also given strict instructions as to the amount. For her convenience, the doctor gave her ample supply—her future refill.

Little did Kati know that this prescribed powder (kept in a jar out of reach of everyone) would play a vital role in their lives. When the AVO demanded wine, Kati reeled into action. She acted like a charming hostess—talking of the special wines, which she now started lacing with her sleeping powder. After the first four glasses of wine consumed by the "guests," she felt confident that their taste

buds would be numb. She poured the contents of her entire prescription into the bottle of a fine red cabernet from Lake Balaton. Shaking it slightly, Kati held the bottle to the light to examine it. The powder dissolved easily and only slight dark grape sediments were visible at the bottom of the bottle. She was actually hoping to do away with them for good, but putting them into a deep coma would work just fine, she thought.

The two houseguests began snoring. Kati confessed to Sandor what she did and told him there was no time to waste or to hesitate about their next move if they were to survive. They all knew his fate was sealed by the returning government and they understood what that meant. They hurriedly discussed the plans.

With their fast and brand-new car from Austria they could escape. Kati began to pack in the dark the very essentials—money, some small valuable jewelry and identification papers. Sandor packed the leftover watches from their last trip in Vienna and rolled up two very valuable oil paintings, one painted by the great 16th-century master Basano. What to do with everything else they would be leaving behind was a big dilemma. How to communicate with the rest of the family to come as fast as possible and clear out the apartment before the government did?

Parting from their loyal Cocker Spaniel, Haver (meaning friend), was heart breaking and painful. They decided that Eta may be a problem. Crossing swamps and mountains or other rough terrain in mid-winter was not for the frail. Many elderly and weak died at the border or caused the capture of others. Eta would have to deal with the two bodies of the AVO, the dog and the remaining property. Their hearts felt heavy with these decisions, but there was no other choice.

Kati was afraid to check the results of her poison. So they laid in bed talking the rest of the night about their fears as well as their hopes. They eventually fell asleep, far into the afternoon as was their habit.

The phone rang and Sandor flew out of bed to silence it. He swept it off the receiver and with a hoarse voice answered, "Hello?"

It was a longtime friend on the other end. "Sandor, we must leave the country. We are all in danger. It's all over for us!" Before Sandor was able to respond the voice informed him that he and an actress colleague of Sandor's were joining them. He knew the man for more than 25 years, although their relationship was very odd and mostly one-sided. Sandor always felt used.

The "friend" was from a wealthy family before the war. Interestingly, he knew both of Sandor's wives before Sandor ever met them. He pursued both relentlessly but unsuccessfully. Now, too, came his urgent call to defect, but Sandor was providing the escape vehicle. Balazs was always suspicious of this cad because it seemed he did very well in all the political regimes, yet no one really knew what he did for a living. Balazs was convinced that the man was an informant. It all made sense to Balazs now how the AVO knew so many personal things about Sandor and Kati.

"Sandor," Kati urged him, "go and see how the AVOs are doing." After Sandor hung up the phone, Kati opened the door quietly and peered through the crack. The man closest to them slid all the way down to the floor and was sprawled out like a corpse, motionless, apparently not breathing. Sandor reached for one of his shoes on the floor and tested the waters by throwing the shoe at the seemingly lifeless body. The shoe hit its mark hard, right on the shoulders, then rolled to the floor; nothing followed.

They crawled next to the AVO man and watched him closely for a moment. They saw no breathing. Sandor, though petrified, reached out and shook the man gently. No response. He got braver and shook him vehemently. Same result, nothing! They looked at each other and smiled with relief. More confident this time around, they repeated the tactics ending with the same results with the other man. Sandor grabbed the man blocking the front door who was curled up like a dead fish and deposited him on top of the other.

Kati, who already packed the essentials the night before, quickly gathered some winter clothes and entered the room where the children and her mother Eta lay fast asleep. Kati shook the sleeping bodies in the bed and realized in the lumps of blankets and pillows

that something was not right. She looked about quickly to see if perhaps the missing body she was seeking was behind her. He was not. She knew for certain that something was really wrong. "Where is Balazs," she asked the sleepy faces of her mother and Barna. They looked bewildered and not yet awake from their deep sleep.

Suddenly, Eta came to life and screamed, "Oh my God, he defected!" "What nonsense, don't be absurd," Kati screamed back at her. "What are you saying, Mother?" The panic swept the family as everything came to a halt. Sandor was beside himself, extremely upset. Eta was hysterical. Why she didn't think of waking her daughter and Sandor was beyond her. She didn't act on it because she did not take Balazs's plans seriously. When she learned of the incredible and immediate changes of her life she nearly fainted. She felt discarded, worthless, abandoned. She and the dog were to be left behind, but Kati loving and firm, remained with her decision.

What to do about Balazs? They could not fathom the news. Then Sandor thought, if Balazs really was on the way, he could only be on one road which they had to drive on until the border. If he left eight hours ago, now being 2 p.m., he could not possibly have gotten far on a bike. As they ran about the apartment in a panic, tripping over the two bodies on the floor, there came a knock on the door.

Sandor ran to open it expecting his friend, but to his surprise a stranger with a droopy mustache stood in the doorway, humbly apologizing for the disturbance. "Maestro, I have news from your son Balazs." The weight of the unknown lifted from everyone from the knowledge that he was indeed well and on the road where they could find him. Now, more than ever, they must be off immediately to find and take him with them.

The goodbyes with Eta and Haver were terrible and quick. They flew out the door. Once out on the street, they heard tanks rumble through the avenue. Kati and Barna slipped back into the vestibule of the gate. Sandor was careful not to awaken suspicion and strolled slowly to the nearby garage where his car was. The gas tank was full since it was unused from the time the revolution began. Like a good

new car it started right up. This beautiful, luxurious car became their salvation now.

By the time he pulled up to the gate, the two extra passengers were already there waiting for their ride. The haste and chaos of their departure out of the apartment, out of their lives as they knew it, was surreal. In an instant it was all behind them. All Kati was thinking about was Balazs. Her heart was heavy with worry. She felt her love for Balazs deeper than his birth mother Jadda could ever feel for him. Balazs and Kati were mystically linked and she saw him as her "soul mate child." Her fear of them getting stopped on the road concerned her less than the thought of Balazs being stopped and captured somewhere if they did not catch up with him on time.

Before too long, they encountered their first road block miles out of the city. Fortunately, Sandor cleared himself and the group by claiming that they were going to Gyor, a city of theaters, to guest star. Since the AVO recognized him, his famous wife and their colleague in the back seat, they let them go. But, they reminded them that if they were contemplating other programs like defecting, all their families left behind would suffer the consequences.

This threat filled Kati with guilt for leaving her mother behind, a target and victim for their retaliation. On the other hand, she was preoccupied with finding Balazs on time. She was miserable in every way, but found some solace by pulling Barna closer into her protective arms.

FORTY THREE

PLOTTING FINAL ESCAPE

JUST WHEN BALAZS prepared to continue his journey and the couple adjusted the shovel on the back of his warm sheepskin coat, a neighbor was outside by the main road, drawing water from the community well. Just as the old man straightened up for a moment to ease his sore back before picking up the heavy bucket of water, he saw a shiny, spanking-new car with a private license plate speed by him. It was a rare sight on the Hungarian roads, the likes of which he had not seen before. He admired the stylish cream-colored Opel and released a deep, long sigh, thinking to himself —well, never in my lifetime for me. He painstakingly lifted the full bucket and walked back towards his house.

Balazs did not have to go through many towns before his first barricade appeared. He took the advice of all his guides and spent the time learning names of people in the towns he had to enter. The shovel acted as a very good passport for him and his worn peasant sheepskin added to his small-town boy look. His successes made him feel confident and positively happy. He was satisfied and fully enjoyed the performance of his new bike. From time to time he couldn't help looking at the shiny, green metallic bar between his

legs. Ever since he was a little boy, colors always gave him unusual sensations of pleasure.

He traveled through Gyor, with a few stops by the Russian uniformed authorities. Here they did not care about names from the next towns, but his get-up seemed sufficient to pass him on. Without any belongings he did not appear to be a defector. Those are the ones they were looking to detain.

He had to reach the ancient city of Sopron (Balazs actually could have been in Austria already, because there was a finger of landmass reaching from Austria, into Hungary. This heavily guarded landmass had to be traversed in order to reach the city.) Sopron was the last city by the Austrian border and Balazs, like most of the 200,000 defectors, was headed in that direction. He stopped for a loaf of hot, freshly baked bread at the city's outer edge and fashioned a deep groove into the bottom of the crust to placed it securely on the bar of the bike. This way he could ride and eat without losing any more of his time. He wanted to reach Sopron by night and find shelter.

He had no plans or information on where and how to escape, so Balazs began to attach himself to other bikers on the road to ask questions. His concerns were different now that he was nearing the border. The incriminating questions had to be well camouflaged so as not to raise suspicions because he never knew if the person he was addressing was an informant or an AVO.

He was getting anxious as darkness fell early on winter days and the cold became a major obstacle. Balazs had to find shelter where he was invisible, yet remain warm. The roads were filled with people going to and from the city. He again entered an industrial area with many smoky factories where thousands of people changed shifts and flooded the roads. If people did not use the public transportation system, their only option was a motorcycle or a bicycle. People often chose the latter for privacy.

He attached himself to a young group on bikes to see if he could get some information. Through the short, veiled and less-than friendly conversation, he realized that they were also in the process

of defecting. But they did not trust him for fear the he was an informant. They took extreme care and kept their distance from strangers. Again, no one trusted any one.

Finally, as a great number of workers poured out of a factory gate, Balazs changed his tactic and pulled next to a factory worker, who looked like the genuine article. He was exhausted and ashen gray. Like a ghost, the typical worker of Paradise always appeared to be from some graveyard. They worked six days a week under slave conditions. The man appeared to be in his early 40s (but most likely in reality he was ten years younger) was the quiet type, but not unpleasant or unfriendly. After a while, in the conversation, he dropped a clue that it was okay for Balazs to let him know what he was up to. They pedaled ahead of several other bikers, so as not to risk being overheard.

"You know," the man said, "there is a train at dawn, preparing to run the border" Balazs nearly jumped off his seat in fear of being overheard. He looked carefully at the man whose face was visible now by the dim streetlights. He was reluctant to give himself away so readily by responding. "I don't know what you are talking about."

"Right," responded the man and looked straight ahead pushing down on his pedals.

He then continued with his narrative as if he were talking to himself. "Just the same, there is a train leaving from the station at dawn and we could get you a ticket on it. It does not stop, if you know what I mean. I noticed you have a great bike, perhaps we could make a trade? You are not going to need it on the train. So, here is my offer." When he phrased it that way, Balazs realized the man was genuine and now he would listen.

"Go ahead," said Balazs. "What's the deal? But still, I really don't know what you are talking about, because I am going to work in the next town." (Balazs really knew someone's name there, too, as he continued to practice the method which worked before as a safety measure.) He still did not trust the man completely and he was not going to jeopardize his plans and get arrested before he had an opportunity to escape.

The plan laid out for him was something so perfect that even he could not have done it better if given the chance. The man offered him room and board for the night and he would purchase the "two-way ticket" at the train station while he washed up and had a hot meal. He would give him two small bottles of strong Hungarian plum brandy (just in case he was captured by Russian soldiers). Alcohol, they knew, was gold to a Ruszki. Also, he would transport Balazs to the right train station in the morning on his own bike. Balazs's heart sank when the man mentioned his last ride on his own bike. It was hard to think of parting with it and having someone else riding it.

"So, what do you think?" the man had to post the question twice as Balazs's thoughts were stuck on giving up his precious bike. Finally he came back to reality and his choice was a bitter-sweet one. Reluctantly, he muttered, "Okay." Frightened, he looked at the man expecting to be arrested on the spot as he would reveal his true identity of being an AVO. That didn't happen. The man's ashen gray face, with the premature wrinkles, lit up with an incredible smile of happiness. In Balazs's mind, it was the smile of a horse thief who just ripped off an unaware costumer.

Balazs didn't know what to feel. His entire plot of escape was just solved by a total stranger. Why did this happy moment have to be spoiled with giving up his bike? As he continued to push down on the pedals next to the man, he worked on getting used to the idea. The man, who had known nothing but poverty, hard labor, living deprived of the good things in life, could not believe his good fortune either in meeting up with this kid. They continued by each other silently, each with his private thoughts, until they arrived at the communists' "prefab concrete heaven." Hundreds of gray buildings stood atop each other without a tree or a blade of grass between them appearing like overgrown cemetery headstones.

They mounted five flights of dimly lit stairs in a ten-story building that had no elevator even on its original blueprint. Balazs could smell every dinner menu in the apartments they passed by, so by the time the man ushered him in to his own, he would have eaten anything.

Balazs could not believe how young and attractive the man's wife was. She, like all women under communism, had a job. The scenario was always the same for everyone, hence the reason for full employment under communism. Ten people had the job of one. The genius of communism was to split that one salary among the ten "employed" persons.

The man quickly told his story to his wife, who showed no protest. Balazs noticed immediately that there was no demonstration of affection between them. The man had a cold, remote personality. He quickly grabbed a bite and left Balazs behind while he flew off toward the train station, naturally on Balazs's bike that was soon to be his property. The small size of the few rooms baffled Balazs. How could anyone keep their sanity living in such a small space?

The twin bed nearly took up the whole bedroom. Besides two small night tables, there was only space for a metal washbasin at the foot of the bed. The tiny kitchen held a small table. She called to him to come and eat. He sat across her and as she dished out the soup from the pot, Balazs noticed her smooth skin and well-shaped arms which were visible because of her short-sleeved blouse. His eyes traveled to her neck and pretty face. Like many Hungarian girls, she wore no bra and her full breasts heaved as she was breathing.

His inquisitive looks satisfied her female ego. To heighten his blood pressure, she stretched her arm out to lift the soup ladle over Balazs's bowl just enough for him to get a glimpse of one of her breasts. He was young, but he was an astute observer of human behavior growing up in a small town surrounded by nature. He saw that animals and humans were totally alike in all their mating games. The language was always clear, all one had to do was simply pay attention.

She smiled like a Cheshire cat; a smile ricocheted off his face, too. When she caught that, she realized he was not a virgin and relaxed. Neither of them spoke for several moments dying to figure out the next step in this ritual dance of the sexes.

Later she spoke to him softly and asked things about him without expecting any return questions. He saw that she wanted to remain

mysterious. He did not push it. He was feeling very tired. After dinner, she said "The train station is at the other end of the city so we don't have to wait up. Why don't we bathe then go to bed?" She filled the large metal basin, at the foot of the bed, with hot water. She placed two towels and a bar of soap next to it. The room was lit by a solitary bulb that hung by a wire from the center of the ceiling between the bed and the basin. The steam from the water rose up invitingly. "You go first," Balazs said realizing that she made no attempt to leave the room. "Okay," she said. He thought, perhaps she will turn off the light.

With ease and natural candor, she took off her blouse and the rest of her clothes revealing her beautiful and youthful body. She stepped into the middle of the water—running her soapy hands all over her velvety skin. Suddenly, his fatigue vanished and his insides felt tense. When she was done, Balazs knew it was his turn to do the same. He had never undressed in front of a girl, but he did not want to appear a greenhorn. After she brought fresh water, he quickly undressed. She was in her light nightgown lying on the bed watching him.

He turned his back on her to hide her effect on him. She relished his discomfort and stared approvingly at his tight behind which was the result of his soccer playing. He hurriedly finished bathing and wanted to get into the bed before the man returned and possibly kill him. He put his underwear back on, shut off the light and hid under the covers. She got up, turned the light back on to empty the water from the basin. Shutting the light off again, she returned to join him in bed.

The street lamps of the city outside gave enough light in the room, so he was able to see her beautiful face. She had one hand under her cheek and the other on the pillow as she stared at him. She could not see him, but was fully aware of his condition. She enjoyed her power and continued to toy with him.

His heart was beating so wildly in his throat, he thought he was going to choke. Her eyes reflected the light coming in from outside the window. He knew by instincts, like a mouse, that the cat was

about to strike, but felt immobilized by her stare. She moved her hand off the pillow and like a snake it slithered to his hip bone and down to her target. His mind went blank and numb with the sense of pleasure. The outside door slammed and the hand withdrew in an instant as she turned her back to face the other wall, pretending to sleep.

The bedroom door opened and after a few fumbling motions in the dark, her husband dropped his tired body next to his wife and fell asleep. She slowly reached back for Balazs under the sheets. After locating him she pulled him tightly into her round buttocks. It seemed that their sleep lasted only for a moment before the alarm went off.

FORTY FOUR

"THAT IS FREEDOM,
IT'S AUSTRIA"

ETA STOOD IN the doorway, dumbfounded and disoriented. Up to this moment her life revolved around her only daughter Kati. Now that life was yanked out from under her she did not have the slightest idea what to do next. She heard the fat little dog scurrying across the wooden parquet behind her. When she hesitantly closed the door behind her departing family, she felt the tragedy of the moment. Her entire life became meaningless.

The dog sniffed at the unfamiliar scent of the bodies lying on the floor. One of them twitched. Fear hit Eta like lightning. My God, she thought, they are not dead! She bolted behind one of the tall chairs as if to barricade herself. She stared at the bodies still piled on top of each other as Sandor left them for dead. In her panic she totally forgot her own woes and went into a survival mode.

Eta observed them for a moment to size up the situation. The dog kept nudging at the face of one of them, but there was no more response. She got some of her courage up and slithered like a snake next to them to see exactly what condition they were in. She noticed

a very slight movement on their chests, but not their mouths. She gently reached for the pulse on one of the wrists. After a while she was able to sense a slight beat and her fingertips registered some body heat.

For a moment she was relieved that they were not dead, but then she became frightened that they were not. What a jam they left her in. She was confident that the drug would last a long time and would give her time to accomplish things. She took an empty suitcase out of the closet and began stuffing it with as much valuables and memorabilia as possible which Sandor left behind. She emptied the secret drawer of the antique furniture and seeing the phone on the desk, quickly called one of Sandor's sisters. She told them there was no time to waste, but must come immediately to remove anything they could carry before the AVO men sobered up.

She could hardly lift the heavy suitcase. She dragged it toward the door as the dog followed on the leash close behind her. She pressed the elevator button not expecting anything. She was startled when she heard the gears engage above her. She pulled on the leash as the superintendent's half-witted son opened the old folding doors. She stepped into the elevator and made her final getaway never to return.

It wasn't until the next morning that the AVO men began to stir with an incredible hangover—one they had never experienced before. Finally they came to their senses. The apartment was totally empty save for a few nick knacks here and there. They knew the dire consequences they will pay for their stupidity. It certainly will be execution or deportation to the Gulag. Their only alternative was to face the border too and join the rest of the refugees.

Kati was in hysterics, to the point of turning around. She insisted on returning to Budapest, and find her son. No one listened or supported her idea of returning. As they drove, they saw truckloads of people of all ages heading back toward the city. As the drivers were all Russian soldiers they knew what unfortunate human cargo was inside. Was her son among them she wondered with her aching, miserable heart.

Near the border, they stopped in a small village. Sandor spoke with several peasants who knew the border well and he offered them

money to take them across. The men suggested avoiding the bridge at Andau because it was so popular in the beginning of the exodus that it was now swarming with AVO and the Russians. They were to select a path only known to those who lived there.

Sandor made several decisions and paid large sums of money to buy their freedom. Naturally, not a penny of contribution came from his "friend." Sandor gave one of the men the equivalent of $1,000 to go back to Budapest and seek Eta out because if Balazs failed in his escape, he would surely return to her. The men were to fetch Balazs and bring him across the border. Kati felt better for the moment. Somehow, with time her feminine instincts and sixth sense told her that Balazs was probably all right and succeeded in crossing the border. She did not know why all of a sudden she felt an inner peace. Then they fell asleep under the puffy goose-down covers the peasant's wife offered them. This couple had been helping hundreds of people cross to the other side, but this was the first celebrity and they felt honored to help. They gave up their own bedroom to Sandor and Kati.

Sandor fell into the same dilemma—giving up his car as Balazs had with his bike. Unbeknownst to him and Kati, Balazs was asleep only a few kilometers away from them.

Balazs and his hosts jumped to the sound of the alarm clock. Without delay, omitting the morning preparations they scurried out the door of the apartment to run down the staircase. Only after reaching the bottom did Balazs realize he did not even say goodbye to her. Her scent was all over him still as he mounted the bar on his bike while the man pushed forward for the start. He felt odd sitting with another adult on one bike as he sat sideways with his long legs dangling. The man let him know that he was taking the back streets to avoid the authorities now swarming at all hours in the border city. Hundreds who weren't careful or knowledgeable about the city were captured daily.

Now that Balazs was near the border, for the first time he began to feel serious fear. The streets were dark as they left the man's apartment, but unusually busy for such predawn hour. Every shadowy

figure posed danger, increasing his heart beat. What seemed forever
may have been only 40 minutes to the station. As he smelled the
familiar scent of burning coal and steam, he realized the train was near.
He thought it ironic that the train which became such integral part of
his life will now complete his journey delivering him to freedom.

They jumped off the bike and rushed under the arched gates of
the train station. Several tracks were laid under the protective dome
occupied by steam engines warming up ready to break out of their
corral like black bulls. Balazs looked up at the closest locomotive and
noticed, to his delight, that the hated red Russian star was removed
from the front of the engine. A pale, faded gray image was all that
remained. The whistles, the huffing and puffing from the locomo-
tives echoed off the walls adding to the colorful noise of the gangway.
No one had ever seen such a mob at this station before. All types of
people were there. Peasants, who proudly wore their traditional hand-
embroidered clothes, which the Russians had forbidden them in their
effort to wipe out their national identity. There were elegantly dressed
city people and ladies with old fox stoles from before the war.

He saw the incredible amount of junk people carried with them.
Balazs thought it was total madness. Many young and old fighters
still proudly carried their "Russian guitars" slung over their shoulders.
A young warrior walked passed him with several grenades attached to
his belt. Balazs felt envious and sad still that he had no part in con-
tributing to the revolution of his people even if it was defeated.
People were calling out for friends and family, children cried and in
the general commotion there was much shoving and pushing.

Balazs began really fearing for his life. What he believed would
be some clandestine train escape now unfolded into a frenzied free
for all. This for certain, will become the target of the authorities. He
could not help looking around, expecting the thunder of of heavy
boots. He imagined armed Russian soldiers descending upon these
naïve people and mowing them down.

He had no time for further worry as his guide lifted him into the
air, depositing him on the top steps of the train bound for freedom.
The man shouted above the noise, "Balazs, God be with you, good

luck. I will take good care of your bike!" His last words almost meant
more to Balazs's comfort than his genuine wish of farewell. He
turned and attempted to wave to the man, but was pushed by the
pressing mob from below.

The tumult forced him into the already crammed wagon. He
was pressed so tightly he could hardly breathe in the already exhaust-
ed oxygen of the stifling compartment. Some desperate woman
pleaded in protest of being crushed. She met with no response,
everyone had their own concerns. Children screamed and men
yelled for the windows to be opened for air. Irritated voices replied
in response, complaining and sighting their own conditions, as oth-
ers did not want to catch pneumonia.

The circus continued. Finally, Balazs felt the forward and reverse
jolt of the train. Bodies hurled in both directions causing people to
trample each other. The wheels began slowly making their continu-
ous motion in the forward direction. They were off!

"This is going to be a short, hard ride and you better hold on,"
said a tall muscular man towering over him. Balazs could tell he was
a coal miner by the permanent coal-dust filled wrinkles on the back
of his neck and hands. He smelled strongly of deep earth and sweat.
In contrast, he still sensed the pleasant lingering scent of the young
woman—reminding him of his deprived pleasure. The locomotive
began to gain speed rapidly and continuously. The floor of the cabin
shook more than usual from barring thrice the original weight
designed by the train's engineers.

Balazs felt the planks bending and rising under his feet. It
occurred to him that the floor might give way and they could fall
through to be cut up by the razor-sharp iron wheels. Someone final-
ly opened a window and the fresh winter air rushed through the hot
cabin replenishing the oxygen depleted lungs. The passengers inhaled
like fish released to water after being snared. At each end of the car
the doors remained open with people hanging for dear life off them.
No one wanted to be left behind by the train that was to break
through the border. Many who arrived late could not get on and with
frustrated tears, watched their train, their salvation, pass out of sight.

Sandor and Kati also were awakened by their hosts in the middle of the night. It was time to go. Sandor arranged one more thing regarding his beloved car. Grudgingly handing over his keys, he made the man promise that they would donate it to the hospital of his choice. This made him feel better than abandoning it somewhere in the forest. The five of them were ushered through hills and a leafless forest, whose sharp branches cut their faces relentlessly. In a short time, the feeling of the unbearable cold was gone as they ran up and down the hills.

Not being able to see things in the dark they often fell on the hard frozen ground and bruised themselves all over. None of this mattered as Sandor thought of the AVO and the Russians who were probably following not far behind them. He felt safe in the company of these good people. They were honest, helpful and most of all, knowledgeable about the terrain to deliver them to safety. Kati held Barna's hand tightly through the ordeal, she was not taking any chances on losing the only son left her.

They were impressed how expertly their guides operated avoiding all the guards positioned throughout the border delivering them through a frozen swamp to freedom. One of the man came to a sudden halt and crouched. He waited a moment and motioned for everyone to do the same. He ventured forward and passed a small hill to scout out the conditions. The reeds were undisturbed, nothing moved, he was satisfied. He ran down the hill to test the soil for its hardness and it was good, too. He gave a short scout's whistle for them to follow. When they reached him, he pointed in the direction of a distant, blue glow in the horizon. He said, "That is freedom, it's Austria!"

As they stared catching their breaths their hearts filled with hope. On both sides, not too far in the distance, they saw flares go up into the sky, reaching their zenith they hung there for a moment, illuminating the sky and land bellow. The hard rattle of machine-gun fire ensued. They looked at the men—frightened. Did these men bring them in to a trap or did they lose their way missing their mark? Were they surrounded? Would they be captured?

One of the men sensed their doubt and whispered, "Don't

worry, as long as they are busy killing the people escaping on both sides of the swamp over the open fields you are safe to go. Just stay facing the lights at all times and you will get there." The thought of people being shot and killed all around them made them feel sick and guilty at the same time. Still, they felt fortunate to have the advantage. They bid farewell to their guides who disappeared into the dark night.They stood there frightened and insecure for a moment. Kati broke the silence and urged, "Let's hurry!" Everyone in the group crouched to avoid being seen by possible stray guards. Cautiously and quickly they started their escape. A path took them meandering through the reeds across the frozen swamps, towards the faint, blue lights of freedom.

Penetrating screams surrounded Balazs. The lights were turned off in the cabin by the train's engineer earlier to avoid detection by the enemy, leaving everyone insecure in the dark. Only the sounds gave hints on what was happening. The people hanging outside in cold and those near the windows had the advantage of visual information.

The border was nearing as the train sped confidently ahead with its full cargo to freedom. Unfortunately the earlier fears of Balazs came to pass. The Russians heard from informants about the train's intent. Instead of preventing its departure, typical of their cruel, blood thirsty nature, they waited in ambush to destroy it right before it reached freedom! Several tanks occupied the train tracks with floodlights to stop the speeding train, knowing full well that the conductors were not going to chance derailing and have everyone's death on their hands. The Russian commander, luckily for the passengers, was an incompetent and lined his soldiers for the ambush on only one side with the executions on his mind.

When the engineers of the train saw what was in store for them, they did as the Russians were expecting. They did not risk the lives of the people. When the madly speeding train finally came to a screeching halt, the engineers hoped their passengers would take advantage of the commander's obvious blunder.

From the sudden stop the bodies flew forward on top of each other. Many were severely injured beyond help and some were

crushed dying instantly. The screams were amplified around Balazs as he was tying to tear himself lose of a pile of bodies. An explosion followed with the machine-gun fire. The immense volley came from the side of the train where he boarded. Bullets flew everywhere and the splinter of train particles covered everyone filling the air. His legs were trapped under lifeless bodies. He could not wriggle free. He struggled to push his body toward the opposite side from where the shattered glass of broken windows came and the spray of victim's blood.

It felt like at the Parliament again with his parents, but perhaps this time his fate was sealed. Balazs was convinced this was his end—he would die. His parents would know nothing of his fate and may never find his dead body. As the images of his life went before him, his thoughts were interrupted. Windows were opened fast on the opposite side from the machine-gun fire. People piled out as fast as they could, pulling others with them. The panic became incredible as people tried to flee from the carnage dealt out by the Russians. Balazs was caught in the center of a tornado of bloodbath.

He became airborne suddenly. Huge powerful hands grabbed the scruff of his neck and crotch and heaved him forward, right through one of the windows that remained closed. Instantly, his head broke the glass. Flying through the air, Balazs landed on top of people who fell into the ditch before him. His thick, sheepskin coat softened his fall. When he quickly examined his body for injuries, he discovered the two flask of brandy still intact.

A large figure climbed through the broken window after him and landed loudly, feet first on the gravel by the tracks. He recognized the miner's shape, who wasted no time taking two large flying leaps over the scrambling bodies. Like a black puma, he disappeared into the night toward the direction of the distant blue lights.

Balazs got to his feet. Following the blue lights, he, too, melted into the darkness.

—xxx

This is the ornament from the wrought iron gate
of the Budapest Parliament which broke off in
my grip at the 1956 massacre.

AFTERWARD

AFTER SUCCESSFULLY CROSSING the border on Nov 21
1956, I was moved through several refugee camps and ended up at
Eisenstadt Castle outside of Vienna, Austria. The castle had been
converted into a refugee camp where the Austrian people were most
generous in helping the refugees. My parents searched on the radio
for me and received an anonymous call reporting that I was seen
alive. After spending several days sleeping in piles of hay among hun-
dreds of other homeless refugees and wondering about our future,
Kati, my relentless "mother," and my father, Sandor, found me at 3
a.m. after tireless and intensive searches through many camps.

Because of my father's fame, our family was granted special sta-
tus with immediate asylum to the USA. Our flight was on a four
engine, old military prop plane. After surviving a bumpy emergency

crash landing at Ireland's Shannon Airport, we flew to the USA and arrived at Camp Kilmer in New Jersey.

We spent a short time there as my father was awarded "honorary citizenship" to the state of Rhode Island by the governor with the stipulation that if we should settle there permanently, we would receive a home and an automobile. After spending our first Christmas with the generous John Sweeney family in Hope Valley RI., my father decided to take our family to New York. On the way, he was invited to visit a distant relative who was living in Connecticut, Jolie Gabor. She was an earlier refugee who escaped the Nazis ten years before. We brought along father's long time friend from Budapest, Mr. Odon Szigeti, whom we discovered at Camp Kilmer. Jolie and Odon fell in love at first sight and were married thee months later in March, 1957.

As years passed, Jolie Gabor became a life long friend and mentor to me. Zsazsa Gabor, her beautiful and witty daughter, continued the same kindness toward my family after Jolie's death.

After settling in NYC, father received The Rockefeller Foundation Scholarship to study English. Having a brilliant mind, he excelled quickly. Within one year, he was not only fluent in English, but appeared on Off Broadway. His first role, ironically, was in Chekhov's play the "Three Sisters." He played the Russian general. Shortly, he went on to Broadway as well as performing in many TV series including Mission Impossible, It Takes a Thief, The Defenders, Bonanza, Sea Hunt etc.

He played a major role with Gregory Peck at the NYC Lincoln Center in "The Matter of Oppenheimer." In Los Angeles, he appeared with Jack Lemon in "Idiot's Delight" and on Broadway in New York in "Barefoot in the Park" with Myrna Loy and Robert Redford. He appeared with Charles Loughton, Celeste Holm, Hermina Gingold, Robert Wagner, and Hugh O'Brian among others. His major film roles in the USA included Hitchcock's "Topaz" and "The Sunshine Patriot."

My parents lived in New York City until 1967. They then moved

to Minneapolis where he acted in the plays of the dissident Russian play-write Alexander Zolhenyitzin at the Guthrie Theater. They also lived several years in Chicago and in Hollywood, Cal.

Meanwhile, Mr. and Mrs. Robert P. Morningstar, the owners of the Paisley Chemical factory in NYC, lovingly provided Barna and I with the finest private schools, i.e., The Storm King School on Cornwall on The Hudson, Peddie School in Hightstown NJ. and Eron Preparatory in NYC. I was awarded a scholarship to Pratt Institute in NYC, but to the dismay of the Morningstars, I chose instead to attend the Fine Arts Academy in Vienna, Austria. Later, I switched to the applied arts school, the Bauhaus, Angevandte Kunst in Vienna. Before returning to the USA, I took a risk and legally crossed the Hungarian border to visit my family, Paula and Eugene, whom I found in good health. They continued to live into their early nineties. In time the Hungarian government and the Soviets realized that if all the refugees would return to visit with US dollars to spend, it would benefit them. Therefore, they passed an amnesty to all the 1956 refugees.

In 1967, I convinced my parents to visit Hungary, despite their grave fears. Thousands awaited their return with cheers and flowers at the train arriving from Vienna. In 1976, father permanently returned with mother to Budapest, after spending twenty colorful years in the USA, to reclaim their successful positions in the arts. This was the result of several visiting delegations dispatched to the USA by the still Russian occupied Hungarian communist government, convincing them of their safety.

In the following twenty years of working in Budapest, my father received all the awards an artist could possibly receive, many of which were denied him before the revolution. Sadly, Hungary still lingered under the same cruel political and economic system. Kati did not pursue her field in the USA or in Budapest because she became disabled from a malpractice hip operation in NYC in 1961. Despite her constant struggle with pain, she remained a positive, loving mother and an inspiring wife. She did not live to see Hungary's

liberation from the Russian occupation as she passed away in 1989 at the early age of 67 from cancer. With the Soviet system's collapse in 1991, the Russians finally left Hungary in the same vicious manner as they came in 1945.

With his re-established success, my father regained his wealth. Unfortunately, shortly after my mother's death, he married a "gold digger." The marriage lasted just two years. After a financially draining divorce, he was befriended by his ex wife's girlfriend, a mediocre opera singer, three decades younger than him. While dating her and under her expert care, my father fell into a mysterious five week coma. She was observed on several occasions by many people, including my brother and our spouses, administering Sandor his heart medication in Scotch. After surviving his coma, he left the hospital to discover that he was miraculously married to the new girlfriend. Somehow, his entire will had also been re-written and this time it was without the mention of Barna or me. While in the "care" of this "loyal wife", he soon entered into another four week coma. This time, she did not contact any family members or us regarding his condition. He never regained consciousness and passed away at the age of 83. Only after his death and her invitation to us to attend his funeral were we made aware of his last hospital stay.

Since 1956, excluding the time I spent in Europe for my studies, I've lived six years in New York State, three in Chicago, five in Los Angeles, four in Connecticut and twenty years in Hawaii. In 1993, my family and I moved to Raleigh, N.C., where I live and work today as an artist. I have two wonderful sons and my beautiful wife from Montana reminds me of my mother Kati in many ways.

The risk I took crossing the border in 1956 was not in vain. For fifty years, I have had the privilege to live in freedom and to be protected by democracy in a land that still inspires the world with its ideas of freedom and liberty.

To view my works of art and read more about my life through interviews, please

visit my website at: **www.balazsart.com**